CELTIC ART

Symbols & Imagery

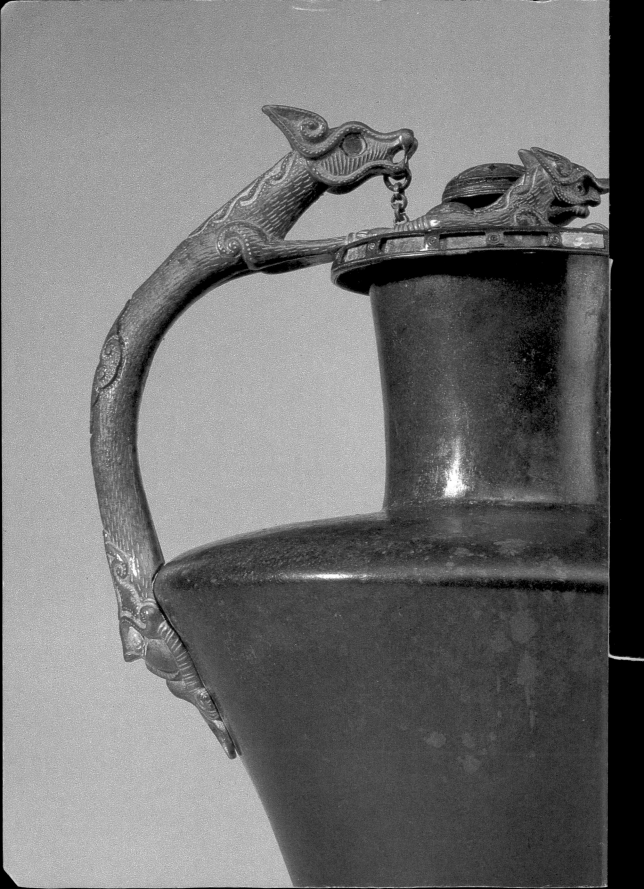

CELTIC ART

Symbols & Imagery

MIRANDA GREEN

Sterling Publishing Co., Inc.
New York

For my Father
Eric Aldhouse

(an artist of great vision)

Acknowledgements

I should like to express my gratitude to the many institutions and individuals who have
contributed to the production of this book. First I wish to thank the staff of Calmann & King
for all their help, particularly Lee Ripley Greenfield, Jacky Colliss Harvey, Susan Bolsom-Morris, and
Tim Barringer. Thanks are due also to the academic staff of the University of Wales colleges of
Newport and Cardiff, for their support and forbearance. I am very grateful to Kenneth Brassil of the
National Museums and Galleries of Wales for reading through the manuscript and for
making useful comments and suggestions. But I owe the warmest debt of gratitude to my family,
especially to my parents Eunice and Eric Aldhouse, my husband Stephen and my daughter Elisabeth,
for years of loving encouragement. Thank you.

Library of Congress
Cataloging-in-Publication Data Available

1 2 3 4 5 6 7 8 9 10

Published in 1997 by Sterling Publishing Company, Inc.
387 Park Avenue South, New York, N.Y. 10016

Originally published in Great Britain in 1996 by
George Weidenfeld & Nicolson Ltd

Copyright © 1996 Calmann & King Ltd
This book was produced by Calmann & King Ltd, London

Distributed in Canada by Sterling Publishing
c/o Canadian Manda Group, One Atlantic Avenue, Suite 105
Toronto, Ontario, Canada M6K 3E7

Series Consultant Tim Barringer (University of Birmingham)
Senior Editor Jacky Colliss Harvey
Designer Sara Robin
Picture Editor Susan Bolsom-Morris
Printed and bound in Hong Kong

ISBN 0-8069-0313-9

Front cover The carpet page from the Book of Durrow, page 125 (detail)
Frontispiece One of a pair of wine-flagons from Basse-Yutz, France, page 62 (detail)

Contents

MAP: *The Celtic World* 6

INTRODUCTION *Finding the Celts, Finding the Art* 9
The Celtic Identity 11 The Nature and Function of Celtic Art 17

ONE *Art and the Artist in Celtic Society* 21
Celtic Society, 700 BC–AD 600 21 Celtic Art: Nature, Range, and Purpose 29
The Celtic Artist 32 Travelling Artists or Travelling Ideas? 34
Artistic Organisation 38 Celtic Metalwork 40 Monks and Manuscripts 51

TWO *Class and Gender: Function and Reason* 55
Wine, Women, and Song 58 Symbols of Status 66
Jewellery, Rank, and Gender 71 Torcs and other Ring Jewellery 74
Belts and Brooches 80 Gender in Human Representation 82

THREE *Talismans of War* 87
The Status of the Warrior 88 The Battle Equipment of the Celtic Soldier 89
War-gear and Display 90 Swords, Spears, and Trumpets 95
Defensive Armour 100 The Art of the Horseman 106
The Significance of Decorated Military Equipment 113

FOUR *Nature in Art: Abstraction, Realism, and Fantasy* 115
From Tendril to Triskele 119 Native Vegetal Symbolism 121
Animals and Monsters 128 Realism and Distortion in Animal Art 129
Monsters of Fantasy and Myth 135 Shape-shifting or Shamanism? 137
The Sacred Head 138 Humans in Art: People or Deities? 142

FIVE *Symbolism and Spirituality: From Paganism to Christianity* 145
Art and Pagan Symbolism: Context 146
Divine Imagery in the Romano-Celtic World 147 Art and Myth 149
The Context and Symbolism of Early Christian Art 152 Christian Metalwork 158
Christian Sculpture 161 The Illuminated Manuscripts 164

TIMELINE 168
BIBLIOGRAPHY 170
PICTURE CREDITS 171
INDEX 172

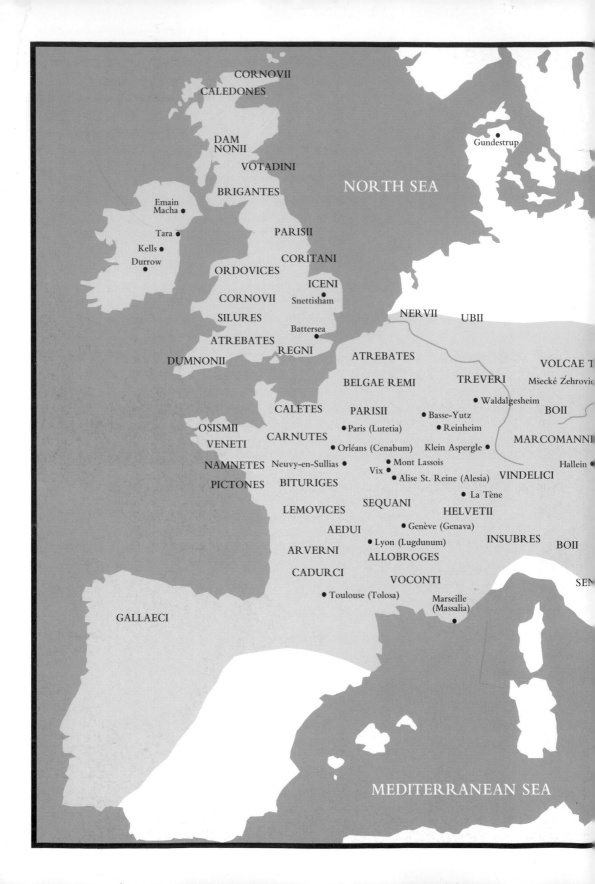

CORNOVII

CALEDONES

DAM
NONII

VOTADINI

BRIGANTES

Emain
Macha •

Tara •

Kells •

Durrow •

PARISII

CORITANI

ORDOVICES

ICENI

CORNOVII Snettisham •

SILURES

Battersea •

ATREBATES

REGNI

DUMNONII

NERVII UBII

ATREBATES

BELGAE REMI

TREVERI Mšecké Žehrovic

CALETES

PARISII

Waldalgesheim •

Basse-Yutz •

OSISMII

VENETI

CARNUTES

Paris (Lutetia) •

Reinheim •

Orléans (Cenabum) •

Klein Aspergle •

NAMNETES Neuvy-en-Sullias •

Mont Lassois •

Vix •

PICTONES BITURIGES

Alise St. Reine (Alesia) •

LEMOVICES

SEQUANI

La Tène •

AEDUI

Genève (Genava) •

ARVERNI

Lyon (Lugdunum) •

ALLOBROGES

CADURCI

VOCONTI

Toulouse (Tolosa) •

Marseille
(Massalia) •

GALLAECI

NORTH SEA

Gundestrup •

VOLCAE T

BOII

MARCOMANNI

Hallein •

VINDELICI

HELVETII

INSUBRES BOII

SEN

MEDITERRANEAN SEA

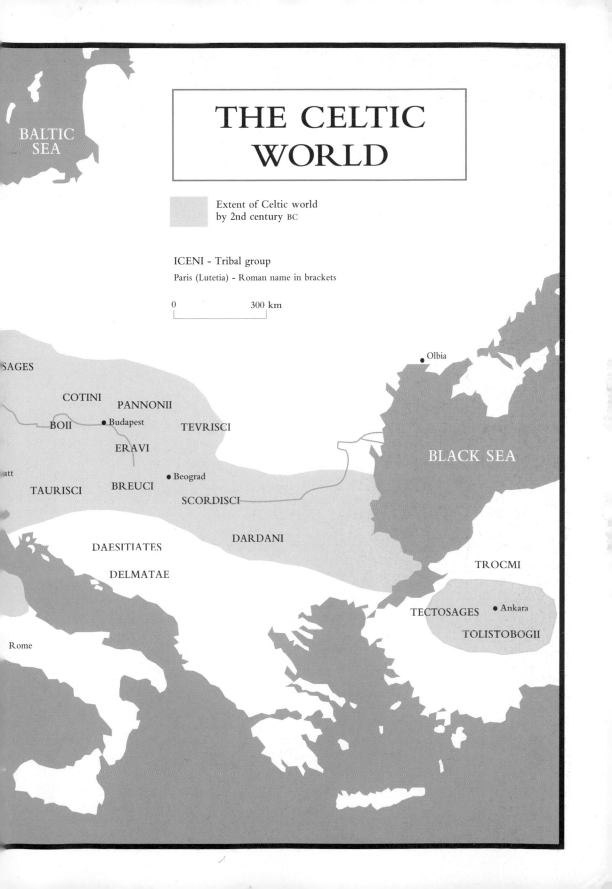

THE CELTIC WORLD

Extent of Celtic world
by 2nd century BC

ICENI - Tribal group

Paris (Lutetia) - Roman name in brackets

0 300 km

BALTIC
SEA

...SAGES

COTINI

PANNONII

BOII ● Budapest

TEVRISCI

ERAVI

...att

TAURISCI BREUCI ● Beograd

SCORDISCI

DARDANI

DAESITIATES

DELMATAE

Rome

● Olbia

BLACK SEA

TROCMI

TECTOSAGES ● Ankara

TOLISTOBOGII

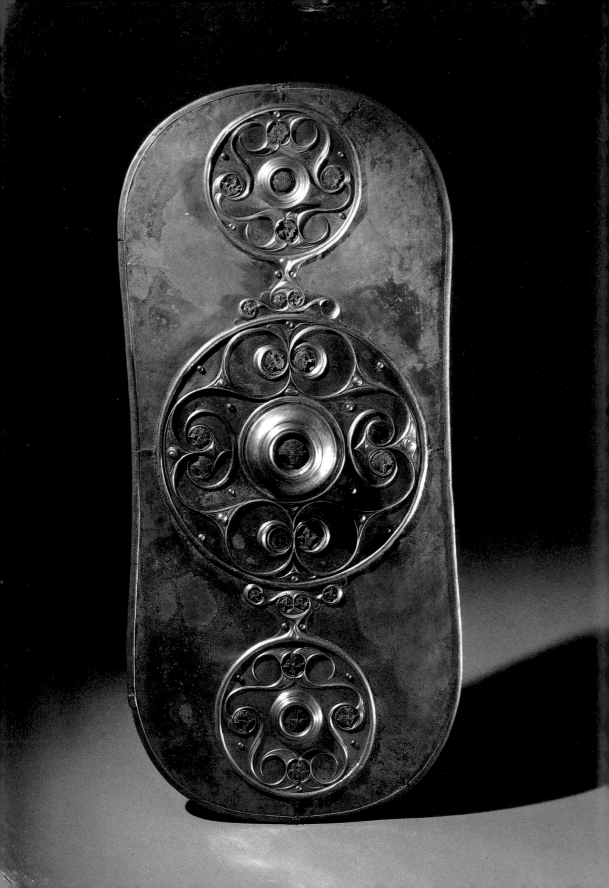

Finding the Celts, Finding the Art

> The Gauls are tall in stature and their flesh is very moist and white, while their hair is not only naturally blond, but they also use artificial means to increase this natural quality of colour ...They are terrifying in appearance, with deep-sounding and very harsh voices.
>
> Diodorus Siculus (fl. lst century BC), *Library of History*

1. The Battersea Shield, 2nd-1st century BC. Bronze with red enamel inlay, length 30¹/₂″ (77.5 cm). British Museum, London.

This object, technically a shield-cover, was purchased from the finder by the British Museum in 1857 for £40. It was a ceremonial piece, too fragile for use in battle, which had been deliberately cast into the River Thames as a gift to the gods, perhaps in thanksgiving for a successful battle. The designs include swastikas (symbols of good luck in Celtic art) and reversible faces.

This book differs from the majority of art-historical studies because it deals, for the most part, with the visual expression of a prehistoric society – that is, one which existed before written records. The first flowering of the ancient Celtic civilisation occurred in the 5th century BC, and the Celts were described at this time only by contemporary historians who belonged to the very different cultural tradition of the Classical world. Celtic art itself diverges from the mainstream of art-history in that it was, above all, a portable art. We are not confronted by Celtic pictures in galleries or by statues in sculpture-parks, but rather by an art that was closely linked with function, relatively small-scale, and which either appeared as decoration on functional objects such as swords, vessels, torcs (neckrings), or mirrors, or art whose primary purpose was as a vehicle for religious expression (FIG. 2). Because of the antiquity of this art, it has generally only been preserved if made of durable materials, such as metal or stone. Wooden objects have only survived in waterlogged conditions.

A number of books on Celtic art have appeared over the past few years: the most important modern studies are listed at

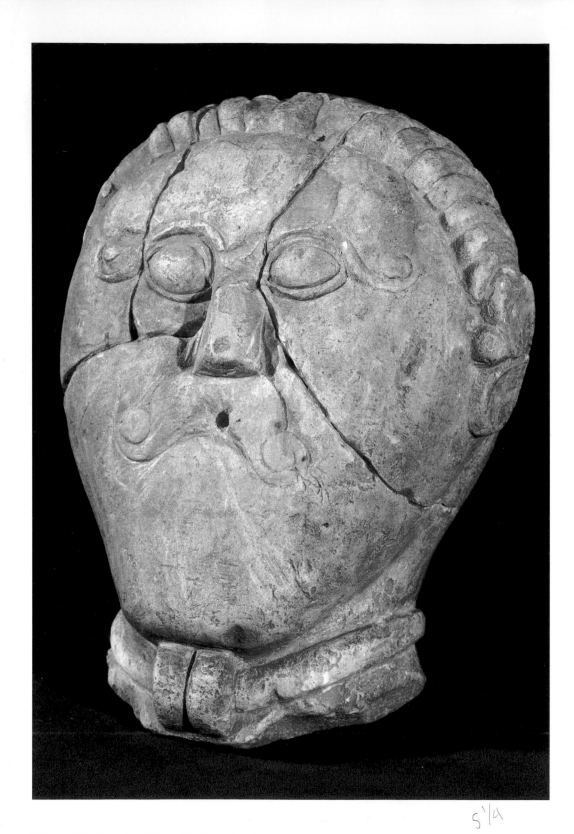

5'4

Finding the Celts, Finding the Art

the back of this volume. This book takes a rather different approach from most other works. Its primary concern is not chronological development, or categorisation of artistic designs in terms of varying styles or regions, but rather an exploration of Celtic art as a reflection of its society and an investigation of whether it is possible to decipher some of the coded messages that may well be present. Using the context of a society to build up a picture of the nature and function of its art is an approach that has still to be fully explored, but it is one which is particularly valid when dealing with prehistoric communities. This book presents Celtic art as it relates to a number of basic and important social and cultural issues: war, spirituality, gender, and status, as well as looking at specific themes, such as the use of zoomorphic (animal in form) and anthropomorphic (based on the human form) motifs, and the balance within it of naturalism, abstraction (art which is apparently non-representational), and minimalism (art reduced to essentials).

Since the ancient Celts did not write about themselves and because their culture flourished more than two thousand years ago, there is a remoteness about them which presents them as enigmatic and obscure. As a result many people have only the vaguest notion as to the Celts' identity or their geographical location. So this book must first establish the parameters of who, when, and where.

2. Head of a Celtic deity from Mšecké Žehrovice, Bohemia, 300-200 BC. Ragstone, height 9¹/₄″ (23.5 cm). Národní Muzeum, Prague.

The head was found in a sacred enclosure, and would once have been part of a statue. The face has typically Celtic flowing moustaches, and round the neck is a torc.

The Celtic Identity

From about 500 BC, first Greek and later Roman historians mention peoples living in a large area of non-Mediterranean Europe as Celts. The diversity between these groups of Celts is not closely defined, but Classical chroniclers seem to have recognised such communities as having sufficient shared cultural traditions to justify their being given a common name, *Keltoi* (by the Greeks) and *Celtae* or *Galli* (by the Romans).

In identifying and locating the ancient Celts, three factors need to be considered: one is the evidence of the Classical writers; the second is the presence of Celtic languages; and the third consists of the material culture of Celtic society – that is, archaeological evidence.

The earliest allusions to Celts by such Greek historians as Herodotus (c. 485-c. 425 BC) in the 5th century BC were followed by later authors, such as Polybius (c. 200-c. 118 BC) and Livy (59 BC-AD 17), who discuss the expansion of the Celts from their Central European homelands during the 4th and 3rd centuries BC.

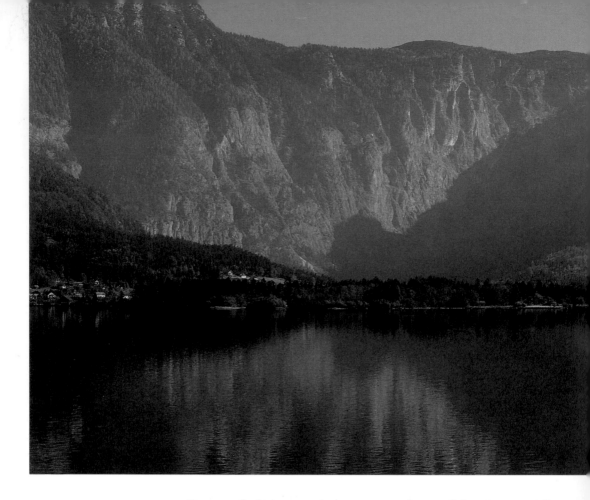

From such documentary sources, we learn of the presence of Celts in Spain, France, Italy, Greece, and Asia Minor, specifically central Turkey (see map of Celtic Europe). These writers testify to the successful Roman resistance to the Celts in Italy, after the ignominy of the sacking of Rome itself by the Celts in 387 BC, culminating in the huge defeat suffered by the Celts at the Battle of Telamon in northern Italy in 225 BC. The Celts in Greece, who sacked the sacred site of Delphi in 279 BC, were defeated by King Antigonos Gonatas of Macedon in 278-277 BC, and in Turkey by Attalus of Pergamon in 240 BC. The Celts in Spain fell under the shadow of Rome from the 2nd century BC; and the Celtic heartland known by the Romans as "Gaul" (modern France, Switzerland, Belgium, and part of western Germany) was conquered and annexed by the Romans under Julius Caesar in the mid-1st century BC. Britain is not referred to as Celtic by ancient authors, but Caesar recognised the close similarities between Britain and Gaul in 55-54 BC, for instance in their political organisation. Tacitus (AD 55-120), Dio Cassius (AD 155-230), and

other historians chronicled the conquest of Britain, which took place between AD 43 and 84.

Linguistic evidence for the Celts in this early period is elusive because writing seems to have been rare in Europe north of the Alps until around the 1st century BC, although a few earlier inscriptions on stone or metal show that the practice of writing had been adopted in Gaul for very limited purposes by the 5th-4th century BC. This writing was, however, almost exclusively in Greek and Latin. Indications of the Celtic languages consist not of documents but of a relatively few inscriptions, legends on coins, and the Celtic names of people and places mentioned in Classical literature. These scattered fragments of evidence suggest that, by the 1st century BC, Britain, France, North Italy, parts of Spain, and Central and Eastern Europe were inhabited by speakers of Celtic languages.

The identification of Celts in the archaeological record is, by its very nature, problematical. How do we know that a particular material culture (monuments and artefacts) belonged to

3. Hallstatt, Austria; centre of the early Celtic salt-mining industry and site of a great cemetery during the earliest Iron Age (750-450 BC).

4. *Krater* (wine-mixing vessel) from Vix, Burgundy, 500 BC. Bronze, height 5'4½" (1.6 m). Musée Archéologique, Châtillon-sur-Seine.

The *krater* was an import from the Classical world (Corinth or Etruria) and was found in the tomb of a high-ranking woman known as the Vix princess, who may have been the ruler of the nearby stronghold of Mont Lassois. The vessel may have been a gift to the woman or her family. Round the top of the *krater* is an appliqué frieze of *hoplites* (Greek soldiers) and chariots. The two handles are decorated with gorgons, lions, and snakes.

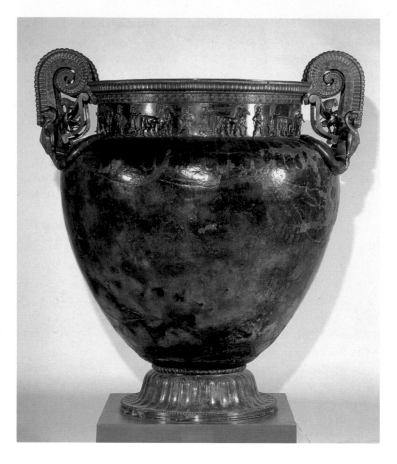

people who identified themselves as Celts? To an extent, the marriage of archaeological evidence with that of language on the one hand, and Classical testimony to Celtic ethnicity on the other, will involve speculation and supposition. Scholars generally distinguish early Celtic (that is, Iron Age) Europe from the preceding cultures of the Bronze Age by the introduction and increasing use of iron, although bronze continued to be used for many purposes. The terms Bronze Age (roughly 2000-700 BC) and Iron Age (700 BC to the Roman Conquest) have long been used by archaeologists to distinguish chronological phases in prehistory. We can assume with a degree of assurance that the origins of the historical Celts lay in the communities of the European Bronze Age. Celtic culture must have evolved gradually over many centuries, and some scholars believe that Celtic languages may already have been spoken as early as the second millennium BC.

The first "archaeological" Celts were people whose culture scholars have labelled "Hallstatt" after their great cemetery,

discovered at Hallstatt near Salzburg in Austria (FIG. 3). The Hall-statt culture is distinguished by the appearance of a new warrior-aristocracy who rode horses and whose trading networks commanded considerable wealth. The people interred at Hallstatt were members of local communities, who made their living by the mining and trading of salt and other commodities. The Hallstatt Iron Age tradition is characterised by its wealth and its links with the Classical world. The graves of these early Celtic peoples contained not only objects of great beauty, value, and artistic merit, but also imports from Greece and Etruria (modern Tuscany). These are clearly seen, for example, in the tomb of a so-called "princess" who died at the end of the 6th century BC at Vix in Burgundy. The Vix princess was about thirty-five years old when she died and was clearly of very high rank (FIG. 4). Another princely grave, belonging to a chieftain of about forty, who was buried in the 6th century BC at Eberdingen-Hochdorf near Stuttgart in Germany, contained the dead man's funeral-wagon and a great bronze couch on which his body was laid, accompanied by feasting equipment that included a massive bronze cauldron (FIG. 5).

This Hallstatt phase of the European Iron Age was succeeded in the 5th century BC by the so-called "La Tène" culture, named after the important Celtic site of La Tène on the shores of Lake Neuchâtel in Switzerland, where huge amounts of decorated and other Celtic metalwork were discovered (FIG. 6). This new

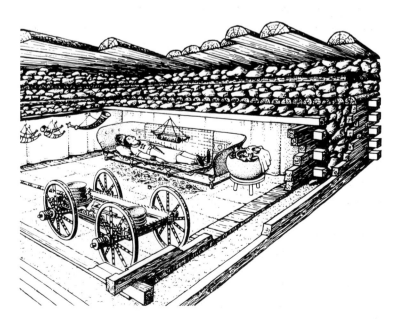

5. Reconstruction of the Hallstatt prince's tomb at Eberdingen-Hochdorf, 530 BC.

The prince was laid on a bronze couch and his person decorated with gold trappings. In addition to his personal effects, he was accompanied by his four-wheeled bier, feasting equipment, and a huge bronze cauldron that could have contained up to 88 gallons (400 litres) of mead (an alcoholic drink made from fermented honey), traces of which were found in the vessel.

6. The Celtic site of La Tène on the shores of Lake Neuchâtel, Switzerland, as it looks today. La Tène was discovered in 1857 when the level of the lake dropped, revealing the remains of wooden bridges and staging, and more than three thousand metal objects that had been thrown into the water as offerings to the gods. The distinctive form and decoration of the metalwork led to the adoption of the term "La Tène" to designate Celtic art dating from the 5th century BC to the Roman period throughout temperate Europe.

phase in Celtic culture coincided with a shift in the centre of power and wealth from Austria and southern Germany north and west to the Rhineland and the Marne region of eastern France. This occurred at the same time as Etruria and the Etruscan civilization in north-west Italy was rising as a major power, and trade routes may have been reorientated to facilitate contact between Tuscany and the Celtic world. The new material culture of La Tène was characterised by distinctive warrior-equipment, including fast, two-wheeled carts or chariots, and, above all, by fine decorative art. It spread both eastwards into Hungary and Romania and westwards into Britain and Ireland. (The new culture may have entered Britain through the activities of a small number of immigrant craftspeople or by means of trade or the exchange of gifts.) The La Tène culture represents the apogée of pre-Christian Celtic civilisation and, in a very real sense, the terms La Tène art and Celtic art are interchangeable.

By the early 1st century AD most of non-Classical Europe lay under Roman domination and Celtic culture was, to an extent, subsumed by the intrusive traditions of the Mediterranean world. But interaction between Roman and indigenous cultures produced a new, hybrid, Romano-Celtic tradition in which Roman influences were balanced by the retention of many pre-Roman elements. This conflation is expressed most eloquently by the religious iconography of Romano-Celtic Gaul, the Rhineland, and Britain, which represents a powerful and dynamic blend of Roman and Celtic art and belief.

Centralised power in Europe collapsed when the Roman

Empire in the west disintegrated during the 5th century AD, at the same time that the European Celts apparently all but disappeared. The areas of Continental Europe which had been under Roman rule were now subjected to a new Germanic tradition. But the regions on the western periphery of the Roman Empire, which had represented the western edge of Celtic civilisation, survived and became its new focus. Ireland, for example, was never ruled by Rome and retained its Celtic traditions unbroken. Nor, unlike Britain, did it ever experience large-scale invasions of Continental Celts; most of its population was descended from Bronze Age forebears. La Tène traditions had been introduced by various means into Ireland, such as trade or the presence of itinerant metalsmiths, as they had been in Britain, the difference between the two countries being that much of Britain was romanised by the early 2nd century AD.

By the early Christian period, following the fall of the Roman Empire, the centres of Celtic culture consisted of Ireland, Scotland, Wales, Brittany, Cornwall, and the Isle of Man. Only here did the Celtic languages survive, and it is these regions (particularly Ireland) that, during the period between the 6th and 13th centuries AD, produced a lively Celtic vernacular tradition of myths, and both archaeological and documentary evidence for early Celtic Christianity. Indeed, the early Christian art of Ireland represents a second flowering of Celtic artistic tradition which is comparable to that of La Tène.

The Nature and Function of Celtic Art

Celtic art belongs to an artistic tradition in the early history of Europe which is arguably no less important than that of the Classical world: it is distinctive in being closely integrated with its society. One of the focal arguments of this book is that art was central to Celtic identity and that its study may serve to illuminate Celtic culture as a whole. Strictly speaking, we are not dealing with art history as such. However, this very lack of written communication in Celtic society may have elevated Celtic art into a kind of visual language, containing messages (sometimes in an enigmatic code) that were meaningful to the artist, the customer, and – perhaps – to the gods. Celtic art was also intimately related to the objects which it decorated, so people were used to seeing art as part of their everyday lives. In fact it should be made clear, at this juncture, that in Celtic society it is virtually impossible to make a distinction between art and decoration. Each ornamented object was individually crafted, whether with a com-

plicated image or simple pattern. Moreover, decoration may have been closely associated with symbolic expression, and a major aim of this book is to come to some understanding of the links between Celtic society and an art which was active rather than passive and which may have played a major part in communication.

The context of Celtic art is a crucial factor in understanding its meaning. By this I mean not only the vehicle for the art – the neckring, shield, or tankard – but also the archaeological and social context. The findspot (place of discovery) of a decorated object in a tomb, a hoard, a bog, or a shrine may provide important clues as to the interpretation of its function and symbolism. For example, the deliberate depositing in water of ceremonial armour such as the Battersea Shield (see FIG. 1, page 9), which was found in the River Thames, has implications for its function as part of ritual activity. It is possible to recognise a recurrent practice of casting high-status military equipment into rivers, lakes and marshes, a practice which took place throughout Celtic (and indeed pre-Celtic) Europe and ranged widely over time. These finds were arguably placed in water as offerings to supernatural powers and may sometimes, indeed, have been made especially for such a purpose. If this is so, then the motifs and symbols with which they are decorated may have had a specific religious meaning. In addition, the high standard of craftsmanship, involving considerable periods of a smith's time, and the presence of exotic or precious embellishments such as coral, amber, enamel, ivory, or gold, may all have contributed to the value of the object as a sacrifice.

One of the challenges we face in attempting to understand Celtic art is how to get close to the society within which it was produced. We inevitably approach a two-thousand-year-old visual tradition with all the preconceptions of modern Western thought. So we tend to look at a human face depicted on a flagon-handle or sword-hilt and comment on its expression as frightening, fierce, sublime, or secretive, without having any genuine basis for such interpretative judgements. The mask may convey a message to us, but how can we judge whether it had the same meaning within the context of its own culture? The other, and related, feature of Celtic art which adds to its obscurity is its apparently non-representational nature. Human, animal, and vegetal (based on plants) motifs are present, but Celtic artists tended to veer away from realism, and naturalism was sacrificed to the love of pattern and form.

However, copying from life is only one aspect of realistic expression. In their apparently abstract motifs and designs, Celtic

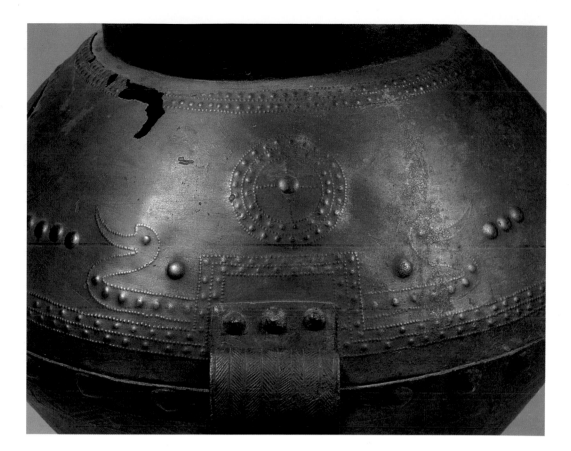

artists may have been representing other truths which were perceived to operate in the world of the mind and spirit, and which were real to them.

Finally, we should say something about the genesis and influences of Celtic art. Its beginnings are recognised as roughly coeval with the earliest, Hallstatt, Iron Age culture. But it must owe something to preceding Bronze Age traditions, and indeed it is possible to see some of these earlier influences recurring in the themes of Celtic Iron Age art: examples of such motifs include the water-bird (FIG. 7) and the solar wheel. External influences also played a large part in the development of Celtic art. Artists did not operate within a cultural vacuum but had access to a wide range of ideas belonging to other cultures, from which they borrowed freely. Traditions from Italy, Greece, and the Near East were all absorbed, adopted, and adapted into the repertoire of Celtic art, but in such a vigorous, dynamic manner that these foreign motifs were transformed into something new and entirely Celtic.

7. Sacred vessel from Mariesminde, Denmark, 1100-900 BC. Sheet-bronze, height 14¾" (37.5 cm). National Museum of Denmark, Copenhagen.

The vessel is decorated with an engraved motif of a sun carried in a ship, with water-birds at the prow and stern. It was probably used in solar rituals.

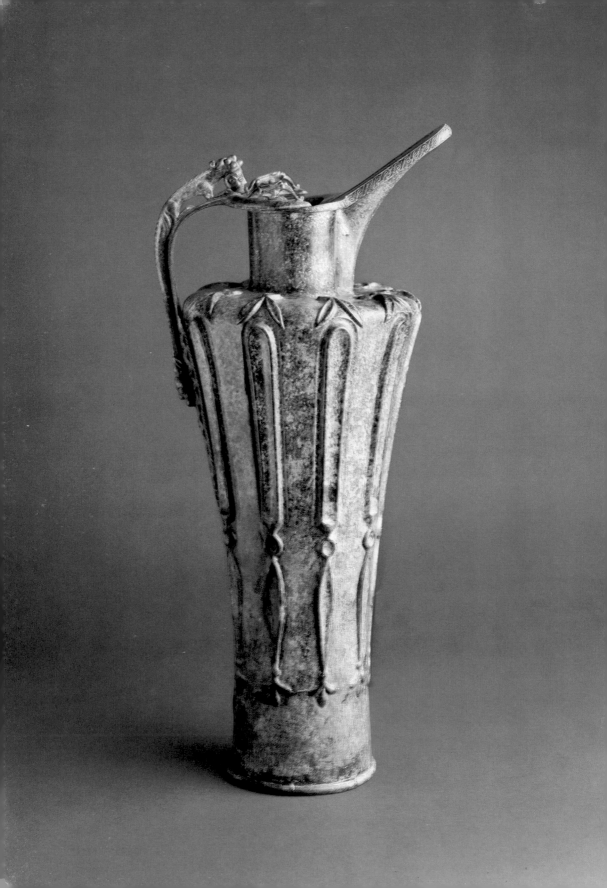

Art and the Artist in Celtic Society

They say that the barbarians who live in the ocean pour colours onto heated bronze and that they adhere and grow hard as stone, keeping the designs that are made in them.

Philostratus (c. AD 170–c. 245), *Lives of the Sophists*

A vital concern in any attempt at understanding Celtic art is the artists themselves: who they were; how they were organised; how they chose their designs; and their status within society as a whole. The first part of this chapter seeks to address these concerns.

Celtic Society, 700 BC–AD 600

8. Wine-flagon, late 5th century BC, from the hill-top stronghold of Dürrnberg bei Hallein, Austria. Bronze, height 18″ (45.8 cm). Museum Carolino-Diernberg-Augusteum, Salzburg.

The style betrays a merger of Celtic and Mediterranean elements. The fantastic beasts on the lid and handle are the product of a Celtic artist's imagination.

It is a commonplace that pagan Celtic society was a heroic society, essentially similar to that described in Homer's *Iliad*, in which a warrior-elite exercised power and in which complex patron-client relationships must be envisaged. In the earliest phases of Celtic life, as represented in the archaeological record by the Hallstatt (earliest Iron Age) tradition, we have a picture of a highly stratified society where the top level enjoyed spectacular wealth and prestige. The evidence, particularly of grave-furnishings, conveys an image of Hallstatt knights as warriors and traders who had control over resources, including metal ores, and who enjoyed close contacts with the Mediterranean world. The community of Hallstatt itself mined and traded salt, but where salt was not available these early European chiefs received Attic pottery and

Italian bronze vessels in exchange, perhaps, for copper, gold, art objects, hides, and even slaves. Some centralisation of power is implied, and there must have been a number of important families who were able to impose their authority upon quite large groups of people. The ancient sites of the Heuneberg in Baden-Württemberg in western Germany and Mont Lassois in Burgundy (eastern France) are examples of Hallstatt strongholds belonging to the top echelons of society: the chiefs who ruled their territory from these sites may have been buried in the sumptuous tombs of Hohmichele and Vix nearby (FIG. 9).

Some chieftains' residences have been identified: the Goldberg, near Aalen in south-west Germany, may be one, where in the 6th century BC an enclosure surrounded by a palisade, or fence of wooden stakes, was built around a series of rectangular houses. More modest buildings of this period are exemplified by the round houses at Staple Howe in North Yorkshire, England, which were situated on a hill top in an oval enclosure. In one of the houses someone had left behind two razors, one of iron and one of bronze.

The former would have been an exotic import from across the North Sea, and might perhaps have been a reciprocal gift from a foreign nobleman.

The 6th century BC centralisation of Celtic Europe, illustrated by the apparent manipulation of resources, rich graves, and large strongholds, began to break down at the time of Celtic expansion east and west. This expansion was at its most developed during the 4th and 3rd centuries BC. The movement of people and ideas, chronicled by Classical historians, led to the development of more local centres which were established from Britain to Romania. The power of the Rhineland chiefs declined, and regions such as the Marne in eastern France and areas of Hungary became great centres of artistic influence. A heroic ideal still dominated Celtic society, however, and symbols of honour and authority were still eloquently displayed by high-status metalwork. The restlessness of the Celts during this period of expansion is reflected in the energy and tension of their art, and the volatility of their society is sometimes also mirrored: the tomb of another so-called

9. Hallstatt chieftain's funerary mound at Tübingen-Kilchberg, Baden-Württemberg, c. 500 BC.

The diameter of the mound measures some 200' (60 m), and on the summit is a two-faced statue.

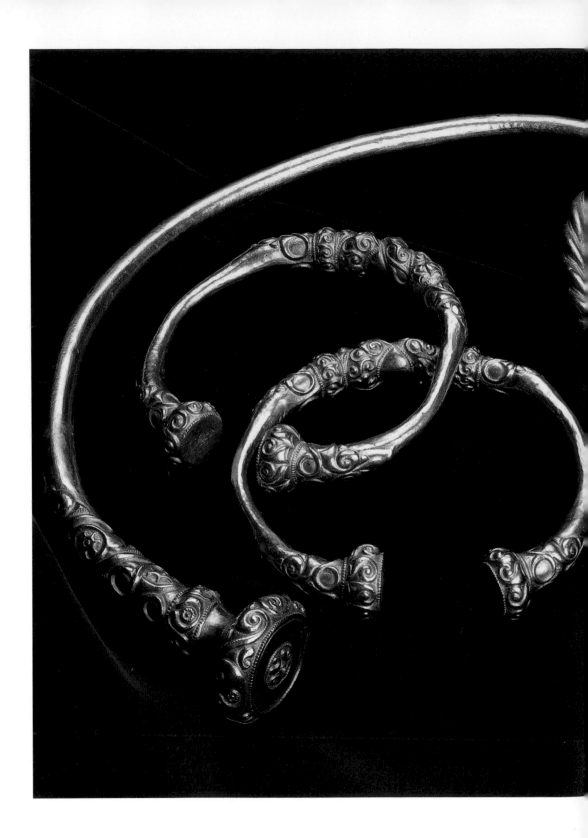

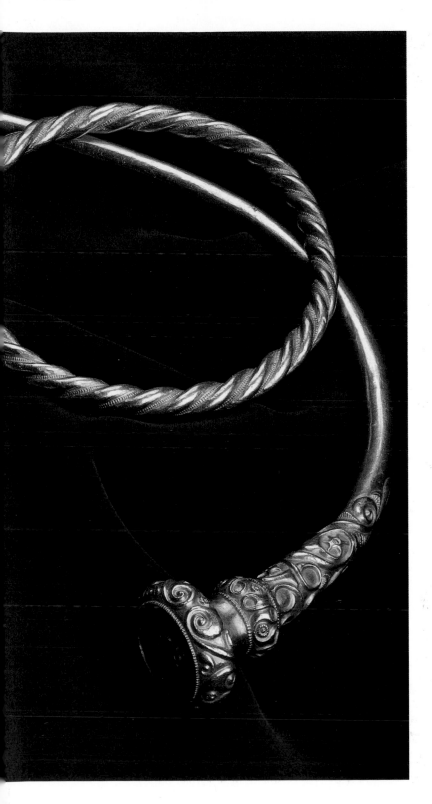

10. Decorated ring jewellery from the grave of a high-ranking woman at Waldalgesheim, near Bonn, Germany, 4th century BC. Gold, diameter of torc 7¹/₃″ (18.7 cm). Rheinisches Landesmuseum, Bonn.

"princess," buried at Waldalgesheim near Bonn in Germany in the 4th century BC, contained jewellery which bears little resemblance to the products of Rhenish craftspeople (FIG. 10). The gold necklace and armlets with which she was interred may have been made in France, Italy, or even Hungary. She may herself have been a foreigner, perhaps travelling with her jewels or her personal craftworker to marry a Rhenish husband. Indeed, Caesar specifically records the custom of aristocratic Gauls choosing wives from outside their territory (exogamy). In addition, the practices of gift-exchange between noble families, fosterage (the rearing of children from one noble family by the members of another) and hostage-taking, which are all mentioned in Classical sources, would all have contributed to the mixing and hybridisation of ideas which are so clearly illustrated in Celtic art.

11. Coin from Brittany with an image of a horse and bird, 2nd-1st century BC. Gold, diameter 3/4" (1.9 cm). Cabinet des Médailles, Bibliothéque Nationale, Paris.

During the 3rd and 2nd centuries BC, Celtic expansion in Europe began to contract, under pressure from the Dacian and German peoples to the east and – above all – from the Romans in the south. Rich graves were by now far less common, partly because of a change in burial practices from inhumation (where bodies were buried unburnt) to cremation. Swords predominate in the archaeological record, as does evidence for the riding of horses and chariots, reflecting the prominence of the warrior, who may not only have protected his own tribe or community but may also have sold his services as a mercenary. The instability and insecurity of this period is demonstrated by the presence of large fortified settlements. Such proto-towns also reflect a resurgence of trade with the Mediterranean world, harking back to the Hallstatt period and, in addition, the strong influence of urban civilisation which had long been enjoyed in Graeco-Roman Europe. This period also saw the adoption of coinage (though not necessarily a money economy), which had been introduced from the Classical world to Celtic lands at the end of the 4th century BC (FIG. 11).

Although Britain had been subjected to Continental influences from the earliest, Hallstatt, Iron Age, La Tène art traditions were not introduced there much before 300 BC. When they did arrive, they may have represented more than the presence of a new taste in art. If, as is argued in this book, Celtic

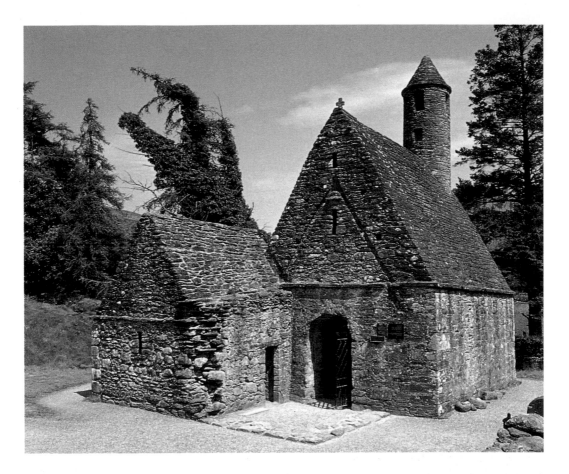

12. The Celtic Christian monastery of Glendalough, Co. Wicklow, Ireland, built c. AD 800.

art had a strong symbolic content, then the corollary is that its introduction to Britain reflected the presence of a new belief-system as well. Things were to change again in Britain (and in France) during the 1st century BC and 1st century AD. When the Romans conquered and then annexed these Celtic regions, the old stratified heroic societies largely disintegrated. Wealth, display, and authority now manifested themselves in being as romanised as possible. Only in areas of Britain that remained virtually outside the Roman province – much of Wales and Scotland – did the old ways continue; and in Ireland, which maintained its traditions unbroken by foreign intrusion. Here, as we shall see, Celtic aristocrats still required the traditional symbols of power provided for them by their metalsmiths.

After the Romans left Britain in the early 5th century AD, various native, Celtic-speaking kingdoms emerged from the vacuum left by their departure in Wales, Cornwall, and the North. In the Celtic West a new force, that of Christianity, began to affect society. There had been Christians in late Roman Britain, but their

13. Carved cross from Ahenny, Co. Tipperary, Ireland, late 8th century AD. Stone, height 12' (3.7 m).

The treatment of the stone indicates imitation of metalworking techniques, for instance in the bosses, which resemble rivets, and in the filigree-like ornament of the arms. Crosses were used to mark burials or land-boundaries, and could also act as places of worship.

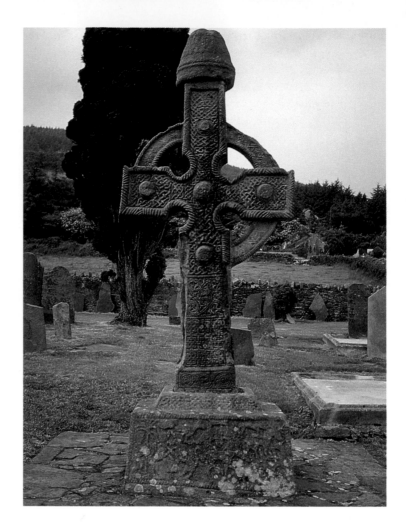

faith had been largely overwhelmed by Saxon paganism (only to be reintroduced by St. Augustine at the end of the 6th century AD). But Christianity flourished in the west of Britain, particularly in Ireland, and by AD 600, a number of important monasteries had been established (FIG. 12). Now the old symbols of power – wealth and display – were no longer relevant, and poverty was seen as a reflection of piety. Wealth began to accrue to the Church instead, and in particular, to the monasteries. The old grave-treasures disappeared, because the provision of tomb-furniture no longer fitted with the new religious system, although personal possessions such as brooches continued to be decorated. Monasticism promoted a new art, which manifested itself particularly in decorated stone crosses (FIG. 13) and illuminated manuscripts. The Irish Church, allegedly spearheaded by St. Patrick in the early 5th century AD, emerged from obscurity

during the 6th century. Irish monks did not simply reside in their local monasteries but travelled as missionaries to the rest of the Celtic West and even further afield, for example to Italy. St. Columba (d. AD 597), one of the great Celtic missionaries, established new centres such as the famous monastery on Iona, off the west coast of Scotland, in AD 562. Irish monks in England came into contact with Anglo-Saxon artistic traditions, and on the Continent with the material culture of the Franks and other peoples.

It is against this kaleidoscopic background of changing traditions, influences, and power-shifts in Celtic society that one can explore the role of Celtic art and that of the artists who produced it.

Celtic Art: Nature, Range, and Purpose

Celtic art involved decoration or elaboration beyond the practical functions of the artefacts themselves. It was inextricably linked with the social, economic, intellectual, and religious life of the Celts. With the exception of rock carvings and a relatively few large stone monuments, Celtic art as it has been preserved is essentially a "mobile" art: the vast majority of designs and motifs are found on portable, functional objects. The most substantial category of art that survives is ornamented metalwork. But pottery and bone objects were also decorated, and the rare survival of wooden objects, for example the vessels found at lake settlements such as that of Glastonbury in south-west England (FIG. 14), shows that more humble, day-to-day objects also claimed

14. Decorated tub or bucket and other utensils from Glastonbury Lake Village in Somerset, 2nd-1st-century BC. Wood, diameter 11¾" (30 cm). Somerset County Council Museums Service, Taunton.

The preservation of such objects at Glastonbury was due to the waterlogged nature of the site.

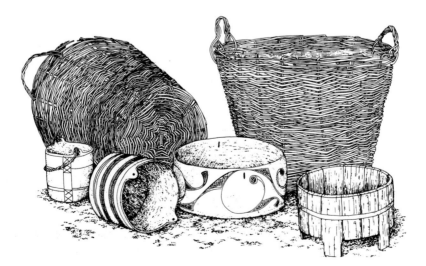

15. Decorated pillar at Turoe, Co. Galway, Ireland, 1st century BC-1st century AD. Granite, height 4' (1.2 m).

Some scholars see a link between Irish decorated pillar-stones and similar monuments in Brittany. This example is ornamented with curvilinear designs, including triskeles (three-armed whirligigs).

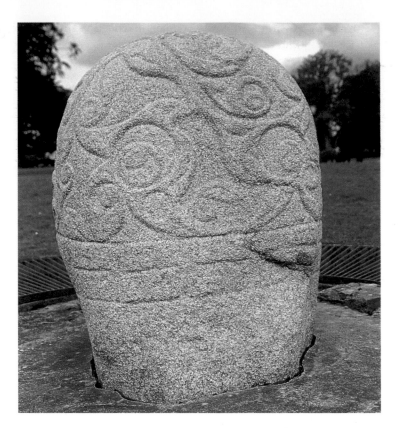

the attention of Celtic artists. Monumental art is rare: we may point to such sculptures as the 5th-4th-century BC Pfalzfeld pillar from St. Goar in western Germany; a group of 3rd-century BC carvings from the Lower Rhône Valley in France (all discussed in chapter four), and the Irish Turoe stone of the pagan Celtic period (FIG. 15). Early Christian monuments, such as Irish stone crosses, had introduced a new medium for artistic expression, but here it is possible to see the influence of the metalsmith: knobs and roundels on such crosses imitate the bosses and rivets on bronzes, while the chip-carving (a technique derived from wood-carving, in which V-shaped grooves are cut into the object) and representation of wire twists on stone mirror techniques more usually associated with jewellery. The early Christian period produced another innovation in art, arguably even more spectacular: illuminated manuscripts written in ink upon vellum and illustrated with intricate painted polychrome designs. These are discussed in chapter two.

Art was a great unifying element in the Celtic world; a set of techniques, patterns, and images that recurred right across non-Classical Europe. It acted as an immediate means of communi-

cation both between individuals and communities. In the pre-Christian period it was used to display rank and to reflect links and divisions between groups in society, but it also embraced religion. Indeed a complex, perhaps arcane, pagan belief-system may be concealed in the designs and motifs used by Celtic artists. It may even be that the avoidance of naturalistic imagery, narrative iconography and, above all, representation of the human form for much of the pagan Celtic period reflects a deliberate religious taboo, as is the case, for example, with large areas of the art of Judaism and Islam.

Much of Celtic art seems to have been aristocratic, used to embellish prestige objects such as war-gear and feasting equipment. But other art was humbler, and is found, for instance, on small brooches, where the miniaturist detail could display a message only to the wearer, or (as with the Glastonbury decorated tub) on everyday pots used in cooking and storing food. Art could represent control over raw materials, luxury goods, and, perhaps, over the artists themselves, who may have been bonded in servitude to their chieftains. Art can sometimes hold up a mirror to society: it can be no coincidence that the great Irish decorated bronze horns from the votive lake at Loughnashade, Co. Antrim (FIG. 16), were found near the remains of a great feasting hall that had been erected at Navan Fort (Co. Armagh) in the early 1st century BC. The highly decorated trumpets indicate the prestigious nature of the stronghold at Navan, and may well have been played there on ceremonial occasions. Early Celtic art reflects a confident, stratified society linked by conventions of the exchange of precious gifts between high-ranking nobles. But these aristocrats have left little clue as to their identity. They did not generally leave their names on their goods; nor did the artists who decorated them or the metalsmiths who made them.

The religious function of Celtic art, especially figurative art, continued in the early Christian period. Now all art was dedicated to the glory of God. The great carved crosses displayed the Christian message in public; the illuminated manuscripts provided a visual image of God which complemented their texts and, perhaps, acted in their stead for an illiterate audience. But it is possible to recognise considerable similarities between pagan and Christian art. Over and above any social or religious messages, the image conveyed both by the

16. Part of a ceremonial trumpet found in a lake at Loughnashade in Co. Antrim, Northern Ireland, near the Celtic stronghold of Navan Fort, 1st century BC. Bronze, diameter of mouth-mount 8″ (20.3 cm). Museum of Ireland, Dublin.

The superb workmanship represented by these instruments, whose manufacture called for highly sophisticated technical skill, points to their association with high-status activities: the maker of the finest surviving Celtic trumpet, recovered from a lake at Ardbrin in Co. Down, had used more than one thousand rivets in its construction.

pagan artists who decorated bronze sword-scabbards or gold torcs and the Christian monks who painted manuscripts is that of a simple love of beauty, form, design, texture, and colour. These elements did not alter with the changing ideologies of faith.

The Celtic Artist

In order to get close to the artists who produced Celtic art, we have to study their products with a view to answering such questions as how mobile or static Celtic artists and craftspeople were; whether they worked for themselves or for aristocratic patrons; what status such artists enjoyed within society; whether they worked as individuals or belonged to communal workshops, craft schools, or guilds; and whence came the inspiration for their motifs and designs.

There is some indirect evidence for aristocratic patronage, for the commissioning of pieces specifically for a prince or chieftain, for display, or as ceremonial regalia. Some very high-quality decorated metalwork, such as the Irish so-called Petrie Crown, and a pair of superb flagons from Basse-Yutz in the Moselle region of north-eastern France (all discussed in chapter two), and the Battersea Shield from the River Thames were in all probability commissioned by powerful patrons. In cases like these, we have to imagine a situation where chiefs controlled sources of metal ore, the artists, and their products, all of which contributed to their own status.

Some metalworkers, particularly the armourers, were professionals who served a warrior-class and, perhaps, followed volunteer or mercenary troops from battle to battle: the wide dissemination of scabbard-motifs in Europe fits well with such an idea. Items such as sheet-bronze belt plaques with repoussé decoration (where the motifs were hammered up from the underside of the metal; FIG. 17) were probably specially commissioned "badges of rank": no two of them are exactly alike, which argues for their manufacture by one individual working for another. The high quality of carved stonework in early Celtic Ireland, as evinced by the Turoe stone for example, argues for the existence of a professional class of stonemasons.

If princely patronage was a factor in the production of high-quality art, how deeply did the skill and taste apparent in such art reflect the sophistication of Celtic communities in general? How closely was the aristocratic layer of society meshed with the rest? Even today much art is associated with privilege. But as we have seen, there is evidence from simple brooches and ves-

sels that art did percolate downwards in Celtic society and cannot always have been the result of high-ranking patronage.

A related question concerns the status of the artists themselves. Some may very well have enjoyed a rank equivalent to that of the warrior-class: in early medieval Ireland we know from literary sources that craftspeople enjoyed high status. Some were specialists, who perhaps concentrated on repoussé, freehand engraving or compass-drawn designs. Others were artisans who produced simpler objects, and perhaps enjoyed a more modest rank. But we cannot necessarily gauge status from products: judging from the remains of their settlement, the bronzesmiths working at Gussage All Saints in Dorset, England, in the 2nd and 1st centuries BC had a simple lifestyle but produced specialist, high-quality horse-gear, in large quantities. Very occasionally, artists or metalsmiths named themselves on their works: a Swiss armourer stamped his name, *KORISIOS*, in Greek on a sword found at Port in Switzerland (FIG. 18); moneyers sometimes inscribed their mark on coins; and a British skillet-maker (a skillet is a small, shallow saucepan) in the early 1st century AD put his Celtic name, *BOD-VOGENUS*, on an example of his wares which was found on the Isle of Ely in East Anglia.

In the Roman period, when Celtic society changed, artistic

17. Belt plaque from Weiskirchen, Merzi-Wadern, Germany, late 5th century BC. Bronze with coral inlay, width 3″ (7.5 cm). Rheinisches Landesmuseum, Trier.

The plaque is decorated with a central human face flanked by back-to-back sphinxes.

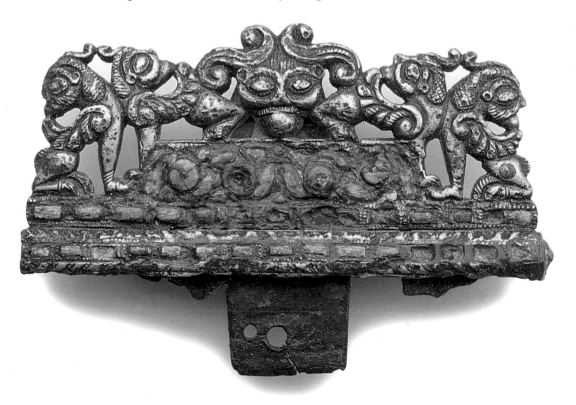

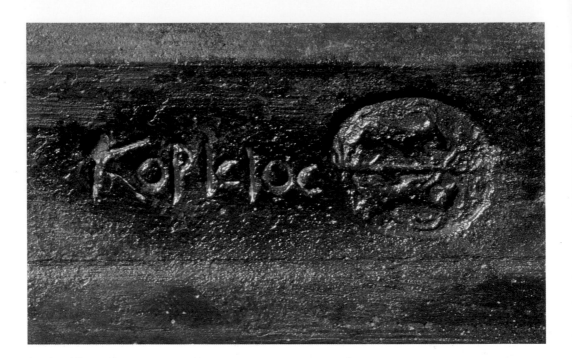

18. Sword bearing the Celtic name *KORISIOS* in Greek characters, 1st century BC. Iron, length (of inscription) 1" (2.7 cm). Bernisches Historisches Museum.

The sword, which shows ritual damage, is decorated with a "Tree of Life" motif, flanked by ibexes (wild goats).

patronage also changed. Outside the western Celtic periphery of Wales and Ireland, artists now worked for a Roman or romanised clientele who required different kinds of art. For example, there is evidence that in Britain, Celtic metalworkers provided horse-trappings in native art styles for the Roman army. Artists had to come to terms with some relatively new forms of art, such as representations of the gods in bronze, clay, and stone (FIG. 19), and some completely new media such as wall-paintings and mosaics, and the introduction of new materials such as zinc and lead. Some of these craftspeople may have been of Roman origin but the vast majority of those living in Gaul and Britain during the Roman occupation were still Celts.

Travelling Artists or Travelling Ideas?

The probable mobility of these artists is an interesting question. Chieftain-patrons ruling from Celtic strongholds presumably had resident craftspeople, called upon at need. But some artists may, like medieval storytellers, have travelled from court to court with their wares, perhaps staying in one place for a few weeks to make a specially commissioned object. By the 4th-3rd centuries bc the wide distribution of styles and motifs argues either for an itinerant class of artists or the mobility of their products over huge tracts of Europe. The Gussage smiths may themselves

19. Figurine of a Romano-Celtic goddess, 1st-2nd century AD. Pipe-clay, height c. 4¾" (12 cm). Museum of London.

Statuettes like this were mass-produced in two-piece moulds in central France and the Rhineland and exported all over Western Europe; some were stamped with the maker's name. The deity represented here is thought to be a mother-goddess.

have travelled: horse-harness of their manufacture (bits, for example) has been found far north of Dorset, in Yorkshire.

Celtic Britain and Europe were probably served by a mixture of craftspeople, some settled, some itinerant. But the dissemination of ideas, motifs, and actual products may have come about in other ways than by the actions of "tinkers" (itinerant metalsmiths). The mechanisms for such sharing could have included complex trading networks; gift-exchange between noble courts; foreign marriages; pilgrims leaving items as votive offerings in holy places far from where they had been bought; tourists with souvenirs; local smiths who had been trained elsewhere; the circulation of "pattern-books"; or of ideas travelling by word of mouth. The treasuries of Celtic chiefs may well have supplied artists with ideas for foreign styles and motifs. This dissemination could be very wide-ranging: a grave near Mantua in northern Italy contained a war-trumpet or carnyx decorated with repoussé birds' heads which are very similar to those on a shield-boss found in the River Thames near Wandsworth in London (FIG. 20); the carnyx itself could well have been made in Britain. There is also evidence, for example, that gold travelled from Hungary to Bulgaria, which lay outside the Celtic world.

In considering how artistic ideas penetrated different regions of Celtic Europe, it is worth looking at the adoption of continental La Tène traditions by Britain and Ireland after about 300 BC. Trade contacts, imports, and limited movements of people must have caused their gradual introduction and within a few years, local artists were using Continental styles as inspiration for their own highly individualistic tradition.

This leads directly to the question of the borrowing and adaptation of motifs and ideas from beyond Celtic Europe, notably from the Classical world. Celtic artists had considerable access to foreign influences from Italy (particularly Etruria) and Greece; and Celtic designers also utilised oriental images, borrowing them through their appearance in Etruscan art and from the products of Greek centres in the Black Sea area, which had also adopted eastern motifs. The mechanisms for borrowing, adaptation, and Celticisation can be very clearly demonstrated by a few examples. The tomb of a Celtic aristocrat of the 5th or 4th century BC at the Dürrnberg near Salzburg in Austria contained a bronze spouted flagon (see FIG. 8, page 21), the prototype for which was Etruscan, but which had been modified for Celtic taste. The bronze belt plaque from Weiskirchen in western Germany (see FIG. 17) displays an eclectic set of influences: "Siamese twin" sphinxes, more at home in Greece or Italy but

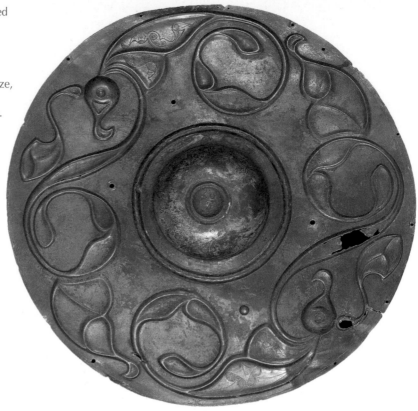

20. Shield-boss decorated with plant designs and birds' heads, found in the River Thames at Wandsworth, London, 2nd-1st century BC. Bronze, diameter 13″ (33 cm). British Museum, London.

Opposite

21. Animal-hooved and torc-wearing god from Bouray, in the Essonne, northern France, 1st century BC. Bronze, with one remaining glass eye, 15¾″ (40 cm). Musée des Antiquités Nationales, Saint-Germain-en-Laye, Paris.

derived ultimately from Near Eastern motifs, flank a human face that is wholly Celtic. Southern Gaulish sculptures from religious sanctuaries around the mouth of the Rhône owe the impetus for their creation to the presence of the Greek colony of Massalia (Marseille), but the recurrent local motif of the severed human head is entirely native. Even in the Roman period, when naturalistic representation was widely introduced, the Celtic imagination continued to break through: the bronze statuette found at Bouray in the Essonne, northern France (FIG. 21), has an exaggerated head, a torc and hooves: all belong to the repertoire of Celtic religious expression. In the early Christian period, Irish missionaries in Britain and Europe adopted for their crosses and manuscripts the vigorous animal imagery of the Anglo-Saxons, and some of the techniques of Franko-Germanic traditions (of which chip-carving, for instance, had originally been one). But, as in the pre-Christian Celtic world, artists asserted their independence; foreign ideas were by no means slavishly copied but were used to inspire, and were so modified as to become peculiarly Celtic.

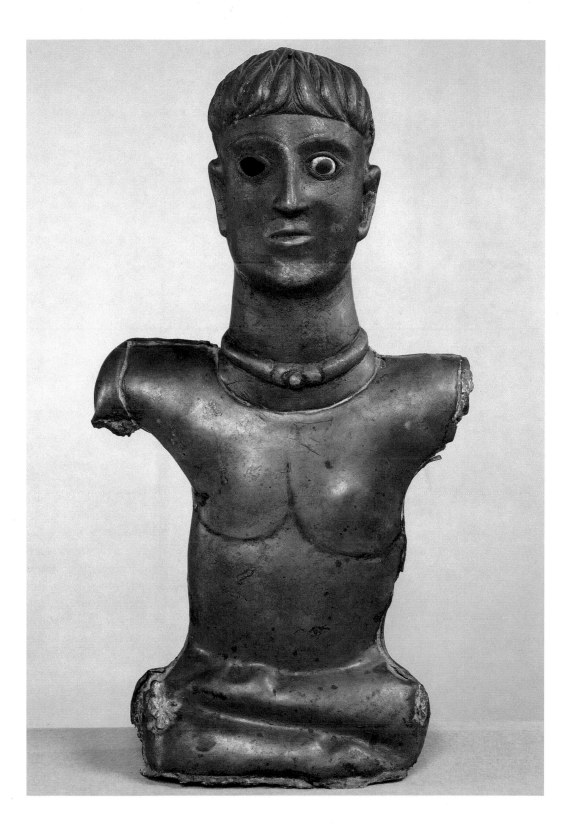

Artistic Organisation

The relationship between the different people who may have been concerned in the manufacture of an art object invites speculation: how far, for example, was the patron involved in decision-making as to design, motif, or image? Was the person making a scabbard, flagon, or necklace always the person who decorated it? Did different smiths specialise in casting bronze, in chasing, and in enamelling it?

The recognition of both variability and homogeneity in Celtic art has led to the supposition that artists organised themselves into regional craft schools, groups of workshops, and perhaps even guilds. This has been expressed as a "kinship linking closely local schools from north of the Alps to Britain." It is difficult to envisage how tight such a network may have been, if it existed at all. Did these artists belong to special social groups, perhaps exclusive and segregational, as well as craft groups? Metalworking has often been regarded with awe, as though there was magic involved, and Celtic artists may well have had a mystique about them which separated them from the rest of society. Whether or not every artist belonged to a workshop or school, his or her individualism shines through. Each object was cast, forged, or drawn as a "one-off"; there were no factories, no mass-production.

Variations between regions of Europe are particularly recognisable in the earlier phases of Celtic art. The flamboyant display of Celtic metalwork seen in the 6th and 5th centuries BC must have had the support of organised communities of producers, specialists whose sole responsibility was to win metal from its ores and make it into fine objects, and who neither had to fight nor to provide their own food. This professional caste continued to operate in later periods. Specialist armourers made swords with decorative hilts, scabbards, and chapes (scabbard terminals), and stamped their mark on their iron blades: examples of armourers' marks can be seen on finds from La Tène in Switzerland and Llyn Cerrig Bach on the island of Anglesey, Wales.

Regional schools of metalworking and other crafts have been recognised in locations from Ireland to eastern Europe. On the Continent, such schools operated in Switzerland, the Upper Rhine, the Marne, former Czechoslovakia, and Hungary. Swiss and Hungarian swordsmiths worked in major innovative centres; the Marne had a school of potters producing fine painted wares in the 4th century BC. Craft centres grew up in Britain and Ireland soon after the introduction of La Tène art traditions from the Continent: one of the earliest Irish schools, operating in the 3rd century BC,

22. Detail of the decoration on a sword scabbard from the River Bann, Co. Antrim, Northern Ireland, 3rd century BC. Engraved bronze, 7 x 1¹/₃″ (43 x 3.4 cm). British Museum, London.

Part of a group of eight swords recovered from the river at this point.

23. Escutcheon (mount) from a hanging bowl, part of the treasure found at Sutton Hoo, in eastern England, early 7th century AD. Enamelled bronze, with millefiori glass in the centre, diameter 2¹/₅" (5.5 cm). British Museum, London.

Hanging bowls are often, as here, found in rich Anglo-Saxon graves, but were clearly the work of Celtic artists (as indicated by the triskele motif). Sutton Hoo was a royal Anglo-Saxon ship-burial, dated by coins found at the site to just after AD 625. The burial was in a wooden ship 100' (30 m) long, and the hanging bowl is one of three found inside it. Other grave-goods from the site include treasures from all over the world, including Egypt and the Byzantine Empire. Although the burial is dated to the early Christian period, such abundant grave-goods were not usually part of Christian funerary practice at the time. In millefiori glass, bundles of glass rods of different colours were heated together and pulled to one thin rod. Multi-coloured sections were sliced off and used as inlays for items such as bronze bowls.

existed in the vicinity of Lisnacrogher (Co. Antrim), where quantities of decorated metalwork have been found, and almost certainly produced the group of eight scabbards found in or near the local River Bann (FIG. 22). From about the same time, distinctive styles of British ornament began to appear, notably high-relief repoussé work. Just before the Roman conquest in the mid-1st century AD, a number of regional British schools stand out, particularly in London, East Anglia, Wales, and Scotland, all of which exhibit considerable diversity from each other.

From the evidence of styles, motifs, techniques, and tools, it is sometimes possible to point to the existence of specialist workshops. In the 1st century BC London bronzesmiths were producing elaborately decorated shields and scabbards of sheet-metal; in the 1st century AD East Anglian craftworkers provided the market with red-enamelled horse-gear decorated with curvilinear designs. On the Continent and in Britain, craftspeople and work-

shops specialised in engraving flagons and mirrors, using compasses. Specialist British goldsmiths were working at or near Snettisham in Norfolk in the 1st century BC, where they cast elaborately decorated terminals onto sheet-gold torcs. The jewellery buried in graves at Rodenbach in the Rhineland, and at Besseringen and Reinheim in the Saarland in Germany, in the 5th-4th centuries BC, all have sufficient similarities to suggest that they came from the same workshop or craft school. Such schools still continued in the early Christian period of the 5th-6th centuries AD, where British and Irish workshops decorated metalwork with designs based upon late La Tène forms. British craftworkers also added to their repertoire at this date such innovations as tinning the surface of objects, niello (decoration with a black silver-sulphide paste), and the use of millefiori glass. It is possible that some British artists were working for pagan Saxon patrons: Celtic motifs ornament the "hanging-bowls" found in Anglo-Saxon cemetery sites. These vessels are hemispherical bronze bowls fitted with rings for their suspension from a tripod. The bowls themselves are plain, but the handle-mounts (escutcheons) are often highly decorated and enamelled. The example illustrated here shows the use of millefiori glass as well (FIG. 23).

Celtic Metalwork

Given that the great majority of surviving pagan Celtic art occurs on metalwork, the materials and techniques used by Celtic metalworkers to attain the desired result are obviously important.

Bronze, for example, is an alloy of copper and tin, with other metals such as lead sometimes added. Tin in particular is quite rare, and the use of bronze in antiquity involved complex exchange networks between communities, to facilitate access to each of its constituent metals. Bronze can either be cast in moulds or hammered out from cast ingots into thin sheets; both methods were used by Celtic bronzesmiths and artists. Decoration on sheet-bronze included high-relief repoussé work, in which sheets of metal were rested on a resilient but giving surface, such as pitch or wet leather, and moulded into shape with blunted hammers. Sometimes a "former" was used: this was a piece of wood cut into a pattern and placed under a sheet of bronze, which was then hammered into the patterned surface beneath (FIG. 24). The obvious advantage of using a former was that it could produce repeated identical designs.

Apart from repoussé work, sheet-bronze could also be decorated by engraving a pattern with a pointed tool across its surface.

24. Bucket decorated with "pantomime-horses," from a cremation grave at Aylesford, Kent, in southern England, late 1st century BC. Wood, with sheet-bronze cover and cast-bronze handles, diameter 10½" (26.7 cm). British Museum, London.

The frieze on the top band clearly shows the vertical edges of a "former" or template, a device enabling the artist to produce a pattern of identical pairs of "horses." The handles are in the form of human heads with leaf-crowns. The bucket may be a Gaulish import.

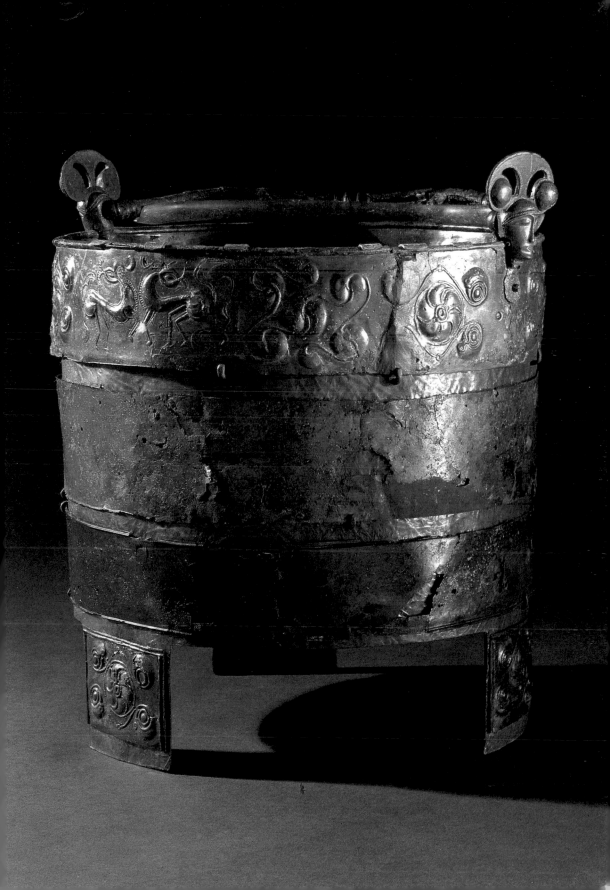

Engraving could be free-hand or compass-guided, and some engraving tools were chisel-ended and used in a rocking motion for a zigzag effect. Occasionally it is possible to make out preliminary sketching marks executed on the metal with a fine-pointed scribing tool (FIG. 25). Engraving involves making a groove and the removal of displaced metal; another technique, known as chasing, uses a tracer (an engraving tool) and hammer and leaves the bronze pushed up in ornamental ridges. Chip-carving was also used for decorating bronze.

Engraved ornament was employed to particular effect on the Continent, as can be seen in the superb foliate engraving of bronze flagons from such places as Waldalgesheim and Reinheim in Germany of the 5th and 4th centuries BC. In Britain there is a series of spectacularly ornamented mirrors, of 2nd–1st century BC date, whose backs are decorated with engraved designs; the spaces between them are filled with "basket"-hatched ornament, perhaps to introduce textural variation. The mirror from the grave of a lady who was buried in the 1st century BC at Birdlip in Gloucestershire is especially fine (FIG. 26): the flat engraved designs on the mirror-back are followed through to the cast handle, where identical patterns are transformed into a three-dimensional shape.

Sheet-bronze was used particularly for objects such as vessels: either the bowl or cauldron was constructed entirely in bronze sheet or the thin metal was used as a cladding for iron or wooden buckets, such as the Aylesford bucket, or drinking vessels such as tankards. Trumpets, horns, shield-covers, and scabbards were all constructed from sheet-bronze and decorated either in repoussé or with incised patterns.

Cast bronze is produced by pouring molten metal into moulds of the required shape. Complex artistic designs were created by the *cire perdue* method, in which an object was modelled in wax (sometimes elaborately decorated) and the wax shape was then covered with clay and heated, so that the liquid wax drained away and the clay was fired. Molten bronze (mixed with a small proportion of lead to increase fluidity) was then poured into the clay mould and allowed to solidify. The mould had to be broken open to release the bronze object, which was then filed and polished to its finished appearance. This has important implications because it means that moulds were only used once, and that each bronze was an individual piece of craftsmanship. In a pit at the Iron Age settlement of Gussage in Dorset more than seven thousand fragments of clay moulds used in the production of bronze horse-gear have been found. Fine bone tools

for wax-modelling were also present. Other tools sometimes survive, notably hammers and files.

Casting and sheet-bronze-working were not always separate activities: sometimes sheet-bronze scabbards such as those found in the River Bann had decorative bronze chapes cast on; in the same way, a sheet-bronze necklet or torc might have moulded cast-bronze terminals. Sometimes the debris from settlements is indicative of different types of bronze-working: cauldron-making was a speciality at Maiden Castle in Dorset, just as casting horse-gear was the trade at Gussage.

The intricate decoration of bronze could, on occasion, be enhanced by the inclusion of other materials. The 2nd-3rd cen-

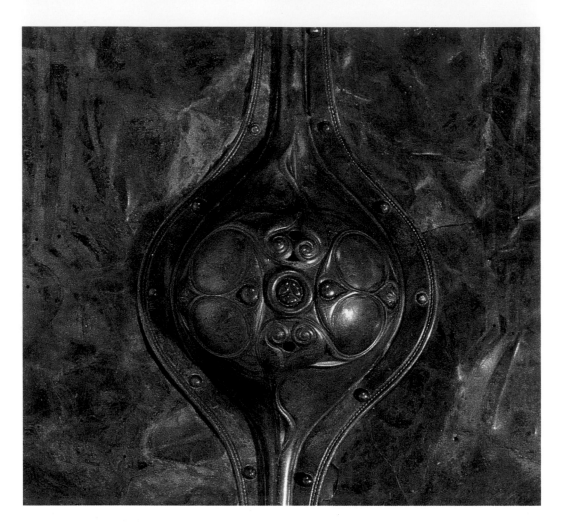

27. Detail of a shield-cover found in the River Witham, Lincolnshire, England, 2nd-1st century BC. Bronze with coral inlay, length 44″ (1.13 m). British Museum, London.

tury AD Classical author Philostratus commented upon British enamelling techniques (see page 21). Enamel was made of red glass, coloured by cuprous oxide crystals. Small lumps of glass were heated to soften them, shaped into pellets and either attached to the bronze matrix by small pins or sunk into a cut-out pattern (see FIG. 1). By the 1st century AD champlevé enamelling had been perfected: in this technique, a sunken decorative field was prepared on the metal object, the enamel was applied in a powdered form, and fused with the metal in a kiln, so that a flat area of enamel flush with the metal was produced. By early Christian times, colours other than red were being developed, and craftsworkers were also experimenting with millefiori glass (see FIG. 23).

Craftspeople worked with other inlays as well: red coral from the Mediterranean was highly prized and used to decorate bronzes,

such as the boss of the Witham shield cover (FIG. 27). Ivory and amber, other exotic imports to Celtic Europe, were also used to introduce different colours and textures.

A very specific type of art is coin imagery. Most Celtic coins were struck, although some late examples were cast in double moulds. In the striking process, metal strips or cast blanks (flans) were placed between two deeply incised bronze dies. When this "sandwich" was struck with a hammer, an imprint was left on each surface of the coin. Hundreds of coins could be struck before the dies wore out. The dies themselves were cut by craftsworkers who exercised incredible skill in miniaturist carving, with no visual aids to help in the execution of fine detail (see FIG. 11).

Although silver coins were in circulation in the Celtic world, silver was comparatively rare. The great silver cauldron from Gundestrup in Denmark was made in the 1st century BC of 96 per cent pure silver, but although its thirteen repoussé-decorated plates bear some imagery that is unequivocally Celtic, it was probably manufactured in neither Celtic Europe nor Scandinavia, but in south-east Europe, possibly Thrace, where there was a great silver-working tradition. The Gundestrup Cauldron (FIG. 28) has been the subject of recent scrutiny which has discerned the hands of at least five separate craftsworkers who used different sets of tools for the moulding, chasing, and engraving work. In Britain, silver jewellery was found buried alongside the gold, bronze and electrum (an alloy of gold and silver) treasure from Snettisham in Norfolk.

Gold- and silversmiths used most of the same techniques as workers in bronze. Indeed, the same craftspeople may have worked with all three metals. Gold was used extensively in the Iron Age to make fine, high-status, prestige objects, just as it had been in the Bronze Age, when the beauty and incorruptible properties of gold were first recognised. There were three methods of obtaining gold: mining, panning, and recycling, and the metal was so valuable that it must have been constantly re-used rather than discarded. Many items of Celtic gold were buried with the dead, or deliberately deposited either as gifts to the gods or in treasuries. The ancient Greek geographer Strabo refers to the accumulation of gold and silver offerings from a Gaulish tribe known as the Volcae Tectosages at a lake near Toulouse in the 1st century BC. That gold was an important symbol of power is suggested by the practice of using it to gild base metal, as if its appearance was more important than the real quantity of gold.

Gold torcs and bracelets form the most important category of Celtic gold. In the 5th-4th centuries BC, these were placed par-

Following pages

28. The Gundestrup Cauldron, 1st century BC. Silver (once gilded), diameter 27¼" (69 cm). National Museum of Denmark, Copenhagen.

The cauldron, consisting of seven outer and five inner plates plus a base plate, was dismantled before being deliberately placed on the dry surface of a peat bog at Gundestrup in Jutland, Denmark. It is decorated with raised repoussé and engraved motifs, both Celtic and exotic, with depictions of deities (many wearing torcs), animals, and mythical scenes. The cauldron was probably made in south-east Europe for a Celtic clientele, and it may have arrived in Denmark as the result of the looting activities of a locally based raiding-party (perhaps belonging to the nearby Cimbri people). The cauldron's original function may have been as a liturgical vessel, the property of temple priests, and it was perhaps used as a container for holy water, wine, or sacrificial blood.

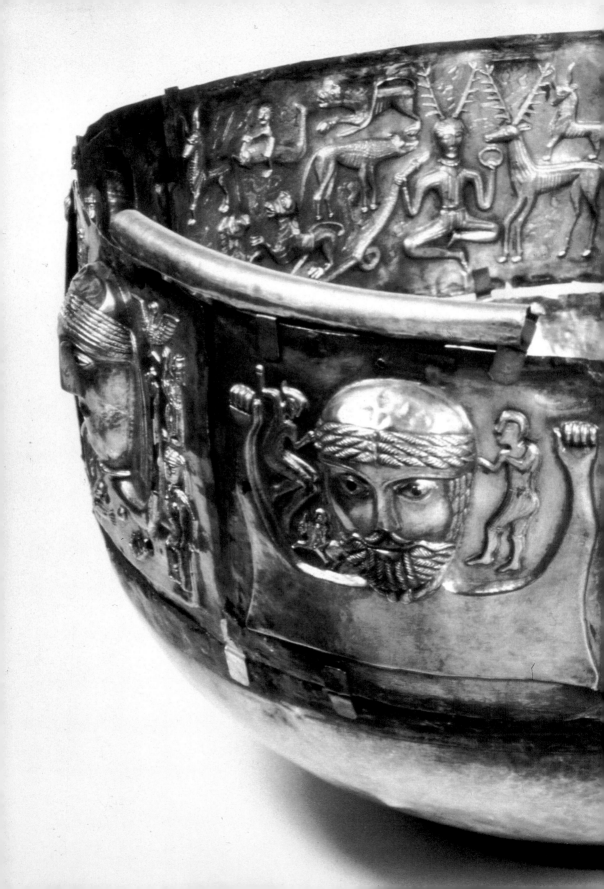

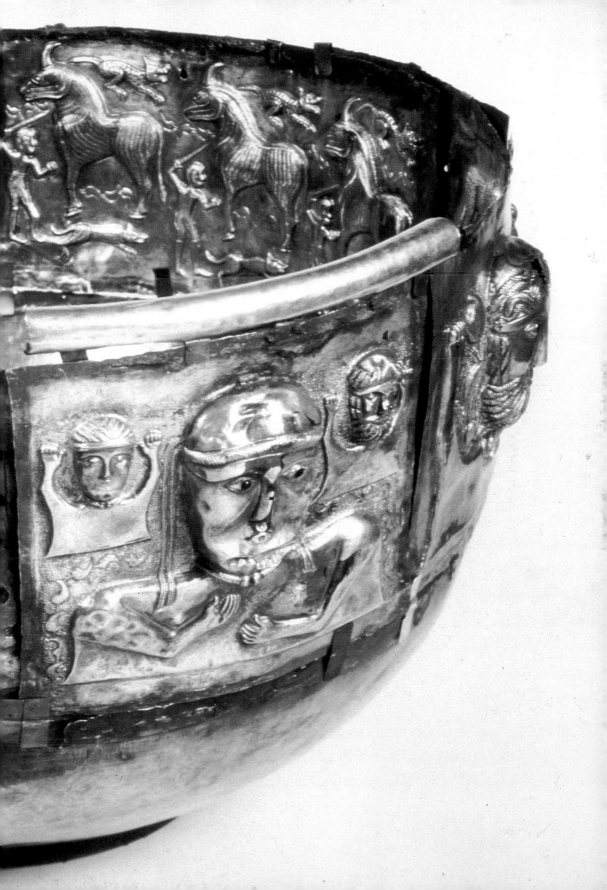

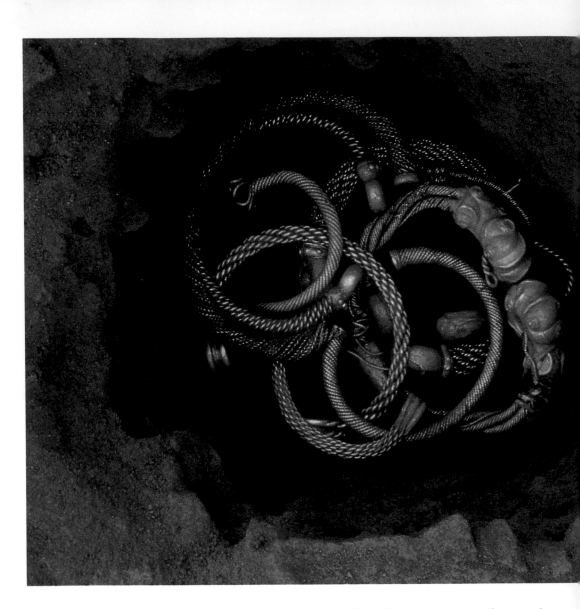

ticularly in women's graves. The Waldalgesheim set of torc and bracelets (see FIG. 10) has intricately cast decoration on the terminals, which were soldered on to the hoops. All the jewellery in this grave came from the same goldsmith's workshop.

The Snettisham hoards, discovered in the 1950s and in 1990, are perhaps the most spectacular find of Celtic gold ever made (FIGS 29 and 30). The sheer quantity (more than two hundred pieces) of material has made detailed study very productive. The gold (much of it is, in fact, electrum) is very similar to other finds from the same area, such as the hoard of six torcs from Ipswich, in the neighbouring county of Suffolk. It is clear that

East Anglia had an important school of goldsmithing which specialised in "plastic," or moulded designs in the 2nd and 1st centuries BC.

The techniques used to make gold torcs, exemplified at Snettisham, demonstrate the incredibly high level and variety of skills employed by the Celtic goldworkers. Some of the necklaces are hollow, and were made of sheets of gold formed on an iron core which had been coated in beeswax and resin. The great Snettisham Torc, 7³/₄ inches (20 cm) in diameter, consists of eight separate strands of metal, each composed of eight wires forged from sheet gold, twisted clockwise into cables and fitted into the *cire perdue* cast ring-terminals. These are decorated with relief ornament, chasing, and hatching, the last executed with a round-ended punch. This torc was also marked by its maker with tiny knobs, dimples, and basket-hatched triangles, decoration paralleled on one of the bracelets from the hoard. At least some of the gold used in the torcs was obtained from melting down gold coins.

The function of the Snettisham hoards is controversial. Some of them were carefully placed in the ground in a series of pits, in which the most precious items were often positioned beneath a false bottom with nests of lesser material on top, as if to fool looters. Thus they may have formed a ritual deposit or a tribal treasury. But while some of the torcs were unfinished or unworn, others were in fragments or had been repaired. In addition, the presence of ingots and metalworking debris is suggestive of a smith's stock-in-trade: the coins in the hoard may have been intended for recycling. The debate is still active and will probably continue.

The Celtic blacksmith and bronzesmith must sometimes have collaborated closely and maybe even shared workshops on occasion: at Gussage iron-forging and bronze-casting waste have been

29. Nest of torcs found at Snettisham in Norfolk, England, 1st century BC. Gold, silver, and electrum. British Museum, London.

This group is one of several hoards, comprising more than a hundred torcs, found at Snettisham in 1990. The whole find amounts to 44 pounds (20 kg) of silver and 33 pounds (15 kg) of gold, and is worth roughly £4 million ($6 million). It represents either an enormous offering to the gods or a tribal treasury.

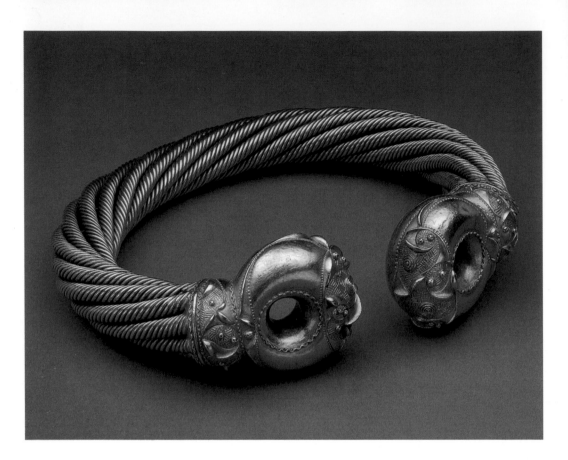

30. The great Snettisham Torc, from the hoard found in Norfolk, England, mid-1st century BC. Gold, diameter 7¾″ (20 cm). British Museum, London.

This magnificent necklet has been likened to the British Crown Jewels. Classical writers comment that Boudica, queen of the tribe of the Iceni, who ruled in this region in the mid-1st century AD, wore a great gold necklet.

found in the same pit. Bronze was sometimes used to clad iron objects, which again argues for close cooperation between the professions. But the processes of working with iron and bronze in Celtic antiquity were totally different. Iron was worked from at least the 8th century BC in temperate Europe, but it was forged or welded, rather than cast. This was not (as is frequently thought) because Celtic smiths could not heat their furnaces to a sufficiently high temperature to melt iron, although iron does have a higher melting-point than bronze. The reason for forging, as opposed to casting, lies in the brittleness of cast iron, which makes hot- or cold-working of it impossible. Forging, therefore, produced a better product.

The tools used by Celtic iron-workers were very similar to those used by blacksmiths in modern times, and included tongs, anvils, hammers, and chisels. Often tools were multi-functional, which would have helped itinerant smiths to limit the weight of their tool-bags. A set of blacksmith's tools of the 1st century BC or AD, found at Waltham Abbey in Essex, England, consisted of five pairs of long-handled tongs (to hold the red-hot metal),

three anvils, a sledgehammer, a poker, and a file. Many of the tools had been deliberately smashed before being placed in water as a ritual act.

Relatively few decorative objects were made of iron. The value of iron objects (and the probable reason why they were selected as votive offerings) lies not in their intrinsic preciousness – the ore was plentiful and is not as beautiful as gold – but rather in the time and effort expended in the smelting process.

Monks and Manuscripts

Celtic Christian artists excelled in the art of illuminating manuscripts. This, with Celtic metalwork, constitutes the peak of Celtic artistic achievement, and the two together reached a level of excellence equal to that of any art in the world, ancient or modern. The early Christian illuminators of manuscripts worked on a medium that was new to the Celtic world: vellum (finely treated sheep- or calfskins). Yet these artists used paint and ink to execute on vellum designs that shared many features with metal. Indeed the designs themselves glow, like enamelled bronze. The decoration used on such manuscripts exhibits a mingling of Celtic, Germanic, and Mediterranean traditions to produce a unique art-form in honour of God, but the La Tène affinities of the artists are clearly visible through this palimpsest of influences, as is discussed in chapter five.

The use of vellum to write on belongs to a Mediterranean tradition, where it was recognised as far more durable than the sheets of papyrus it replaced by the 5th century AD. However, because of the way skins were processed, Irish vellum is distinct from its Continental counterpart in having a suede finish which is particularly receptive to ink and paint. The labour required in the preparation of vellum for a manuscript was prodigious: at least fifty calfskins were used for a psalter known as the "Cathach of Saint Columba," for example, which was made in AD 600.

The illuminators used quill pens, usually from goose- or crow-feathers that were cut to a chisel-end in order to make a contrast between thick and thin lines, and brushes. They had access to a range of pigments taken from different minerals: lapis lazuli – a costly pigment from the Orient – for blue; lead for red and white; verdigris (oxidised copper) for green, and so on. Sometimes the colours were built up layer by layer to produce subtle variations in shade: the Lindisfarne Gospel artist was thus able to produce more than forty different pastel colours. Inks were made from carbon and oak-gall berries. Compasses, rulers, and

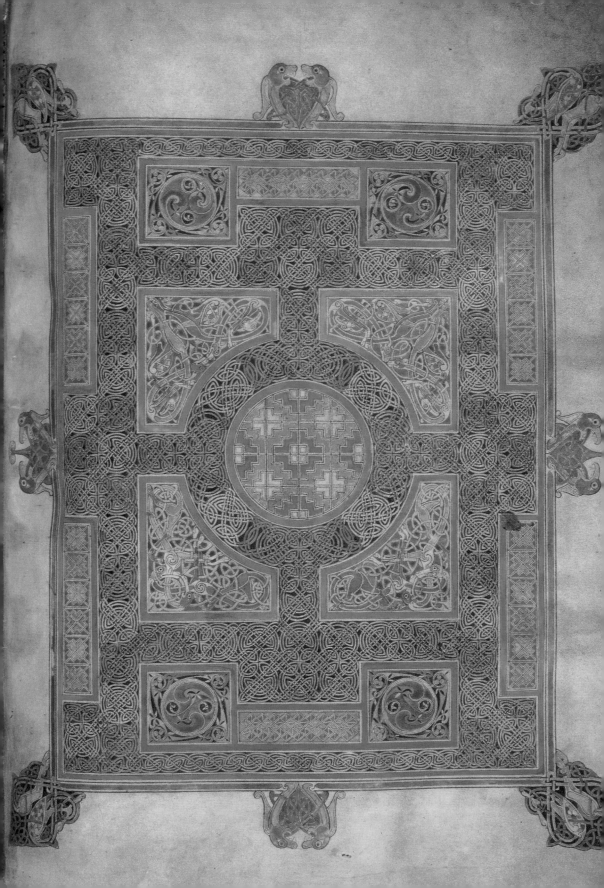

templates were used to lay out the designs; and the perforations from compass-points can sometimes still be seen on manuscript pages.

Manuscript illumination may have begun as early as the 5th century AD, when the first scholarly religious houses were established. The Book of Durrow, of the late 7th century AD, is one of the earliest decorated manuscripts to survive. The *scriptorium* at Lindisfarne in north-east England was both a scholastic establishment and a workshop (FIG. 31). The Christian artists were highly regarded: a life of Saint Columba (who died in AD 597) refers to the crafting of both Celtic stone crosses and manuscripts as the "work of saints," and many other contemporary statements endorse the high value placed on the manuscript illuminator's skill. Its apex can be seen in the superb Irish Book of Kells of the late 8th-early 9th century AD, which continued the pagan Celtic love of elaborate detail into a Christian context (see chapter five).

31. The Carpet page from the Lindisfarne Gospel, early 8th century AD. Painted vellum, 13$\frac{1}{2}$ x 9$\frac{3}{4}$" (34.3 x 24.8 cm). British Library, London.

TWO

Class and Gender: Function and Reason

To the frankness and high-spiritedness of their temperament must be added the traits of childish boastfulness and love of decoration. They wear ornaments of gold, torcs on their necks, and bracelets on their arms and wrists, while people of high rank wear dyed garments besprinkled with gold. It is this vanity which makes them unbearable in victory...

Strabo (64/63 BC-AD 21), *Geographia*

32. Four-sided pillar carved with human heads and foliage, from Pfalzfeld, St. Goar, Germany, 5th-4th century BC. Sandstone, height 4′10″ (1.48 m). Rheinisches Landesmuseum, Bonn.

The four heads each wear a mistletoe-leaf crown and on their foreheads is a lotus flower, symbol of eternity in the Classical world but which here (perhaps intentionally) gives the faces a frowning, forbidding expression.

The Classical geographer Strabo's comment on the Gaulish Celts of the 1st century BC is well supported by material evidence: the European Celts clearly loved finery, a love manifested in jewelled weapons and personal ornaments, such as torcs, armlets, anklets, decorated belts, brooches, and finger-rings. Some of the most elaborate jewellery comes from the tombs of the Hallstatt aristocrats of the 6th century BC. Flamboyant gold and silver was still being worn by high-ranking Celts in the 1st century BC. The form and amount of precious metal jewellery in circulation in Celtic Europe varied according to region and period.

The function of visual art as an expression and communication of status and wealth was important in many ancient cultures, and is still prominent today. In this context, Celtic art has to be evaluated in two ways: firstly in terms of its form – for example, a gold torc or bracelet – and secondly in terms of its intrinsic decoration. The wearing of a torc may itself have conveyed

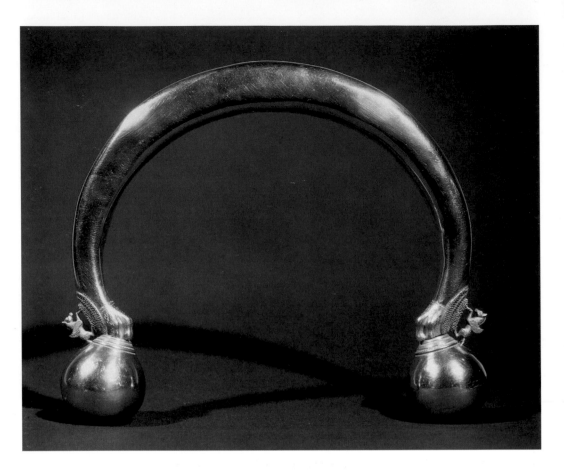

33. Torc worn by the Vix princess, c. 500 BC. Gold, height of terminals 1″ (2.5 cm). Musée Archéologique, Châtillon-sur-Seine.

The torc-terminals are decorated with winged horses, a motif that betrays Mediterranean influence.

messages about rank, gender, and wealth. The great torc (FIG. 33) from the tomb of the Vix princess dates to the end of the 6th century BC, and consists of a massive gold collar, the body made of sheet-gold, with elaborate terminals incorporating cast, punched, chased, and filigree decoration. The designs and symbols on the torc may contain other visual language associated, perhaps, with place or membership of a special group, or a single family. In this respect they may have had what could be called a heraldic function too.

The use of art for displaying status, prestige, power, or authority is complex and is concerned with conceptions of value. It is difficult for us to be accurate in assessing value-factors in past societies, but some general suggestions can be made which fit the surviving evidence. The rating of an object in terms of its value was probably dependent upon many factors, including the rarity of the material from which it was made, access to this raw material, and the skill and time taken to make and decorate it. Gold is comparatively rare; it is virtually incorruptible; it is easy

to work and it has a beautiful appearance. Iron ore occurs widely, but it was difficult and time-consuming to smelt, and in the early Celtic period at least it was an exotic novelty. Bronze requires copper and tin, the latter of which is rare. Added to these considerations is the possibility that access to raw materials, hence mineral wealth, lay in the gift of a small privileged class. The inclusion of exotic imports such as coral, ivory, and amber must also have enhanced the value of pieces upon which they were used.

Stone sculpture dated to the pre-Roman Celtic period is rare. This may, in part, reflect the preferences of the artisan but also the re-use of carved stone in subsequent periods. When stone was used, it may have had a value based partly upon its apparent rarity as an artistic medium and partly upon its monumental nature: statues such as that at Hirschlanden in Germany, discussed in this chapter, are large and highly visible. Such large-scale art was meant to be permanent and differed from that occurring on metalwork inasmuch as it was not part of the exchange economy. The other value-indicator is the skill of the mason: Ireland's Turoe stone, for example, is a superb piece of control over an intractable medium. But lower down the prestige scale, we have decorated Irish stone beehive querns (corn-grinding stones) whose curvilinear designs raise them above the level of mere practical utensils. Indeed the status of such items may have been quite high; most of them have been found buried deliberately in bogs, probably as votive offerings (perhaps to do with harvest thanksgiving ceremonies), and many of these appear to be virtually unused.

In evaluating the function of Celtic art objects as status-markers, their context has to be taken into account. It will be clear from this chapter and, indeed, from the book as a whole that while a substantial number of pieces come from hoards, settlement sites or chance finds, a great deal of Celtic art, particularly of the earlier periods, comes from graves. The provision of grave-furniture in the form of personal possessions – jewellery, weapons, or feasting equipment – is assumed to have something to do with conspicuous consumption. This concept involves the display of wealth and power through the public demonstration both of ownership and the voluntary relinquishing of precious possessions. An example of this is the presence of sepulchral goods at funeral ceremonies and hence their deliberate removal from circulation. In addition, the interment of funerary goods is presumed to say something both about the status of the deceased and, perhaps, about perceptions of an afterlife in which such goods had a role to play. The concept of conspicuous consumption may

also be applied to the deliberate depositing of precious objects in water or underground.

An important question is whether valuable art objects were specially selected or made for depositing in graves or in hoards, many of which must have been dedicated to the supernatural powers. Unfortunately, the fact that so much of our surviving Celtic art comes from tombs or ritual deposits skews its interpretation. We have no commensurate body of lay art with which to compare the sepulchral or ritually deposited material, but it is generally accepted that the best pieces may well have been chosen to accompany the dead to the Otherworld and as propitiatory offerings to the gods.

It is also possible to see a clear relationship between art and class. If it is right to conceive of Celtic society as one in which such resources as metal and the craftspeople to work it were, to an extent, controlled by a small upper class, then the art must likewise have been so controlled. We may envisage the circulation and exchange of high-status art objects between relatively few aristocrats, who may have jealously guarded their right to own or commission such material. However, Celtic art was not confined to the accoutrements of the nobility: simple brooches and armlets, wooden tubs, pottery, and even quernstones were decorated, as we have seen.

Wine, Women, and Song

> They are exceedingly fond of wine and sate themselves...their desire makes them drink it greedily and when they become drunk they fall into a stupor or into a maniacal disposition.
>
> Diodorus Siculus, *Library of History*

Feasting (and in particular drinking) equipment occurs mainly in high-status graves, indicating a popular activity among the Celtic upper class. In view of the undoubted contacts between the Celtic and Classical worlds from as early as the 6th century BC, it seems likely that not only were wine and the vessels containing it imported from southern Europe but also the custom of the *symposion* or drinking party. The bronze wine-flagon (FIG. 34) and the Attic drinking cups, so lovingly repaired by Celtic goldsmiths before being placed in the princely tomb at Kleinaspergle, are indicative of this kind of Mediterranean-style banquet. Decorated cauldrons, flagons, buckets, cups, and drinking-horns of gold or bronze occur in many rich graves.

The Hallstatt Iron Age princes and princesses of central Europe

were the first to adopt this kind of feasting paraphernalia. The late 6th-century BC grave of the Hochdorf chieftain was well equipped for feasting. Having been carried to his grave on a bronze-covered wooden hearse, the dead man was laid on his couch (FIG. 35), on a bed of animal-skins. Flowers were placed with him. The chieftain was lavishly adorned with gold: gold-sheathed dagger, gold jewellery, and even gold shoes. But most striking of all was the provision of a full drinking and feasting service, including nine drinking-horns which hung on the tomb-wall, the huge Grecian cauldron which along with its gallons of mead also held a beaten sheet-gold bowl (perhaps used as a ladle), plus a set of nine bronze platters, and three large bronze bowls, which were stacked upon the wheeled bier (see FIG. 5).

The Classical *symposion* was an all-male affair, although women were sometimes present for entertainment. But in Celtic Europe,

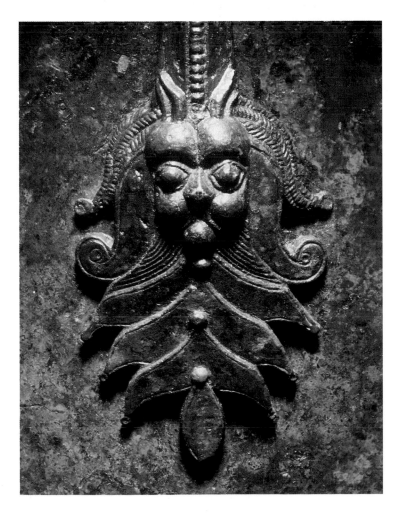

34. Detail of flagon-mount from Kleinaspergle, Germany, showing a bearded human face, late 5th century BC. Bronze, height of face 2³/₄″ (7 cm). Württembergisches Landesmuseum, Stuttgart.

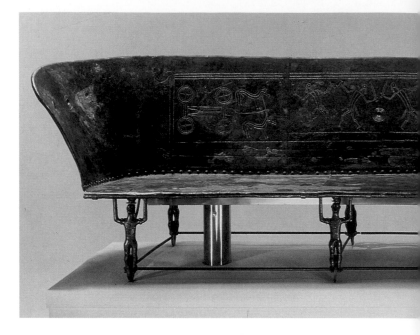

high-ranking women seem also to have enjoyed such banquets: several late Hallstatt and early La Tène women were interred with similar drinking equipment to that of Hochdorf. The Vix princess had her huge bronze *krater* or wine-mixing vessel, 64^1/$_2$ inches (1.6 m) high and weighing 460 pounds (209 kg), which had probably been made in Greece or Italy in separate pieces, transported over the Alps, and assembled in Burgundy (see FIG. 4). It is possible that this vessel was made especially for the princess by Graeco-Italian artisans, for her to enjoy in life or in death. In any case, it shouts to us of extremely high status, if not of slightly vulgar display.

Many 5th- and 4th-century BC noblemen and noblewomen were buried with beaten bronze beaked or spouted flagons, the basic form of which was copied from Etruscan prototypes. Celtic artists engraved intricate vegetal designs on these vessels, and cast fantastic zoomorphic or anthropomorphic images on the handles and lids. The 4th-century princesses buried in graves at Waldalgesheim and Reinheim possessed such flagons, as did the owner of the princely tomb at Kleinaspergle. The funeral chamber of the latter grave lay beneath an enormous mound 30 feet (9.1 m) high, the building of which was itself an act of display. The main tomb was robbed, but a side-chamber, with cremated remains, survived untouched. One wall of the intact tomb was lined with metal and pottery vessels, including a bronze cauldron, a ribbed Italian bronze bucket, an Etruscan bronze *stamnos* (a

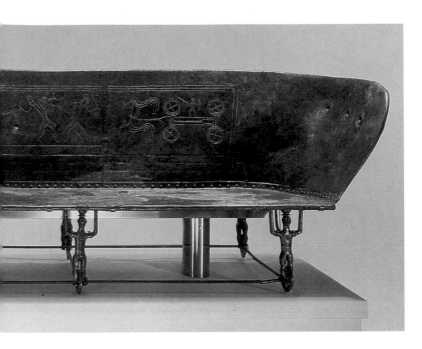

The body of the chieftain lay on this couch in his tomb (see FIG. 5). The back of the couch is decorated with images including pairs of men sparring or dancing, and four-wheeled chariots (similar to the bier in the tomb itself) drawn by two horses. These scenes have an air of ritual, and perhaps reflect activities that took place as part of the funeral ceremony. The couch is unique and bears witness, perhaps, to the dead man's pleasures in life: we may imagine him reclining at his ease to enjoy the convivial companionship of his friends while they ate and drank, very much in the manner of a classical *symposion*.

> And the banqueters in the halls are listening to the bard, sitting all in order, and at their sides the tables are full of bread and meats, and drawing the strong wine from the mixing-bowl, the wine-pourer carries it around and pours it in the cups.
>
> (Homer, *The Odyssey*, Book 9)

tall two-handled vessel), a locally made flagon, and a pair of drinking-horns decorated with sheet-gold and terminating (at the pointed end) with rams' heads, a fashion emanating, perhaps, from the region of the Black Sea. Two *kylixes* (two-handled cups) from Attica in Greece, repaired with Celtic-decorated gold strips, date the tomb to about 450 BC. The handle of the flagon betrays its Celtic maker: it is ornamented with a bearded, bulging-eyed face, with horns and a curling crown of leaves, the latter being a recurrent feature of Celtic imagery. But the undisputed apogée of the flagon-maker's craft is represented by the pair of not quite identical vessels made in the late 5th or early 4th century BC, and found at Basse-Yutz in Moselle in 1927 (FIG. 36). These vessels are decorated with coral and enamel inlays and are exquisitely worked, with elegant sheet-bronze bodies and zoomorphic cast ornament on handles and lids. The Basse-Yutz flagons were locally made, as was that belonging to the Waldalgesheim princess: it is interesting that her flagon was an heirloom, already old when it was put into the tomb. The Dürrnberg flagon (see FIG. 8), made in the late 5th or early 4th century BC, is a blend of Mediterranean and Celtic elements. The mechanisms of the relationship between the two worlds must have been complex: the wine came from southern Europe as did some of the vessels involved in storing, mixing, and drinking it. But local fashion provided Celtic smiths with an opportunity to use their imagination, particularly in the decoration of such vessels.

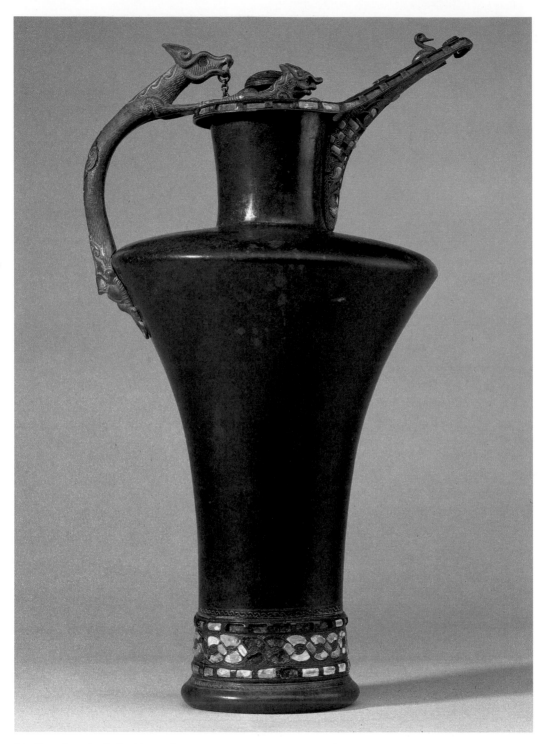

36. One of a pair of wine-flagons from
Basse-Yutz, France, late 5th-early 4th
century BC. Bronze with enamel and
coral inlay, height c. 15¹/₄″ (38.7 cm).
British Museum, London.

The Hallstatt and earlier La Tène drinking equipment forms a distinct chronological "horizon" which is not seen to the same degree with later La Tène material. But in the very late Iron Age, such equipment is again prominent in some high-status graves. This is exemplified by a group of bronze-covered wooden buckets, some of which are highly decorated with both cast and repoussé designs. The Aylesford bucket, old when it was buried, was found in a Kent cremation-grave of the 1st century BC or AD (see FIG. 24). This wooden stave-built vessel, covered in sheet-bronze, was used for serving liquor. A series of tankards, dating to the very end of the Iron Age, comes from the western periphery of the Celtic world: one, from Trawsfynydd in North Wales, is made of yew and covered in sheet-bronze (FIG. 37). The vessel itself is plain, but its handle is highly decorated with curvilinear moulded patterns, including triskeles (three-armed whirligigs which, with their many variations, are some of the most commonly found motifs in Celtic art). Such tankards, and indeed also the buckets, may have been made for holding beer, mead, or berry juice rather than wine, but they all represent high-status possessions. The Trawsfynydd tankard could have been a votive offering, as it was found in a peat bog.

37. Tankard from Trawsfynydd, Wales, 1st century AD. Bronze-covered yew, height 5¼" (14.3 cm). City of Liverpool Museums.

It has been suggested that the maker of this tankard may have moved west into north Wales with the followers of Caratacus (fl. AD 50), the British leader of resistance against the Roman occupation who, according to the historian Tacitus, took his rebels across Britain away from the Roman presence in the south-east.

Also indicative of high-status, late Iron Age feasting are the elaborate iron "firedogs" from tombs such as that at Barton in Cambridgeshire, England, which was found with a gang-chain (a probable reflection of the dead person's ownership of slaves). These wrought-iron utensils were made to contain the logs of the cooking hearth, and are characterised by their bull-head terminals, symbolic of a cattle-owning landed gentry. The Barton graves were also furnished with wine-drinking equipment, including strainers, cups, and *amphorae* (tall clay vessels used for shipping wine and oil from the Mediterranean). The most superb British example of a firedog comes from Capel Garmon, Gwynedd, in Wales (FIG. 38). It has been assumed it was deliberately placed in a bog as a gift to the gods, with a stone placed over it at either end.

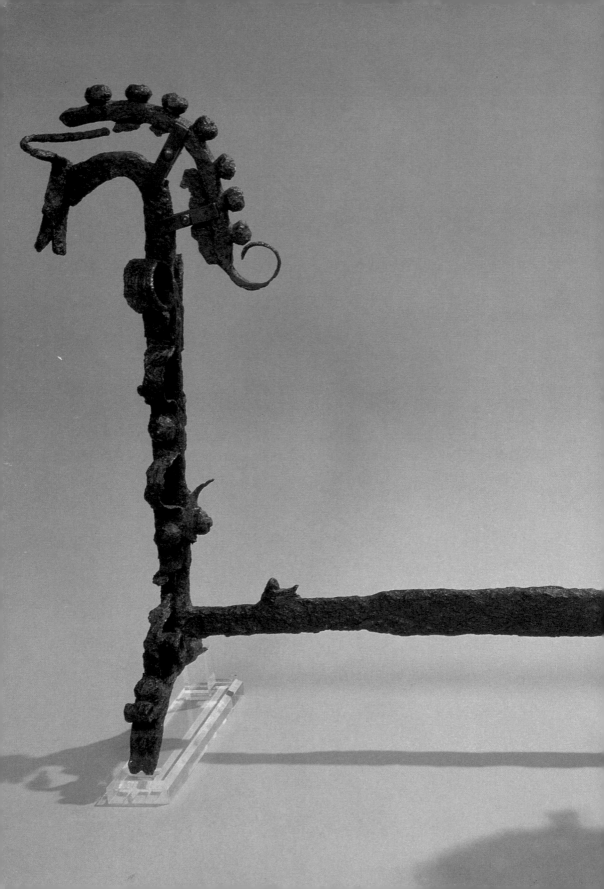

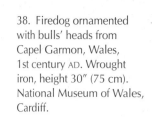

38. Firedog ornamented with bulls' heads from Capel Garmon, Wales, 1st century AD. Wrought iron, height 30″ (75 cm). National Museum of Wales, Cardiff.

This is one of the most important known pieces of Celtic decorated ironwork, and its contemporary value can only be guessed at. Winning the metal from its ore was itself time-consuming and, when the firedog was recently replicated for a museum exhibition, the blacksmith David Petersen commented that using ancient methods of manufacture, the piece could represent three years of work.

The graceful animal heads have horns, like bulls, but decorative manes, like horses. It is a spectacular exception to the rule that during the Celtic period, few such wonderfully decorative objects were made of iron.

Decorated wine-vessels continued to be made in the early Christian period, but now they were often used in the service of God. (A late example is the chip-carved silver Ardagh Chalice from Co. Limerick in Ireland, discussed in chapter five. This was made in about AD 700 and clearly used in the Christian liturgy.) "Hanging-bowls" may likewise have been used for sacramental wine. Although they are sometimes found in Anglo-Saxon graves in eastern England such as Sutton Hoo, their decoration strongly suggests that they were commissioned from Celtic metalworkers.

Symbols of Status

The role of Celtic art − and that of the objects it adorned − as a status indicator is demonstrated by a group of objects that appears to have been made primarily for ceremonial or display purposes. The four-wheeled hearses or carts that carried Hallstatt Iron Age notables to their graves were sometimes lavishly ornamented. The 6th-century BC example at Býčiskála in Moravia (former Czechoslovakia), was sheathed in bronze and decorated with swastikas − in Celtic art a symbol of good fortune − and other symbolic

39. Crescent-shaped plaque from Llyn Cerrig Bach on Anglesey, Wales, 1st century BC. Bronze, diameter 7⅛″ (18.1 cm). National Museum of Wales, Cardiff.

The central roundel is decorated with a triskele, its arms terminating in birds' heads. The precise function of the plaque is not known, but it may have decorated the front of a chariot and could have been a symbol of rank, good luck, or divine protection. From a votive deposit found during construction of a military airfield.

motifs. It has been suggested that the 1st-century AD crescent-shaped plaque from Llyn Cerrig Bach on Anglesey, Wales (FIG. 39), with its bird-head-ornamented triskele (three-armed whirligig), was a kind of badge that adorned the front of a chariot, equivalent to the identification logo of a modern car. The brightly enamelled harness-fittings for chariots and horses, which were particularly splendid in late Iron Age Britain, were likewise display-items which signified the rank of the rider. Indeed, some of the weapons owned by the warrior-elite were probably more effective for display than for fighting.

In Ireland, two specific types of bronze object were very closely linked to high rank and ceremonial: crowns and trumpets. Two Irish crowns or headdresses, probably dating to the 1st century AD, are recorded, one from Cork and an unprovenanced example, known as the Petrie Crown (FIG. 40). The latter is the more complete and originally consisted of a number of hollow bronze horns attached to discs and mounted on an openwork band. The crown is decorated in fine repoussé curving lines. The crown from Cork survives in the form of three horns which, when found, had fragments of leather adhering to them. In Britain, a decorated bronze headband was found adorning the skull of a Celtic warrior buried at Deal in Kent between 200 and 100 BC (FIG. 41). Ceremonial headdresses from the Roman period have also been found, particularly in East Anglia: one findspot was the Romano-Celtic temple at Hockwold-cum-Wilton in Norfolk, and it seems likely that such head-gear was part of the liturgical garb of priests. Some of the crowns are adjustable, which perhaps indicates that regalia was shared. The main decoration on these headdresses consists of roundels bearing human faces in relief.

40. The Petrie Crown, an Irish ceremonial headdress, 1st-2nd century AD. Bronze, diameter of discs 2¹⁄₃″ (6 cm). National Museum of Ireland, Dublin.

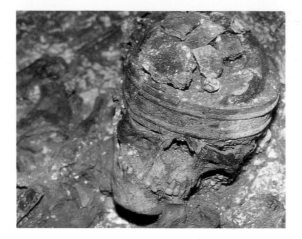

41. Headdress found at Deal in Kent, England, 2nd century BC. Bronze. British Museum, London.

The bronze head-band was found *in situ* in a tomb as shown here, around the skull of a warrior who had also been buried with his sword (see FIG. 94, page 127, where the scabbard is illustrated) and shield.

One item associated with status or ceremonial comes from an unequivocally female grave at Wetwang Slack in Yorkshire, England. In the 2nd century BC, a high-ranking woman was interred with a chariot and a curious small bronze canister or casket, cylindrical in shape, completely sealed, and decorated with La Tène designs. It had a chain-attachment, as if meant to be hung from the waist. It has been suggested that the little box may once have held holy water, aromatic spices, or oils: if that were so, then the woman may have been a priestess. It is a unique object and this fact, combined with the presence of the prestigious chariot, indicates the relative importance of the Wetwang woman.

Apart from the crowns, the other distinctive Irish status-markers are trumpets. These are hollow curving tubes of bronze, the bells ringed by hollow discs which bear moulded decoration. The group of four trumpets from Loughnashade in Co. Armagh (see FIG. 16) was deposited at the foot of the hill upon which stood Navan Fort (FIG. 42). This royal site, called Emain Macha in Irish myth, features prominently in the group of early prose tales known as the Ulster Cycle. A great ceremonial timber building was erected there which has been precisely dated by dendrochronology (tree-ring dating) to 95/94 BC. The marsh or lake in which the

42. Reconstruction of the ritual structure found at Navan Fort in Co. Armagh, Northern Ireland. Diameter of structure 131′ (40 m).

The felling-date of the original timbers (determined by dendrochronology, or tree-ring dating) was 95/94 BC. The building was deliberately burnt down very soon after it was erected, and covered with a stone cairn.

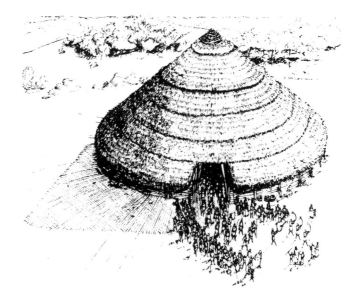

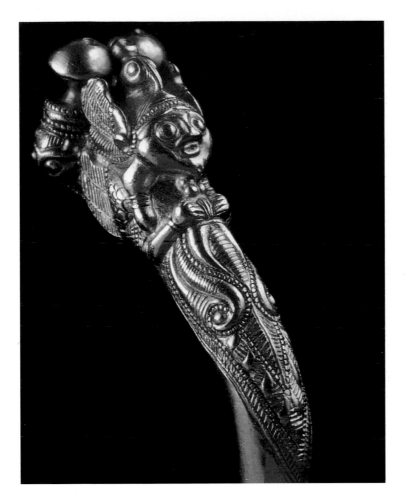

43. Armlet decorated with the image of a woman and bird, from a princess's grave at Reinheim, Germany, mid-4th century BC. Gold, diameter 3¹/₄″ (8.1 cm). Museum für Vor-und Frühgeschichte, Saarbrücken.

four trumpets were found also contained human skulls, and the site was evidently the focus of concentrated ritual activity. The consistent depositing of trumpets in watery contexts again argues for their being offered as prestigious gifts to the spirit-world.

Mirrors were high-status possessions and are usually associated with British late Iron Age female graves. One such was that found at Birdlip in Gloucestershire, England. The massive bronze mirror (see FIG. 26), with intricate lyre-decoration on the back, accompanied the body of a woman whose high rank is suggested also by the silver-gilt brooch that fastened her cloak. Other mirrors, of similar date and splendour, have been found at Holcombe in Devon and Desborough in Northamptonshire. A much earlier burial of a woman with a mirror was that of the Reinheim princess, who died in the 4th century BC and was accompanied by sumptuous gold jewellery (FIG. 43), as well as feasting equipment and a mirror. Classical writers refer to the vanity of the

Celts and their love of ostentation, and the evident value placed upon mirrors indicates the source of their comments.

Celtic coins, particularly high-denomination gold and silver issues, may also have been status-markers. Clues to such a role may be found in the iconography of coins. The animals most often chosen to decorate the reverse of coins were the prestigious beasts associated with heroic warfare or the hunt: deer, boars, and, above all, horses. The horse-riding, chariot-driving elite alluded to by Caesar is also represented on coinage, and it may be significant that some of the warriors represented are women (fig. 44). Indeed it is interesting that, unlike much of Celtic art, coin decoration contains many figural images. The presence of possible mythic scenes, such as the north Gaulish coins depicting a horse ridden by a bird of prey (see fig. 11), or the wolf devouring the sun, may reflect control of the supernatural by rulers or priests. The first image has been associated by some scholars with an early Irish myth in which female battle-furies transformed themselves into ravens and harried soldiers on the battlefield, using psychological warfare to drain their power. The wolf symbolism has a possible link with an early Norse myth of the world's creation, fall, and renewal, where the end of the world is signified by the wolf's attack on the sun and moon. That coins were sometimes intimately connected with status is indicated by some of the inscriptions on them, which proclaim the name and title of the issuing ruler. The last of the free Gaulish gold coinage is represented by an issue struck in 52 bc which bears the name of the Gallic freedom fighter Vercingetorix and an idealised portrait of him, as the last bastion of freedom against Julius Caesar and the might of Rome. Coins had political importance as symbols of power, authority, identity, and wealth. A direct link between coins and prestige is suggested by their association with undoubted symbols of rank: gold torcs are sometimes found with coins, and such jewellery has close connections with rank. So the deliberate (and arguably ritual) depositing of gold torcs and coins, as at Niederzier in the Rhineland and Tayac in the Gironde, France, may indicate the role of coins as symbols of status.

44. Coin from Brittany, depicting a Celtic horse-woman, early 1st century BC. Gold, diameter 4/5" (2 cm). Cabinet des Medailles, Bibliothèque Nationale, Paris.

Initially Celtic coins consisted of high-denomination gold and silver issues, used to fill the treasuries of chiefs (and perhaps druids), as units of wealth and gift-exchange, and as payment for mercenaries. Celtic artists used images from Greek and Roman coins as inspiration for their motifs, but adapted Classical forms to their own taste and culture.

Jewellery, Rank, and Gender

Study of the way jewellery makes statements about society is relevant not only to antiquity but also to modern communities. However, any attempt to interpret past societies by means of personal adornment will, of course, come up against ambiguity and misunderstanding. Questions of gender, age, and social status are all pertinent but difficult to answer with conviction. Celtic jewellery is found most frequently in graves, and we need to try to establish the extent to which such grave-furniture reflects earthly status and function or whether some jewellery was especially made for the tomb. When we examine an adult skeleton wearing a solid neckring which could not be removed in life, we assume that this was first put on in childhood or adolescence, perhaps as a symbol of approaching adulthood, and worn to the grave. But where, for instance, we have a grave with a multiplicity of brooches, we can validly enquire whether the woman buried with them used them all, whether they may represent all the family's brooches or whether they were made for a funerary purpose. Little can be said about age, although in general children's graves were relatively simply furnished. But at the Austrian stronghold of the Dürrnberg, a deformed and stunted girl was buried with special ornaments, including solar amulets, perhaps to being her better luck in the next world (FIG. 45).

45. Ornaments from a child's grave at Dürrnberg, Austria, including a miniature wheel and axe, 4th century BC. Bronze, diameter of wheel 2" (5 cm). Keltenmuseum, Hallein.

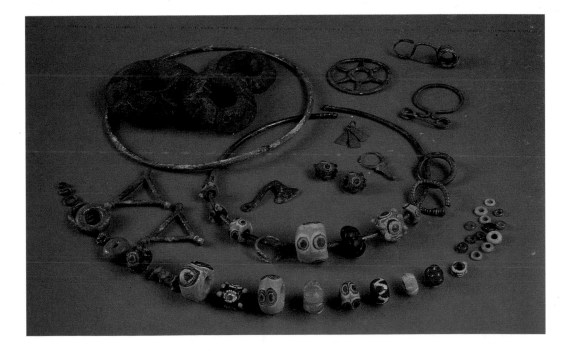

Some work has been done on a number of Continental Celtic tomb-assemblages to see whether the presence of certain types of ring jewellery (neckrings and armrings) worn in different regions can identify movement of individuals from one area or group to another. For instance, it might be possible to demonstrate that women were leaving their home communities to marry outside them (exogamy). This may have been true of the Waldalgesheim princess, whose gold jewellery was not local to the Rhineland where she was buried.

There is an enormous variety in the forms of personal adornment worn by the Celts. The sheer amount of jewellery for which we have evidence points to a society which was at one and the same time preoccupied with appearance on the one hand (a view thoroughly endorsed by Classical writers' remarks) and, on the other, which sought to display its surplus wealth, power, and status by this kind of visual expression.

The most important types of Celtic jewellery are torcs, armlets, bracelets and anklets, earrings, finger-rings, brooches, and belt-ornaments. But other forms, such as pendants and bead necklaces, were also worn. Gold, silver, bronze, and even iron were used, together with amber, coral, enamel, glass, bone, and other materials. By far the most important class of jewellery, as well as being the most highly ornamented, is ring jewellery: armlets, finger-rings, and above all torcs. These provide significant evidence about rank and ritual practice in Celtic society.

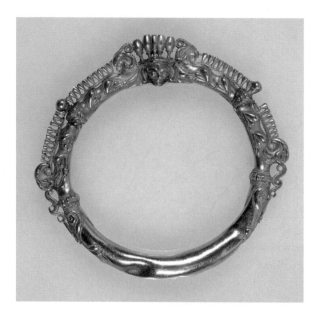

46. Armlet decorated with a human face crowned with yew-berries, from a chieftain's grave at Rodenbach, Germany, late 5th century BC. Gold, diameter 2²/₃″ (6.7 cm). Historisches Museum der Pfalz, Speyer.

The small size of the armlet may indicate that it was first put on in childhood and never removed.

Before we examine specific items of jewellery, it is worth taking a look at some of the lavish early Iron Age tomb-assemblages, to appreciate the quantity and value of such material. The Continental graves of the 6th-4th centuries BC provide the greatest display of wealth, expressed by means of jewellery, particularly gold. By the 6th century BC gold had apparently acquired prestige and seems to have been the exclusive preserve of nobles. Men were sometimes buried with a single gold armring, perhaps as a badge of rank or war-prowess: the soldier interred at Rodenbach in the Rhineland wore a great gold armlet decorated with fantastic animals and a central moustached human face (FIG.

46). His gold finger-ring was adorned with a janiform (double, back-to-back) bearded head. The Vix princess buried in about 500 BC wore both her massive gold torc and a bead necklace of amber, diorite (a type of speckled stone), and serpentine; her clothes were fastened with coral-inlaid brooches. She wore an anklet and two bracelets, one of bronze, the other of lignite (brown coal). Her status was shown by the amount of jewellery worn, its variety, and its high value.

In this early Iron Age period, it is clear that both sexes wore high-status jewellery. The double male/female Hallstatt grave of the 6th century BC at Hohmichele is situated near the princely stronghold of the Heuneberg in Baden-Württemberg. The man and woman were interred at the same time, and they were accompanied by secondary burials with simpler furnishings. But the "royal" couple were lavishly bedecked with ornaments: she wore a long necklace of glass and amber beads (the remains of Chinese silk thread, indicative of far-reaching trade links, which embroidered her clothes mark her high rank); he wore a torc made of iron, an unusual and exotic medium for such an object, especially in the very early Iron Age, and a richly decorated belt. The finery of both proclaims the high esteem with which they were regarded in life, but their jewellery was sharply differentiated, presumably by gender.

During the Hallstatt and early La Tène Iron Age, it is possible to identify a number of high-ranking female graves, which suggest that women could – and did – have independent status. We have to be extremely careful about ascribing jewellery types to different sexes because we are always in danger of introducing circularity to the argument. Early excavators of Celtic tombs made the assumption that certain types of jewellery were associated with women, but this cannot be proved unless the body has been independently sexed on skeletal grounds. The sumptuousness of the Vix princess's tomb is unparalleled by any coeval male grave in the locality. This situation was repeated at Reinheim in Saarland, Germany. The decoration of the gold neckring and matching armlet (see FIG. 43) with which the Reinheim princess was interred is of especial interest because it may relate to some mythical episode: the iconography on both the neck and arm ornaments includes the image of a woman with a bird of prey above her head, and the fact that this jewellery was already about fifty years old when it was laid in the tomb argues for its veneration. The Reinheim woman was also buried with a jewellery box containing more than two hundred items, including brooches, finger-rings, and polychrome glass and amber beads.

Torcs and other Ring Jewellery

Torcs dominate some of the early princely Celtic graves, and are such a distinctive phenomenon that they repay detailed scrutiny. Their importance is demonstrated by their longevity: people were wearing torcs in the Celtic world from at least the 6th century BC to the 2nd century AD, and we must remember that the Bronze Age ancestors to the Celts also wore torcs. Such jewellery also has the distinction of having been singled out by Classical authors as worthy of comment. The third indicator of the status of torcs is their appearance, in late pre-Roman and Romano-Celtic iconography, as jewellery worn by the gods.

A Celtic torc may be defined as a metal (usually gold or bronze, sometimes electrum or silver) neckring, which curves to fit closely round the neck. It may be plain or highly decorated; it may be tubular, or made of a twisted bar of metal, or of several strands of twisted wire. The terminals may be massive and are often the focus of elaborate, high-relief decoration, which might have made the torcs uncomfortable to wear.

Before the end of the 3rd century BC, gold and bronze torcs appear most commonly in female graves, although rare pieces of monumental stone sculpture, like the Hallstatt figure at Hirschlanden, show that men also wore torcs (FIG. 47). After this time, their function appears to have changed, in that they were more commonly associated with men and they were now also increasingly being used as votive offerings to the gods, being placed as deliberate deposits, sometimes in lakes or marshes, sometimes in clusters. Both sepulchral and votive contexts are indicative of status, but while grave-ornaments might suggest personal wealth and rank, the giving of torcs as presents to the supernatural powers might be understood as introducing a wider symbolism associated with prestige, power, authority, and sanctity. The possessing of torcs, particularly those of precious metal, probably occurred within the context of their control and exchange by small numbers of powerful people.

In the late 5th or early 4th century BC, four decorated gold torcs and three armlets were placed beneath a large rock in an Alpine pass at Erstfeld in Switzerland (FIG. 48). They may have been brought from a region to the north: they are exotic rarities for their findspot. The hoard was probably buried as a sacrificial offering to the spirit of the mountain pass.

By far the most spectacular group of precious metal torcs comes from the hoards discovered at Snettisham in Norfolk (discussed in chapter one), where over 175 gold, silver, electrum,

47. Statue of a Hallstatt warrior from the top of a burial mound at Ditzingen-Hirschlanden, Germany, late 6th century BC. Sandstone, present height 5′ (1.5 m). Württembergisches Landesmuseum, Stuttgart.

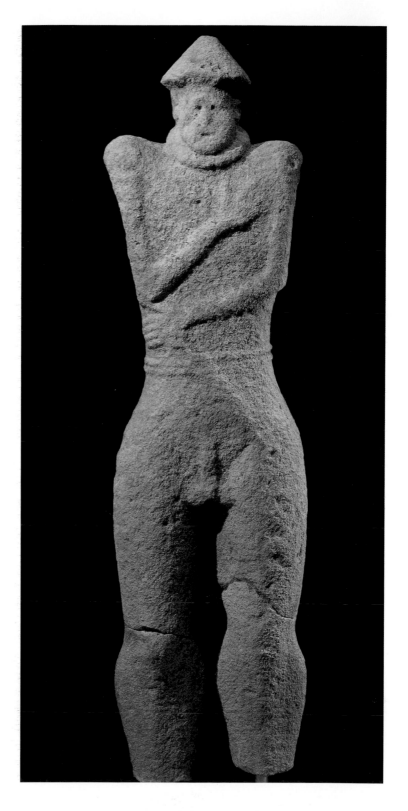

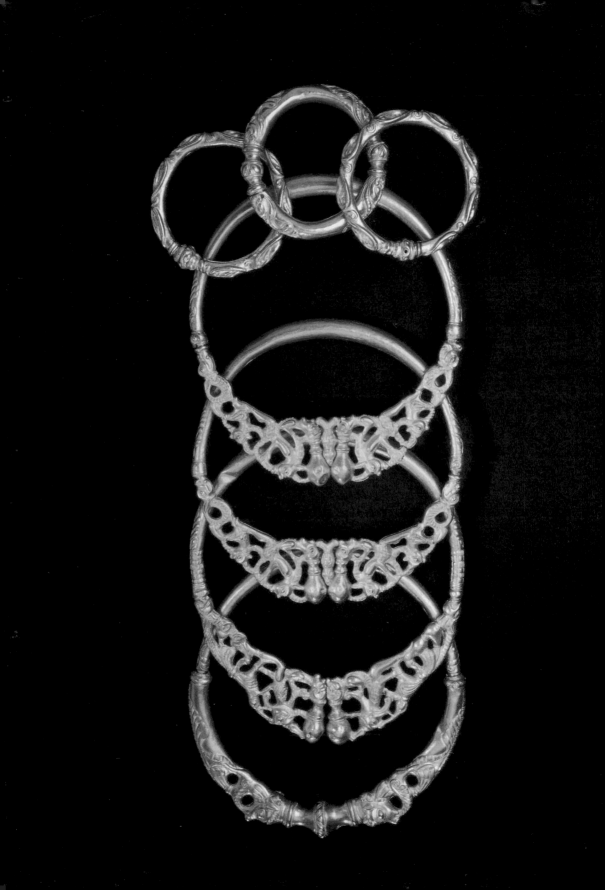

and bronze neckrings have been discovered. That East Anglia was incomparably wealthy during the 1st century BC is shown by other torcs found in the same region: a group of six gold necklets comes from Ipswich in Suffolk. The question as to whether the Snettisham torcs represent a huge ritual deposit or a treasury remains open and controversial. But discussion of this great mass of precious metal neckrings leads us directly to consideration of the light thrown on these enigmatic objects by the contemporary Greek and Roman commentators on the Celts. Despite the fact that much of the Snettisham material pre-dates the Boudican rebellion by nearly a hundred years, it is tempting to associate the tradition of using precious torcs with the great Celtic queen of the Norfolk tribe of the Iceni, Boudica, who defied and nearly defeated the Roman forces in Britain in AD 60/61. One writer, Cassius Dio (fl. early 3rd century AD), comments on the "great twisted golden necklace" worn by the warrior-queen (see FIG. 30).

Several ancient chroniclers from the Graeco-Roman world refer to Celtic torcs as being distinctive to Celts, and there are hints at their function as badges of rank and prestige. Polybius (c. 200–after 118 BC) speaks of Celtic spearmen called *gaesatae* who fought at the Battle of Telamon in 225 BC, a campaign in which the Celts were heavily defeated and which halted the Celtic expansion in northern Italy. The *gaesatae*, comments Polybius, went into battle wearing nothing but a torc. The 1st-century BC Roman marble copy of a bronze statue from Pergamum in Asia Minor shows a dying Gaulish warrior, naked except for a twisted torc (FIG. 49). Several Classical Roman writers refer to the taking of torcs as booty or trophies from Celts by Romans after a battle: Pliny alludes to the looting of 183 torcs by the Romans from dead Celtic soldiers in 386 BC; and Livy speaks of this happening at the Battle of Como in 196 BC. An eminent Roman family adopted the name Torquatus after one of its members won a gold torc in battle from a Celt. That the situation was sometimes reversed is demonstrated by a comment from Florus (fl. early 2nd century AD), who recounts the desire of Ariovistus, ruler of the tribe of the Insubres, to dedicate a torc made from the captured accoutrements of Roman soldiers to his war-god. A reference in Quintilian reflects a more peaceful encounter between Celts and Romans: he records how a group of Gauls gave the Emperor Augustus a gold necklet weighing 100 lbs (45 kg).

That torcs were highly prized personal belongings, indicative of authority, rank, and prestige, is beyond question. They were precious, sometimes beautifully decorated, repaired, and handed down as heirlooms. They were, above all, symbols of status. But

49. *The Dying Gaul*, mid-1st century BC (Roman copy of an earlier bronze statue from the Sanctuary of Athena Nikephoros at Pergamum). Marble, lifesize. Museo Capitolino, Rome.

The statue epitomises the Classical descriptions of Celtic warriors going naked into battle but for a torc, and with hair stiffened with limewash. "Very terrifying too were the appearance and the gestures of the naked warriors in front all in the prime of life, and finely built men, and all in the companies richly adorned with gold torcs..." (Polybius, *Histories*). The statue captures the pride of Celtic fighters but also their defeat by their Mediterranean neighbours.

did they have a symbolism over and above this? The decoration itself is, generally, not specific to torcs but is shared with other jewellery. But sometimes religious motifs may be recognised. We have already noted the idiosyncratic iconography of the Reinheim ring ornaments, and many torcs bear human or animal motifs which may refer to a lost mythology or belief-system. Occasionally, other symbols alert us to the possibility of magical symbolism: there is a swastika on one of the Snettisham torcs; and another British torc, from Clevedon in the west of England, has a triskele on the terminal. The triskele, or three-armed whirligig, may refer to the sanctity of the number three and was possibly also associated with the sun; and the swastika was a well-known sign of good fortune, like the wheel.

There is also a number of representations of divinities wearing torcs, dating to the late Iron Age and Romano-Celtic periods. For example, the gods and goddesses on the Gundestrup Cauldron wear torcs. These torc-wearing images tend to represent the deities associated with prosperity. Most frequently found is the antlered god Cernunnos (his name is known from an early Romano-Celtic monument from Paris bearing a dedicatory inscription to him), who often has two torcs (one worn and the other held in his hand, as represented on the Gundestrup Cauldron). A little stone statue of the horse-goddess Epona from Alesia in Bur-

gundy shows her carrying a twisted annular object which may well be a torc (FIG. 50). Both these divinities were linked with well-being and abundance. But while many deities are depicted wearing torcs, the likelihood is that they adorn such images not because they were themselves religious symbols but because they were emblems of power, authority, and rank in secular Celtic society.

Although it is true that torcs appear to enjoy an especially high status, both in terms of their occurrence in the archaeological record and their prominent role in Celtic society, it would be quite wrong to conclude from this that other kinds of jewellery were insignificant. Armlets seem to have been of similar importance to torcs for the upper classes. We have seen how single gold armlets in early Celtic graves, such as that at Rodenbach, could be male status-markers. By contrast, females were buried with pairs of arm ornaments. Like torcs, armlets enjoyed a long-lived popularity, though changes occurred in their form and, perhaps, in their significance. In late Iron Age Scotland, massive coiled bronze armlets, some decorated with enamel, were worn. Leg-rings or anklets are usually assumed to have been worn by women, but caution is needed in such an assumption, because the skeletons of the wearers have not generally been sexed independently of their jewellery. Such anklets were often worn in pairs.

Earrings and finger-rings are found in both male and female graves. As today, earrings clearly adorned the ears of both sexes and could be worn singly, in pairs, or in multiple groups. Finger-rings, again, were worn as single or multiple ornaments. At the Münsingen cemetery in Switzerland, a woman was buried with a silver ring on her right thumb, and others of gold, silver, and electrum on the third finger of her left hand. Some finger-rings bore symbolic motifs: the janiform head on the Rodenbach chieftain's ring may have signified the dead man's position, at the boundary between the human and spirit-worlds.

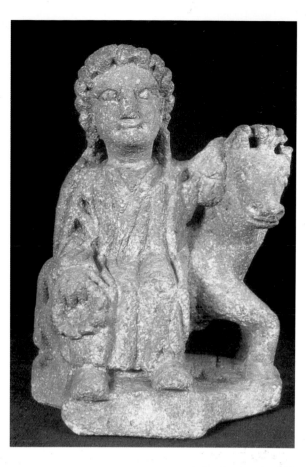

50. The horse-goddess Epona holding a torc, Alise-Ste.-Reine, Burgundy, 1st-2nd century AD. Stone, height 12½″ (32 cm). Musée d'Alésia.

Epona's name is Celtic, derived from the Gaulish epos (horse); her iconography, that of a goddess seated side-saddle on a mare, is not Roman but her appearance and clothing betray Classical influence. What is fundamentally foreign to Roman ways of religious thought is the centrality of the animal symbolism.

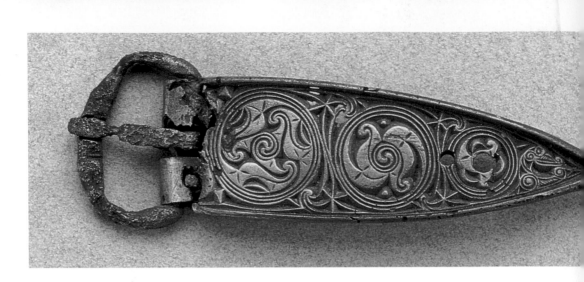

Belts and Brooches

51. Decorated belt buckle from Lagore, Co. Meath, Ireland, 8th century AD. Bronze, length 6¼" (15.8 cm). National Museum of Ireland, Dublin.

The pagan Celtic triskele symbols were still used as ornamental motifs on metalwork of Christian date.

A frequently neglected but important category of personal ornament is that of belt plates, hooks, or buckles. Some spectacular cast-bronze belt plates adorned wide leather belts of the Continental early Iron Age, sometimes occurring in tombs identified as female. They are often ornamented with elaborate openwork vegetal or animal designs, as is the coral-inlaid plaque from Weiskirchen in the Rhineland, Germany (see FIG. 17). The opposite end of the chronological and spatial spectrum of the Celtic world is represented by a belt buckle from Lagore in Ireland (FIG. 51): made in the 8th century AD, it is decorated with a three-legged triskele, perhaps still a symbol of good luck, even in the early Christian period.

Brooches and pins were worn to fasten clothing and, in the case of pins, in the hair. The position of pins in graves suggests their frequent use as cloak (or shroud) fasteners. But some of the most ornate pins from the Yorkshire cart-grave cemeteries were found close to the skull, as if they might have pinned up coils of hair: one very beautiful pin from such a tomb is a coral-inlaid, ring-headed pin of 4th-3rd century BC date, found at Danes Graves in northern England (FIG. 52). Its openwork head is in the form of a decorative four-spoked wheel. Again, such pins are often presumed to have belonged to women, but there is no specific evidence that this was invariably the case: both sexes needed to fasten their garments, and it is by no means impossible that men's long hair was sometimes pinned.

Other dress fasteners included *fibulae*, brooches with a spring and pin which worked on the safety-pin principle. The bows

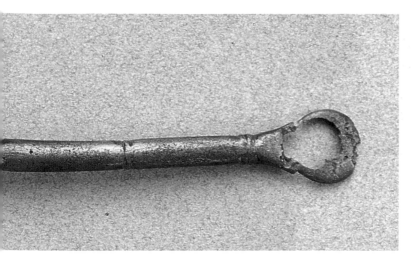

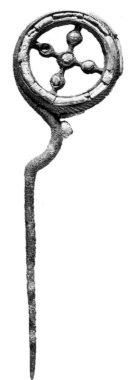

of many of these brooches are ornate, with human or animal-based designs, some showing the fantastic Celtic "dream-imagery," described in more detail in chapter four, which so effectively combined realism with the imagination. Others bear swirling curvilinear patterns. Some attempts have been made to link brooch types with gender and even marital status, but without much success. But it is worth noting that many brooches are decorated with miniature symbolic motifs which, on the one hand, required great skill to produce and, on the other, were so difficult to see that perhaps such images had a function not to display but to express private, symbolic, and even secret messages to which only the brooch-wearer and, perhaps, the gods had access.

In the early Christian period, while the most prominent Celtic art (the manuscripts, crosses, and liturgical metalwork) was dedicated to the glory of God, the upper classes of the native

Above

52. Wheel-headed pin from Danes Graves, Yorkshire, England, 3rd century BC. Bronze with enamel inlay, length 5" (12.6 cm). British Museum, London.

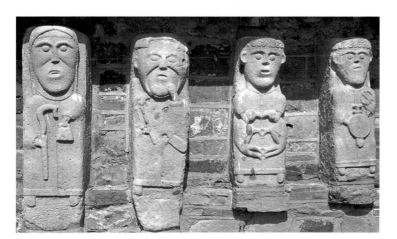

Left

53. Stone statues, including one of a man wearing a penannular brooch, White Island, Co. Fermanagh, Ireland, 9th century AD. Height of tallest statue 40" (101 cm).

54. The Tara Brooch, found at Bettystown, Co. Meath, Ireland, 8th century AD. Silver-gilt, length nearly 9″ (22.2 cm). National Museum of Ireland, Dublin.

The brooch is intricately decorated with gold wire, bands of amber, and red and blue enamel. Its maker combined different ornamental techniques, including relief-work, engraving, filigree, and chip-carving. Two little human faces were carved in amethyst; other motifs include animals and triskeles.

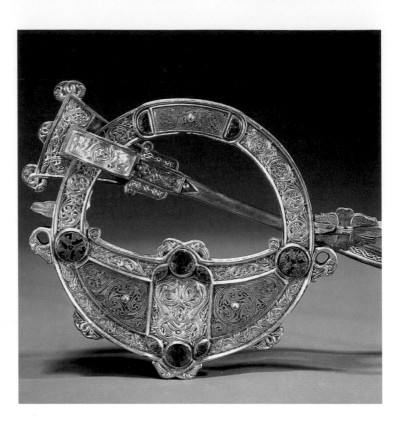

western Celtic kingdoms still required personal objects of status. One group of ornaments which displayed rank consisted of decorated penannular brooches (FIG. 53), which occur particularly in Ireland and Wales between the 6th and 8th centuries AD. The most spectacular of these (technically a "pseudo-penannular" brooch) is the cast silver-gilt brooch from Bettystown in Co. Meath, popularly known as the Tara Brooch (FIG. 54). It is large, nearly 2 inches (4.6 cm) wide at the terminals, and is lavishly decorated with images of interlaced animals and birds, inlaid with enamel, glass, and amber, and embellished with filigree and engraved ornament.

Gender in Human Representation

It is useful to review the gender balance in Celtic art, particularly in the light of remarks made concerning the association of specific art objects with females and males.

Where representations of humans (or of divinities in human form) are present, they are frequently portrayed by the head alone and, very often, the image is subordinated to design. Thus the 5th-4th-century BC faces on the Pfalzfeld obelisk merge with their

background of swirling vegetal patterns, and the leaf-crown on the head is part of the overall design (see FIG. 32, page 55). In jewellery, too, the head or face peeps out from a tangle of curves and tendrils, and there is often a doubt as to whether a human face is even intended. We see this, for example, on the Waldalgesheim torc (see FIG. 10). The use of the human head on its own is a symbolic device which may be linked with a complex belief-system, a theme explored further in chapters four and five. The human forms represented in metalwork show a fairly even balance between the sexes, but more monumental depictions, such as the Hallstatt warrior, generally appear to be male. The imagery on the Rodenbach tomb jewellery is unequivocally masculine: the armlet bears a face with a moustache (see FIG. 46); the finger-ring a double bearded head. The bronze mount from the Dürrnberg flagon depicts a leaf-crowned face with forked beard (see FIG. 8). But the Reinheim and Waldalgesheim ring jewellery, which comes from female graves, show depictions that are apparently also female. In some instances, therefore, the imagery on the jewellery matches the sex of the deceased. This is not the case with the Hochdorf Hallstatt chieftain: the dead person was a six-foot man, with his weapons and drinking equipment round him. But some of the decorative imagery on his couch is female (see FIG. 35): women balanced on mono-cycles support the couch, and the engraved pairs of dancing or fighting figures wear skirts, which could have been worn by women. A woman's tomb at Bad Dürkheim in the Hunsrück-Eifel, Germany, dated to the late 5th or early 4th century BC, contained a sheet-gold ornament depicting a reversible face (FIG. 55): one way up it shows a clean-shaven head with leaf-crown; turn it upside-down and you see a bearded older face. Are we witnessing a visual pun? Are youth and maturity or female and male represented? On some occasions, there may be deliberate sexual ambiguity in the imagery.

Coins portray human heads or beings that are usually male, but there are notable exceptions: certain issues which turn up over a wide area (from Rennes in Brittany to Romania) depict female charioteers, who brandish shields, torcs, or branches (see FIG. 44). Long-haired running female figures wearing torcs also appear on coins. There are problems inherent in interpreting coin-heads as male: a beardless face with abundant curling hair could just as easily represent a female. If the heads portray rulers, this does not weaken the case, since we know from some of the early Continental graves and from later Classical sources, that women could hold authority in Celtic society: "We British are used to women commanders in battle," as Queen Boudica is alleged to have said

55. Reconstruction of a fragmentary openwork plaque with a reversible face from Bad Dürkheim, Germany, late 5th-early 4th century BC. Gold, height of head 2/3″ (1.7 cm). Staatliches Museum, Berlin.

56. Figurine of a goddess, priestess, or pilgrim, wearing a torc, from a healing spring sanctuary at Chamalières, France, 1st century AD. Wood, height 15¾" (40 cm). Musée Archéologique, Clermont-Ferrand.

during the conflict between the Celts and Romans in Britain in AD 60, in a speech recorded in Tacitus's (AD 55-120) *Annals*. The Gundestrup Cauldron (see FIG. 29) bears several images of deities, some male, some female. The females, represented on the outer plates by their heads and shoulders, are shown with long hair, torcs, and breasts. They wear torcs more often than the male images. The few other surviving pieces of "narrative" art are associated with male figures, often warriors.

The two areas of Europe to have produced monumental stone sculpture in the 6th–3rd centuries BC are southern France (around Marseilles) and central Europe. In both regions, all the images appear to be male. The naked, torc-wearing Hallstatt warrior, who once adorned the top of a burial mound at Ditzingen-Hirsch-landen in Baden-Württemberg, Germany, in the 6th century is ithyphallic (with penis erect). The 3rd-century BC Mšecké Žehrovice head from Bohemia (see FIG. 2) is definitely that of a man: it has a long curling moustache. A group of sculptures from the Lower Rhône Valley in southern Gaul likewise depicts males. It is probable that they are associated with a warrior-cult; and the real human skulls embedded in the niches of temples such as Roquepertuse and Entremont, where the images have been found, are those of adult males who might have died in battle.

A group of small stone, bronze, and wooden images from the late Iron Age or early Roman period (2nd century BC to 1st century AD) depict both women and men: the naked, cross-legged, torc-wearing, and hooved bronze deity from Bouray in the Essone is male, but a torc-wearing wooden image from the sanctuary at Chamalières, Puy-de-Dôme, in central France (FIG. 56) is female. The small bronze figure of a woman found at the sacred Iron Age site at Henley Wood in Avon, England, may represent a goddess: she is naked but she has a decorative torc and – interestingly – her head is extremely worn, as if from constant handling of the most sacred part of the image.

The wearing of torcs on images is shared between females and males, and this matches the evidence from graves. If we are correct in linking torcs with rank, then this is significant. Study of both the sepulchral and the iconographic material suggests at least some power-sharing between the sexes in early Celtic society, despite the longstanding stereotype of the swaggering, bellicose Celtic warrior, straining his wine through his moustache and spoiling for a fight, which had its genesis with the Classical writers and continues today with the popular cartoon figure of Asterix.

Talismans of War

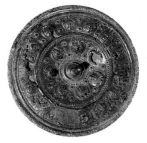

> The whole race is war-mad, and both high spirited and quick
> for battle, although otherwise simple and not ill-mannered.
>
> Strabo (64/63 BC-c. AD 21), *Geographia*

C onflict was endemic among the early Celts of Britain and
Europe (FIG. 58). Ranging from small-scale personal squab-
bles over property or status to the great battles between
the Celts and the Romans, combat was the medium by whch dis-
putes were settled and relationships made and broken. From
the 5th century BC, marauding Celtic armies overran much of
Europe, including the Mediterranean worlds of Rome, Greece,
and Asia Minor (modern Turkey). There are Classical literary ref-
erences to this expansion from the Celtic heartlands of central
Europe, and to the fact that Celtic soldiers fought as mercenar-
ies. The Greek and Roman historians, who chronicled the con-
frontation between their armies and those of their "barbarian"
adversaries, spoke with awe of the ferocity and fearlessness of the
Celtic warriors with whom their soldiers came into conflict between
the 4th century BC and the 1st century AD (see FIG. 57, opposite).

But Classical writers also commented upon the weakness some-
times apparent behind the bravado. The Greek geographer Strabo
commented:

> And when they are inflamed, they assemble in their bands
> for battle quite openly and without forethought, and so they
> are easily handled by those who desire to outwit them. For
> at any time or place, and on whatever pretext you stir them up,
> you will have them ready to face danger, even if they have noth-
> ing on their side but their own strength and courage.
>
> (*Geographia*)

57. Figure of a Celtic
warrior from St.-Maur-en-
Chaussée, France, 2nd-1st
century BC. Bronze, height
21½" (55 cm). Musée
Départemental de l'Oise,
Beauvais.

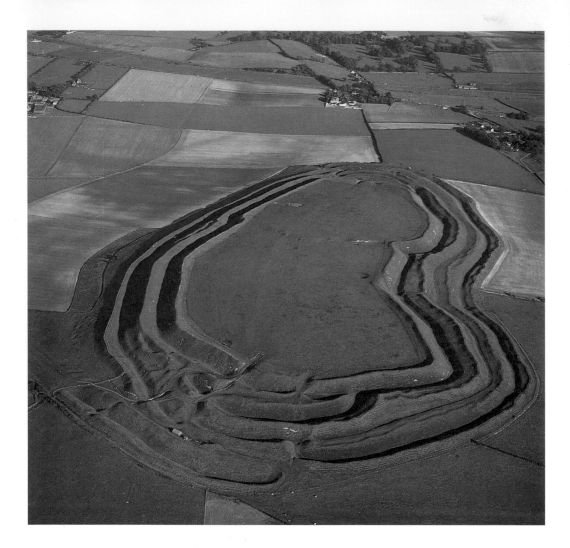

The Status of the Warrior

58. The Iron Age hillfort of Maiden Castle in Dorset, England, tribal capital of the Durotriges.

The massive bank-and-ditch defences are indicative of an unstable, warlike society. Maiden Castle was stormed and sacked by the Romans in the mid-1st century AD.

For the Celts, warfare was inextricably associated with rank, prestige, and display. Julius Caesar, who fought the Gauls from 58 to 50 BC, remarked that, below the chief or king of the tribe, the warrior knights enjoyed the highest social status in Celtic society. These were the aristocratic, land-owning, and horse-riding elite, who led the armies into battle and who were responsible for the protection of their chief on the battlefield.

If we bear in mind the close association between warfare and prestige, it is no surprise that display formed an important element in the Celtic war ethos. Indeed, we are told by such Classical writers as Diodorus Siculus and Polybius that showiness and flamboyance were essential features of Celtic warfare. Poly-

bius, commenting on the Battle of Telamon in 225 BC between the Romans and the Celts in north Italy (at which the Celtic troops were soundly beaten), says that image played a major role in battle: "Very terrifying too were the appearance and gestures of the naked warriors in front, all in the prime of life and finely built men, and all in the leading companies richly adorned with gold torcs and armlets." (Polybius, *Histories*.)

Diodorus says:

> When the armies are drawn up in battle array they are wont to advance before the battle-line and to challenge the bravest of their opponents to single combat, at the same time brandishing before them their arms so as to terrify their foe. And when someone accepts their challenge to battle, they loudly recite the deeds of valour of their ancestors and proclaim their own valorous quality, at the same time abusing and making little of their opponent and generally attempting to rob him beforehand of his fighting spirit.
>
> *Library of History*

The Battle Equipment of the Celtic Soldier

Depictions of warriors on images of stone or bronze give information about the weapons or armour borne by soldiers in the Celtic army. The panoply of war-gear included spears, swords, and daggers as offensive weapons; shields and helmets as defensive armour, and occasional body-armour, usually of chain-mail. This last was rare, perhaps because it was expensive to make, and it occurs only in late Iron Age contexts. In addition, we are told by Classical writers that the Celts sometimes fought naked. Horses were an important element in warfare: they were ridden by cavalry units and also used to pull chariots. Other equipment used by soldiers included a war-trumpet which gave a harsh braying sound and unnerved their enemies.

Much of our archaeological evidence comes from graves. It was the practice in Celtic Europe to bury warriors with their arms if inhumation rites were followed. If the dead person was cremated, sometimes only a token piece was placed with the remains. There is evidence that weapons buried in the tomb or thrown as votive offerings into water were sometimes ritually "killed," snapped in pieces or bent in half. The purpose of this act may have been to remove them symbolically from earthly existence to that of the spirit-world, to render them valueless, or as a display of extravagance. By contrast, some weapons were cast into rivers

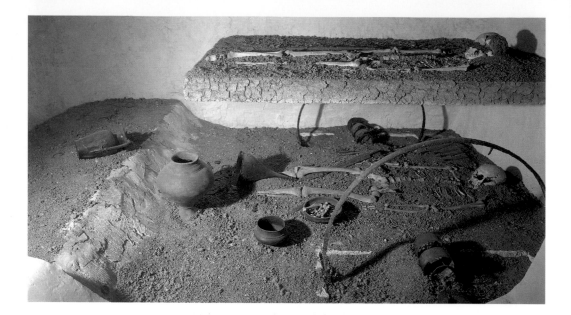

59. Chariot-burial of a warrior from La Gorge-Meillet, Marne, France, 5th century BC. Musée des Antiquités Nationales, Saint-Germain-en-Laye, Paris.

The warrior was accompanied by his weapons, a helmet, and his war-chariot, and with goods for the afterlife. His charioteer was interred above him, indicating that the charioteer may have died with his lord in battle or been killed in a *suttee*-like ritual, to accompany his lord to the next world.

in mint condition: a late Iron Age sword and scabbard from Isleham in Cambridgeshire, England, were nearly new when offered to the gods in the River Lark.

As an example of a Celtic warrior grave, we may cite that at La Gorge-Meillet in eastern France (FIG. 59), where a soldier was buried with his chariot, his coral-decorated bronze helmet by his feet, his weapons, and equipment for the funerary feast, including joints of pork and beef. His charioteer-companion was entombed above him.

War-gear and Display

Set against the backdrop of flamboyance, boasting, display, and rivalry on the part of Celtic warriors, which is chronicled by Classical writers, it is appropriate that weapons and armour should reflect this attitude to warfare. Such equipment was often lavishly and elaborately decorated with carved or repoussé designs, sometimes inlaid with enamel, coral, amber, and other exotic materials (FIGS 60 and 61). Indeed, a substantial amount of Celtic art appears on shields, helmets, equestrian equipment, and above all on swords. The accoutrements of war provided both a splendid scope for the craftworkers to express visually their own ideas and those of their society and for the warriors to display the symbolism of their status and craft: "Their arms correspond with their physique; a long sword fastened on the right side and a long shield, and spears of like dimension," as Strabo puts

it in his *Geographia*. The more impressive the warrior's weapons, the greater his standing.

Strong testimony to the display element in Celtic war-gear is presented by certain objects which were made especially for ceremonial rather than practical use. Many Irish swords, for instance, would not have been effective in battle: aesthetic, prestige, and symbolic properties may have had greater significance than their killing power. The fragility of the bronze shield-covers from the rivers Witham in Lincolnshire, England (FIG. 62), and the Thames at Battersea suggest they could never have been used and that they were deliberately placed in the water as offerings to the gods, as were so many items of war-gear in late European prehistory. It is unlikely that these were chance losses. Rather, such finds should be interpreted as the precious possessions of the Celtic elite, whose prestigious arms were fit and proper gifts to the supernatural powers.

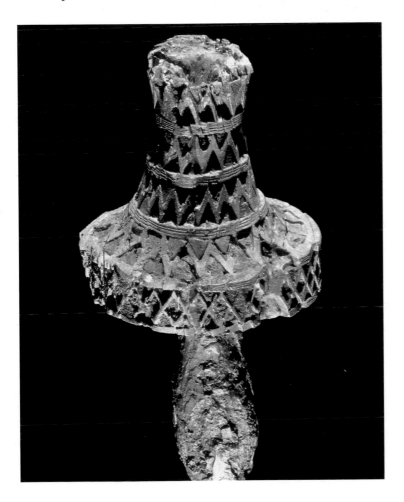

Above
60. Sword with enamel decoration from Kirkburn in Yorkshire, England, 3rd century BC. Iron with bronze plate and red enamel inlay, length 27½" (69.7 cm). British Museum, London.

The cutting edge of the sword was hardened by a process known as carburisation, in which the iron blade was heated in a bed of charcoal so that carbon was absorbed into the surface, forming a thin skin of steel.

Left
61. Sword with decorative pommel from a grave at Hallstatt, Austria, 7th century BC. Iron decorated with amber and ivory, width of pommel 3¾" (9.5 cm). Naturhistorisches Museum, Vienna.

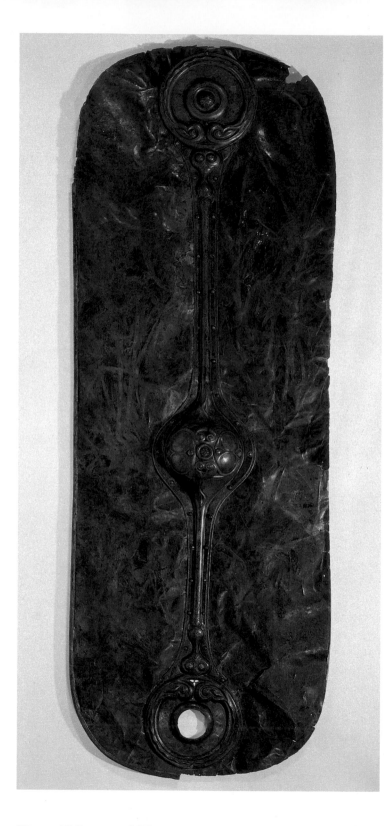

62. Shield-cover found in the River Witham in Lincolnshire, England. Bronze with coral inlay, length 44½″ (1.1 m). British Museum, London.

The end-roundels are decorated with animal heads, and originally the front of the shield-cover was decorated with the long, thin figure of a boar made out of sheet-bronze (the outline of which is still preserved by rivet-holes in the shield-cover).

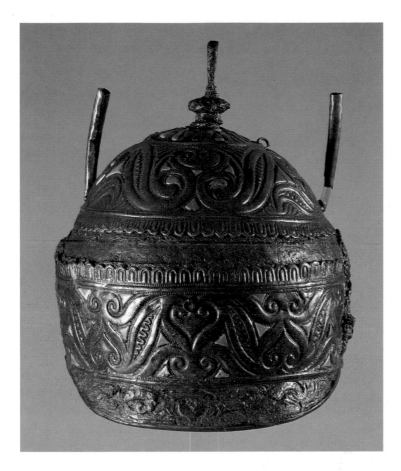

63. The Canosa Helmet from Canosa di Puglia, Bari, Italy, late 4th century BC. Iron overlaid with bronze, with coral inlay, height 10" (25 cm). Preussischer Staatliche Museen, Berlin.

The helmet is ornamented with Celtic-style leaf motifs, from which peep schematised human faces. From the style of the work, the artist may well have come from the Marne region of eastern France.

Celtic war-equipment was usually made of iron or bronze, but the element of display is represented in the embellishment with rare, expensive, or exotic materials. Gold and Mediterranean coral decorated helmets such as that from a grave in Canosa, Puglia (FIG. 63). The form of the dead man's weapons suggest that he may have been an Italian, but his helmet is of an Italo-Celtic design. More than 200 pieces of Baltic amber were set in a geometric design on the African ivory pommel on a long iron sword found in a cremation grave at Hallstatt in Austria. The presence of this amber and ivory implies important trading networks over wide areas. The status element of weaponry may also be demonstrated by its appearance in graves. The custom of burying warrior chiefs with their weapons was linked with funerary display, with rites of passage, and the need for the warrior's rank to be clear as he transferred between worlds. It may also be that a soldier's war-gear was personal to him alone and was not generally re-used by others, perhaps because it contained a symbolism which protected only him with supernatural power. We are reminded of

64. Boar's head war-trumpet mouth from Deskford, Grampian, in Scotland, 1st century AD. Bronze, length 8¹/₂″ (21.5 cm). National Museums of Scotland, Edinburgh.

When found during peat-cutting in 1874, the open mouth contained a movable wooden tongue on springs. Recent excavation of the findspot has revealed the presence of a defended Iron Age settlement; the trumpet had been placed, probably as a deliberate votive deposit, in a marsh surrounded by wooded scrubland. Recent reconstruction of the entire instrument by the National Museums of Scotland demonstrated that the trumpet could have made a variety of sounds, including a fearsome roar, grunts, and pig-like squeals.

King Arthur's sword Excalibur, which was given to him by the supernatural and had to be returned to the spirit-world on his death. Bedevere's act in casting Excalibur into the lake is exactly comparable to the water-finds of weapons in the archaeological record.

The use of weapons to mark status is shown by their presence in tombs of people who were probably not combatants. This may be the case in the burial of a man at München-Obermenzing in Bavaria, Germany, who was laid in his grave in about 200 BC, accompanied by a sword, spear and shield. That he was a physician rather than primarily a soldier is indicated by the trepanning saw (used for removing small sections of bone from the skull to relieve pressure on the brain), probe, and retractor that were also found in the grave. This individual may have been an army doctor who treated the wounded after battle. It is perhaps unlikely that a surgeon would have engaged in combat, and more likely that he was an honorary warrior and his weapons were given to him as a mark of respect.

Some of the motifs which occur on war-gear – such as images of boars (FIG. 64) and wolves – are directly associated with ferocity and aggression, and their choice as decorative themes may well indicate symbolic potency. But others are more enigmatic, and we can often only speculate as to whether the themes decorating a shield or a scabbard had any relevance to war. It is possible that subtle but complex messages were frequently conveyed in symbolic,

visual form, messages that may have been associated both with communication between groups of humans and between the war-hero and his gods. Many of the motifs on scabbards and shields may have been linked with the efficacy of the equipment and its endowment with enhanced powers: their purpose may have been to give a sword or shield magical properties, to increase the capacity of the former for destruction and the latter's ability to deflect blows.

Swords, Spears, and Trumpets

The Celtic iron sword represents the pinnacle of the blacksmith's skill. Swords were difficult to make and the hard steel cutting edge produced by carburisation reflects considerable technical expertise. Such highly prized weapons were very personal possessions. The swordsmith's craft is well illustrated by the 3rd-century BC sword recently found at Kirkburn in northern England: the weapon was skilfully crafted from more than seventy components, and it was decorated from hilt to tip with scarlet enamel (see FIG. 60). The iron scabbard had a bronze plate with an elaborate chased pattern, and the weapon had been carefully repaired in antiquity. Many Celtic swords were long, designed for slashing rather than for thrusting at close quarters, and they were worn high up on the body, slung from shoulder-rings rather than from a waist-belt. The blade itself was usually plain, but the hilt and scabbard offered ample scope for decorative art. Scabbards were often made of bronze, formed of two plates, one fitting over the other and joined at the bottom by a chape, which itself could be elaborately ornamented. Early scabbards were adorned with relatively simple designs, the decoration sometimes appearing to copy stitching patterns on leather sheaths.

The ornamentation of scabbards presents a wide variety of motifs and patterns, some of them very abstract in form, others quasi-representational. There are few motifs which can be described as narrative art. But one scabbard, from the great cemetery at Hallstatt, breaks the conventions. The tomb contained the remains of a warrior who died in about 400 BC. The dead man was laid on a stone platform with his iron helmet, a knife, a set of throwing spears and a bronze-wire strainer, perhaps for wine. His sword was slung high up on his right side; it was decorated with coral but more important is the engraving on the scabbard (FIG. 65). A narrative scene is presented, which is unique in Celtic sword-art: two pairs of men stand facing each other, holding between them a large spoked wheel; in between the two pairs is a row of

four horsemen wearing round helmets and carrying spears (one knight thrusts his lance into the body of a fallen enemy) and three foot-soldiers with spears and shields. The weapons and the clothes (tunics, trousers, and shoes with upturned toes) are Celtic in style. Indeed, the shoes bear a striking resemblance to those worn by the chieftain buried at Hochdorf. The tip of the scabbard depicts two unarmed wrestling opponents. The question is what is represented here? It could record a real event, a particular battle, but it could equally depict a mythical scene.

Most scabbards bear artistic designs which are far less straightforward to interpret but which, nonetheless, may have possessed an important symbolism for their owners. Such symbolism could have been quite general: a statement of status, identity within a community, or battle prowess. But others may have had a religious function, perhaps apotropaic (magically protective). Many motifs, which are discussed in more detail in the next chapter, are vegetational in origin, owing inspiration to plant forms such as tendrils, palmettes, or lotus flowers. But the naturalistic plant forms are often transformed into pure design and are all but subsumed by the derivative pattern. However, amid the mass of meandering scrolls and tendrils which adorn many scabbards,

65. Detail of a sword scabbard with engraved military scene from a grave at Hallstatt, Austria, early 4th century BC. Iron and bronze, with coral studs, length just under 27″ (68 cm). Naturhistorisches Museum, Vienna.

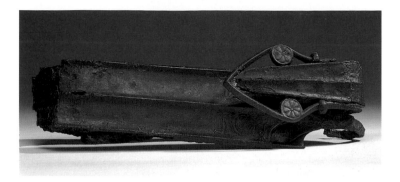

one specific "vegetal" form may be identified as having, perhaps, a special significance. This is the so-called "Tree of Life" form, found on the Korisios sword from Port, near Berne in Switzerland (see FIG. 18), and on a 5th-century BC engraved scabbard from Bouy in the Marne, France; the motif may have been adapted from Oriental prototypes. Whether or not a particular "Tree of Life" is intended, there is no doubt that trees had a symbolic meaning for the Celts, being associated with longevity and rebirth. Both ideas would be appropriate images for a warrior facing victory or death.

Animal-decoration on swords may have conveyed symbolic messages. Perhaps the most interesting animal motifs on sword-scabbards are the so-called "dragon pairs," which appear over a wide area during the 3rd century BC, including Romania, eastern France, and southern England. The motif may have developed in Hungary, but it spread rapidly, and far-flung regions have produced scabbards with dragon pairs so similar that they may have been made in the same workshop. This striking similarity has led scholars to call the dragon pairs an "inter-Celtic currency." The dragon-pair motif consists of two opposed creatures with open jaws, vaguely reptilian in form but belonging to the realm of the artist's imagination rather than that of earth (FIG. 66).

Alongside plant and animal images on scabbards appear human heads or, very occasionally, entire human representations. Sometimes human, animal, and plant forms occur in association: a late 4th-century BC grave at Santa Paolina di Filottrano, near Ancona, Italy, contained an elaborately decorated scabbard-plate with stylised human faces peering from foliage. On weapons of a later date, human motifs appear increasingly as sword decoration: anthropomorphic sword-hilts occurred in the 2nd and 1st centuries BC, for instance at Ballyshannon Bay in Donegal, Ireland, and at Tesson, in the Charente, France (FIG. 67).

The plants and animals which appear as ornamental motifs on

Left and above
66. Two scabbards with "dragon-pair" motifs, (that on the left found at Kosd, Hungary, and that above from Hammersmith, London), both 3rd century BC. Iron, length (Kosd) 28$^{1}/_{3}$" (72 cm); (London) 27$^{1}/_{2}$" (70.1 cm). Magyar Nemzeti Múzeum, Budapest, and British Museum

This idiosyncratic double-animal motif is confined to swords. The symbolism of the dragon pairs is enigmatic, but their presence only on weapons must in some way be significant. We may be looking at some kind of heraldic insignia, a mark of rank, membership of an arcane group, or a religious symbol.

scabbards may possess a mythical or talismanic symbolism and one might, perhaps, turn to later Celtic religious imagery or myth for explanations. Birds, deer, bulls, and other creatures all possessed symbolic meaning for the Celts of Roman and later periods, as did the human head. The anthropomorphic representations are interesting partly because they are comparatively rare in prehistoric Celtic art. The sword-hilt men may depict deities or the owners of the weapons. They may equally represent the essence of "maleness," which itself may have been perceived as endowing the weapon with magical powers.

Spears – either throwing-spears (javelins) or thrusting-spears (lances) – were the other main weapons of the Celtic warrior. Diodorus Siculus describes the formidable nature of some of these spears, which were notched or barbed, capable of inflicting horrific wounds. In early Irish mythology, the Ulster hero Cú Chulainn had a special spear, the Gae Bulga, given to him by a god, which was jagged-edged and from the wound of which no one could ever recover. The only part of a spear which gen-

67. Dagger with anthropomorphic handle from Tesson, France, 1st century BC. Iron, length 20″ (51 cm). Musée des Antiquités Nationales, Saint-Germain-en-Laye, Paris.

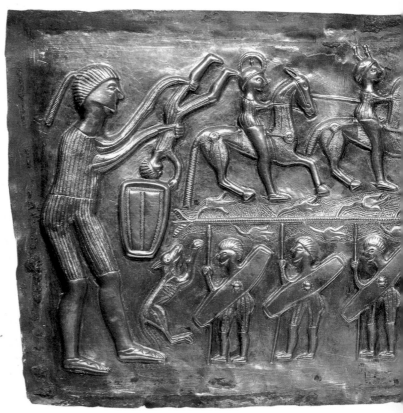

erally survives in the archaeological record is the iron head. Comparatively few spears bear decoration, but a 4th-century BC example from Hungary has an engraved foliate pattern very similar to that on a gold torc from Waldalgesheim in Germany. More spectacular is the 1st-century BC iron spear-head from the River Thames in London (FIG. 68), which was ornamented with four bronze sheets in cut-out shapes, one riveted to each spear-lobe, back and front. Each of the shapes is subtly different from its fellows, as are the patterns which adorn them: these take the form of scroll designs, the smooth surface of the metal offset with areas of cross-hatched engraving.

War-trumpets are not weapons in the strict sense, but the Celts employed them on the battlefield to confuse and terrify their enemies with their dreadful noise. They consisted of long tubes of bronze with the mouth in the form of a snarling boar's head or, more rarely, that of a wolf. Depictions of such trumpets can be seen on the great silver cauldron from Gundestrup in Denmark (FIG. 69), and the bronze boar-head mouth of one, found in Britain,

Above
68. Spear with decorative plates, found in the River Thames, London, late 1st century BC. Iron, with cut-away bronze overlay, length 12" (30.2 cm). British Museum, London.

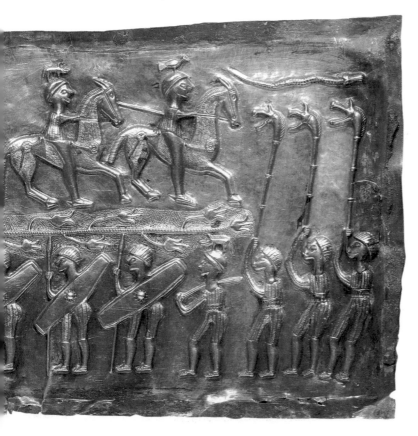

Left
69. Detail of a plate from the Gundestrup Cauldron showing trumpet players, 1st century BC. Silver, 7³/₄ x 16" (20 x 40 cm). National Museum of Denmark, Copenhagen.

Talismans of War 99

at Deskford in Scotland, has linear decoration round the eyes (see FIG. 64). This trumpet was made in the mid or late 1st century BC, and it is tempting to link its presence in the far north with the great battle between the Romans and the Caledonian Celts at Mons Graupius (probably in the vicinity of Inverness) in AD 84, the battle which effectively ended Celtic freedom in Britain.

Defensive Armour

Body armour is rare: a few pieces of chain-mail have been found and, very occasionally, we have evidence that such armour was decorated; a bronze rosette which once adorned a mail-shirt from Çiumeşti in northwest Romania is ornamented with triskeles. This motif was an important religious symbol for the Celts: the triskele seems to have been a good-luck, possibly solar, symbol which incorporated the sacred number three.

70. The Agris Helmet from Agris, France, 4th century BC. Iron with gilt-bronze overlay, decorated with gold, silver, and coral, height (without cheek-piece) 8¹/₂″ (21.4 cm). Musée Municipal, Angoulême.

The horns of the helmet were made separately and riveted on. At the sides of the helmet are rings for pennants or cheek-pieces.

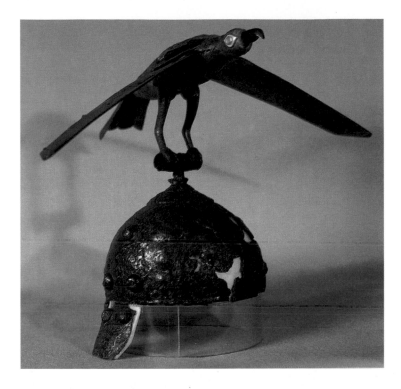

71. Raven-crested helmet from Çiumeşti, Romania, 3rd century BC. Iron, with bronze crest, height 10" (25 cm). Muzeul National de Istorie al Romaniei, Bucharest.

Helmets were the only common items of defensive equipment worn by Celtic soldiers:

> On their heads they wear bronze helmets which possess projecting figures lending the appearance of enormous stature to the wearer. In some cases, horns form one piece with the helmet while in other cases it is the relief figures or the fore-parts of birds or quadrupeds.

Diodorus Siculus, *Library of History*

Helmets were of plain leather, bronze, or iron; either pointed or rounded in shape, with cheek-pieces and sometimes a neck-guard. A few finds show that helmets could be more splendid affairs, offering considerable scope for Celtic artistry. A helmet from France, of the fourth century BC, demonstrates this well: it comes from Agris in the Charente (FIG. 70) and consists of iron covered in a gilt-bronze overlay, decorated with intricate patterns and with minute animal-heads on the cheek-pieces. Other helmets also possess animal-decoration on their cheek-pieces. Two from Slovenia, at Šmarjeta and Mihovo, bear images of cranes.

Two helmets in particular bear out the testimony of Diodorus just quoted. From Çiumeşti in Romania comes an iron hel-

met of the 3rd or 2nd century BC, which is surmounted by a spectacular crest in the form of a bronze raven, with red-enamelled eyes and articulated wings that would have flapped up and down in an unnerving manner when its wearer charged towards the enemy (FIG. 71). A bronze helmet of the 1st century BC (FIG. 72), recovered from the River Thames at Waterloo Bridge, London, and decorated with enamel inlay and a meandering asymmetrical pattern, has short conical horns flaring from the crown. It may have been for ceremonial rather than practical use. Helmets decorated with horns, boar, and bird images are depicted on the Gundestrup Cauldron and on Celtic coins. Small figurines of boars from such sites as Hounslow near London and Luncani in Romania may originally have been helmet-crests.

It seems clear that much of the decoration on helmets may contain specific symbolism, which may be designed as talismanic or to enhance aggression. It is especially interesting that the evidence for helmet-crests is present both in the literature and the archaeology. For the Celts, horns represented ferocity and virility; boars were emblems of indomitability and aggression. The Çiumeşti raven was a symbol of battle and death and in early Irish myths the raven-goddesses were harbingers of doom and creators of havoc on the battlefield. On the other hand, the triskeles on a helmet from Amfreville, in the Eure, France, may have protected the wearer from the appalling head injuries which would have been sustained from a slashing iron sword.

Apart from helmets, the Celts relied almost exclusively on shields to protect their bodies in battle. Most shields were made

72. Horned helmet found near Waterloo Bridge on the River Thames in London,
1st century BC. Bronze, width (between tips of horns) 16³/4″ (42.5 cm). British Museum, London.

of organic materials – leather or wood – and thus have not usually survived. But occasionally waterlogged conditions have preserved these perishable shields and this evidence, together with iconography and the occurrence of model metal shields, gives us some idea of their size and shape. In addition, we have rare British finds of sheet-bronze coverings for shields which, again, serve to demonstrate their overall form. From all this evidence, we know that many Celtic shields were long and sub-oval (rectangular with rounded corners), covering most of the body, with the main decorative features, as far as we can tell, being largely confined to the metal boss which projected from the centre of the shield and behind which was the shield-grip or handle. But a recent find from western Britain may contradict some assumptions about Celtic shields. In July 1988 a group of twenty-two miniature bronze shields (FIG. 73), apparently from a single collection, came to the notice of the British Museum. The finds, almost certainly (and possibly illegally) discovered with a metal-detector, appear to form part of an enormous collection of antiquities which are mainly of Bronze Age date but include model Iron Age cauldrons and the shields. There is little clue as to provenance, but the material may have come from the area around Salisbury in Wiltshire. The form of the shields and their decoration may throw light on the original appearance of some full-size ones: they are mostly hide-shaped, with bowed sides, concave ends, and projecting corners, and five of them are decorated over much of their surface. The motifs include triskeles and birds'

73. Miniature bronze shields, four of a cache of twenty-two, unprovenanced but probably from the Salisbury area of England, 2nd-1st century BC. Bronze, length of longest 3½" (8.7 cm). British Museum, London.

heads, fish-shapes and "yin-yang" circles (in which a circle is divided into two halves by a spiral or S-shaped line). We may deduce from these models that some real wooden shields may have been covered with ornamental patterns.

Four normal-size shields, all found in British rivers, serve to illustrate the general forms of the Celtic shield: the three from the Thames in London and one from the Witham in Lincolnshire; all probably date to the 2nd or 1st century BC. Of these only the central bosses of two (from Wandsworth, London) survive, and both were decorated with repoussé work: one is round, with a running design of tendrils and lobe-shaped leaves which meander around the surface, but incorporated within this foliate pattern are two birds' heads, which themselves look almost like leaves (see FIG. 20).

The shields from the Witham and from Battersea are unique in that, in each instance, a bronze covering for the entire shield has been recovered. The practice of facing shields with metal may have been confined to Britain, for examples have only been found in British rivers. The Witham shield (see FIG. 62) has a spindle-shaped boss, with a projecting central roundel bearing high-relief repoussé ornament, enhanced by red enamel, and joined by a long thin spine to two end-roundels. The most important features of the decoration are the fantastic animal heads, with feathery ears, close-set eyes, and long snout which form the connections between the roundels and, even more interesting, the shadowy outline of a boar with a thin, sinuous body, long thin legs, and an elaborate snout, which had evidently been applied as a sheet-bronze cut-out, whose rivet-holes can still be seen. The shield-cover itself was formed of two thin plates joined at the midrib, and must have been originally mounted on a wooden or leather back-board. It was far too flimsy ever to have been used in combat, but the boar motif is an aggressive emblem which is entirely fitting for a piece of armour. It was probably a ceremonial shield, perhaps carried by a tribal chief in a victory parade and then consigned to the spirit-world.

The bronze shield-cover found in the Thames near Battersea (FIG. 74 and see FIG. 1) has been described as the "noblest creation of Late [1st-century BC] Celtic Art." The Battersea Shield consists of several pieces of bronze which together formed the facing for a shield made of organic materials. The artist responsible for the decoration was a highly skilled bronzesmith who must have worked in Britain since, like the makers of the other shields, the artist chose a specifically British form of circular central boss and used a high-relief repoussé technique which

74. Detail from the Battersea Shield (see FIG. 1) showing swastika motifs. Found in the River Thames at Battersea in London, 2nd-1st century BC. Bronze with enamel inlay. British Museum, London.

was favoured by British but not Continental bronzeworkers. The ornament closely resembles that of the shield from the Witham, in the presence of two terminal panels linked to the great central roundel by fantastic animal heads, which this time have spreading antler-like projections above small ears. Some scholars have instead seen these as reversible human faces, with a headdress or moustache depending on which way up they are viewed. One dominant feature is the recurrent swastika motif which appears on small roundels filled with red enamel. The swastika, like the triskele, was associated not only with good fortune but also with solar energy.

The shields described are objects of great beauty and skilled work, and they undoubtedly contain symbolic messages in their decorative motifs. The swastikas, animal heads, and possible human faces may all have possessed profound significance, which may have been linked to the secular world of the warrior or to the supernatural. They were fitting gifts to the gods.

The Art of the Horseman

The early Hallstatt Iron Age saw the development of a warrior-aristocracy which was closely associated with horse-riding. By the 5th-4th centuries BC light, two-wheeled chariots were being used (FIG. 75), partly as marks of status but also in battle, where they were employed to ferry warriors speedily to and from the enemy lines. High-ranking individuals were interred with their chariots, for instance in the Marne region of France and in Yorkshire in north-east Britain. In the mid-1st century BC Julius Caesar wrote in his Gallic Wars that, while chariot warfare had become obsolete in Gaul by this time, it was still an important element in British combat. Gallic horsemen were renowned in the Roman world and units of Celtic cavalry were recruited into the Roman army as early as Caesar's time. The last recorded use of chariots in Britain was during the campaigns of the Emperor Severus against the Caledonians of northern Scotland in AD 207. In Ireland, how-

75. Reconstruction of a Celtic chariot, based on finds from Llyn Cerrig Bach on Anglesey, Wales, 1st century BC or AD. National Museum of Wales, Cardiff.

These light, fast vehicles were made of timber and wicker, with iron tyres on the wheels. They were pulled by two horses or ponies, and generally carried the warrior and charioteer.

ever, there is evidence for a much longer tradition both of riding and of chariot-driving; descriptions in early Irish myths suggest that chariots were still used in early medieval times, from about AD 700 to 1200.

There is no doubt that horse-gear and chariots were used as media for display and symbolism in just the same manner as weapons and shields. This is demonstrated both by their inclusion in graves and by the decoration on harness and chariot-fittings. That the chariot was a status symbol is shown by its presence in graves without weapons: this occurred at the King's Barrow in Yorkshire, England, where not only the chariot but also the horse-team was buried in the tomb. A woman's grave at Wetwang in the same region and another at Waldalgesheim in Germany both contained chariots but no weapons. There is some, though sparse, evidence for Celtic female warriors: it is more likely that these were the graves of high-ranking women for whom the chariot represented prestige and authority. The Wal-

dalgesheim tomb is interesting because the chariot fittings are decorated with images of janiform (double) faces, birds, and cross-legged humans which, on close inspection, appear to depict females, in keeping with the gender of the dead person. It may be, therefore, that these images are portrayals of the princess herself.

Lynch-pins and other chariot fittings often bear images of humans or animals, albeit usually in highly schematic form. But a 1st-century BC lynch-pin from the stronghold of Stradoniče in Bohemia, from the axle of a chariot, bears a cast bronze head which betrays a new realism in the way the features, wavy hair, and moustache are depicted. Again, it is possible that the warrior-owner of the vehicle is represented here, as with anthropomorphic dagger-hilts (see FIG. 67).

Animal symbolism also occurs on chariot fittings: the image of an owl, with cruel jutting beak and staring eyes, decorates a lynch-pin from Manching in Bavaria, Germany, made in about 100 BC. From a hillfort at Bulbury in Dorset, England, comes a pair of chariot-mounts in the form of straddle-legged bulls, with decoratively curved-up tails. In the 1st century BC a bronzesmith fashioned a tiny mask, probably meant as a chariot ornament, at the Brigantian tribal stronghold of Stanwick in Yorkshire, England (FIG. 76): the image on the mask is that of a deceptively simple horse's head, in which the features are depicted by means of abstract trumpet-scrolls and a pair of eyes. The Stanwick Mask (as it is known) is a masterpiece of Celtic minimalism in art.

Horse-bits, terrets (rein-rings; FIG. 77), and *phalerae* (circular harness ornaments) all provided scope for art. Celtic horse-bits were of two main types, with either two or three links joining the side-rings. Some horse-gear was lavishly decorated with enamel. Late in the Iron Age British smiths produced superb harness fittings ornamented with flowing designs in bright bronze, offset by patches of brilliant red enamelling. Santon Downham in East Anglia and the Polden Hills in Somerset are two major findspots of such material: a hoard from the latter region produced terrets with matching decorated horse-bits. Such bridle-bits have been found in pairs, in Yorkshire chariot-graves, but some of the finest decoration occurs on examples from Ireland, for instance from Attymon in Co. Galway, where a matching pair of bits was found bearing a design of scrolls and spirals (FIG. 78). Significantly, these and other horse-gear had been deliberately placed, presumably as a ritual act, more than twenty-three feet (7 m) deep in a bog. The fact that so

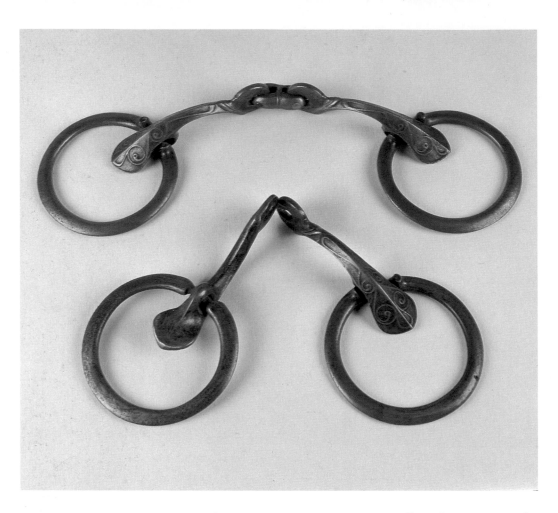

78. Pair of matching decorated horse-bits from Attymon, Co. Galway, Ireland, 1st-2nd century AD. Bronze, width of end rings 1″ (2.4 cm). National Museum of Ireland, Dublin.

many bits occur in pairs appears to reflect the presence of a chariot-team rather than a ridden war-horse.

Phalerae were often ornamented: one found at Horovicky in Bohemia (FIG. 79), made in the 5th century BC, bears images of human heads adorned with mistletoe-leaf crowns. Leaf-crowned heads are not uncommon in Celtic art, but the choice of mistletoe may be significant since, according to the Roman writer Pliny, mistletoe was sacred to the Celts as a remedy for infertility, as is discussed in more detail in chapter four. The strikingly ornamented bronze plaque from a ritual deposit at Llyn Cerrig Bach on Anglesey is probably a chariot fitting. The plaque (see FIG. 39) is crescent-shaped, made of sheet-bronze, and decorated in repoussé with a whirling triskele whose arms end in birds' heads. It comes from a hoard of 170 pieces of high-status metalwork which, together with other material, was deliberately thrown into the lake at Llyn Cerrig Bach. The metal objects, most of which are

made of iron, are of various dates between the 2nd century BC and 1st century AD, but they all appear to have been cast into the water in a single act of piety in the mid-1st century AD.

Finally, the horses or ponies that drew these chariots or were ridden into battle had their own forms of ornamental regalia. A unique find from a peat bog at Torrs in Dumfries and Galloway, Scotland, consists of a decorated bronze pony-cap with two horns (FIG. 80). Although the horns and cap were long thought to be part of a single *chamfrein* (head-armour for a war-horse), this is not in fact the case, although they may be contemporaneous. The head-piece was for a pony and has two ear-holes and a central perforation perhaps for a plume. It was made from two sheets of bronze, decorated with symmetrical repoussé designs. Three engraved repair-patches disguise cracks in the sheet-metal. The patterns on the cap, which include birds' heads, have similarities to those on the Witham Shield, as does the horn ornament,

79. *Phalera* (circular harness-decoration) depicting seven leaf-crowned heads, found at Horovicky, Rakovnik, Bohemia, 5th century BC. Bronze, diameter 4³/₄" (12 cm). Národní Muzeum, Prague.

The whole of the circular *phalera* is reproduced on page 87.

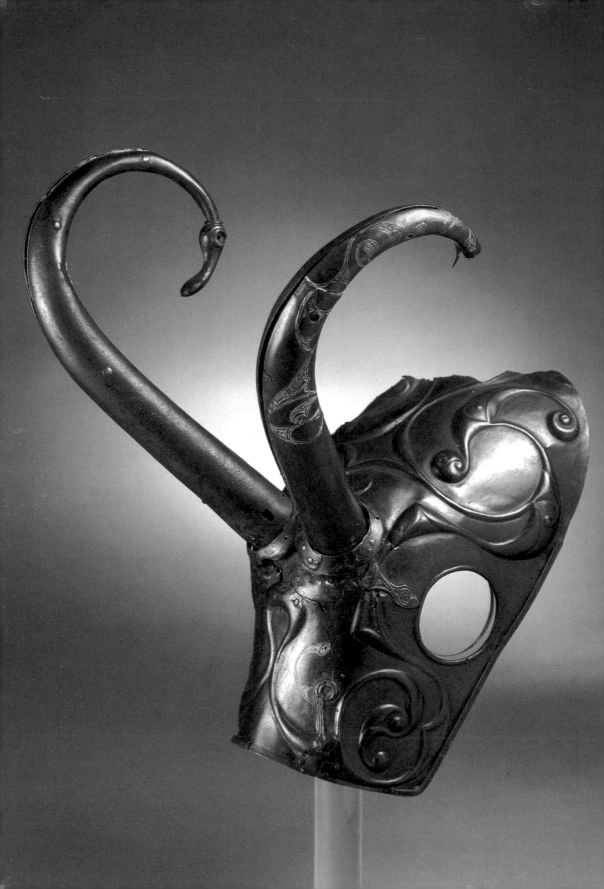

which incorporates bird-head motifs and a tiny human face, not normally visible because of its size and position: each horn once terminated in a bird's head, but only one survives. The horns may originally have been part of a helmet, yoke-terminals from a chariot, or drinking-horn mounts. The cap itself was probably a ceremonial piece rather than horse-armour for battle-wear.

The Significance of Decorated Military Equipment

Certain features of military art hold the key to its significance. The context in which these objects were discovered is important: many swords, shields, helmets, and items of horse-gear come from graves and from ritual deposits, such as rivers or bogs. Additionally, the decoration itself, though often enigmatic, sometimes opens a window on what was surely a complex symbolic system. Triskeles, swastikas, lotus flowers, animals, human heads, and other motifs may have been conveyors of symbolic messages, associated with identity within a community, protection, good luck, potency, or simply reflect a recognition of omnipresent supernatural power that required acknowledgement in exchange for success in warfare.

By contrast, there is very little evidence for the continuation of decorated armour and weapons into the early Christian Celtic period. But reliquaries (see chapter five) were carried into battle, like standards. The Cathach of Columba records this practice.

80. Pony-cap and horns from Torrs Farm, Kelton, Scotland, 2nd century BC. Bronze, length of horns 10″ (25 cm). National Museums of Scotland, Edinburgh.

The horns have been wrongly attributed to the cap, and were probably originally parts of drinking horns. The cap itself is a parade piece, and the holes to which the horns are now attached were possibly designed for plumes. The two visible openings were probably for the pony's ears.

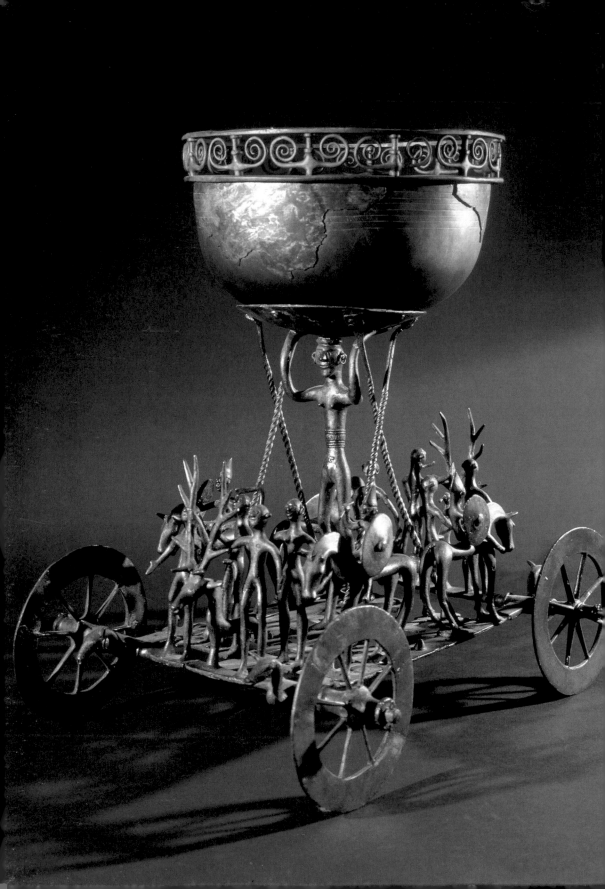

FOUR

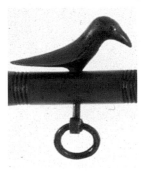

Nature in Art: Abstraction, Realism, and Fantasy

81. Cult wagon depicting a goddess and stag hunt, from a chieftain's grave at Strettweg, Austria, 7th century BC. Bronze, height of goddess 9″ (22.6 cm). Steirmärkisches Landesmuseum, Graz.

The presence of a goddess (interpreted as such because of her relative size) with a vessel, warriors or hunters, and stags suggests that a ritual stag hunt is represented.

In conversation they use few words and speak in riddles, for the most part hinting at things and leaving a great deal to be understood.

Diodorus Siculus, *Library of History*

Like people in most rural, pre-industrial societies, the Celts enjoyed a close, symbiotic relationship with the natural world. It is therefore no surprise that artists drew a great deal of inspiration from what was to them, perhaps, a sacred landscape. But although it was the local countryside and its inhabitants that inspired so many motifs, Celtic artists drew also on exotic and mythic images: sphinxes, griffons, leopards, and elephants appear alongside boars, wolves, deer, horses, and cattle; Classical vines, acanthus plants, and Oriental lotus-flowers join the trees and foliage of temperate Europe to form an exotic garden of motifs.

A striking feature of pre-Roman Celtic art is its avoidance of narrative, representational themes. Human images are rare, although the head is a recurrent symbol. It has already been suggested that this apparently deliberate shunning of anthropomorphic depiction, which amounts almost to iconoclasm, may have been for religious motives. Where humans are represented in Celtic art, the faces are often mask-like and the bodies stiff, as if to present archetypes rather than individuals; the janiform (double-headed) or triadic (triple-headed) depiction of the head, once again, must reflect something supranormal.

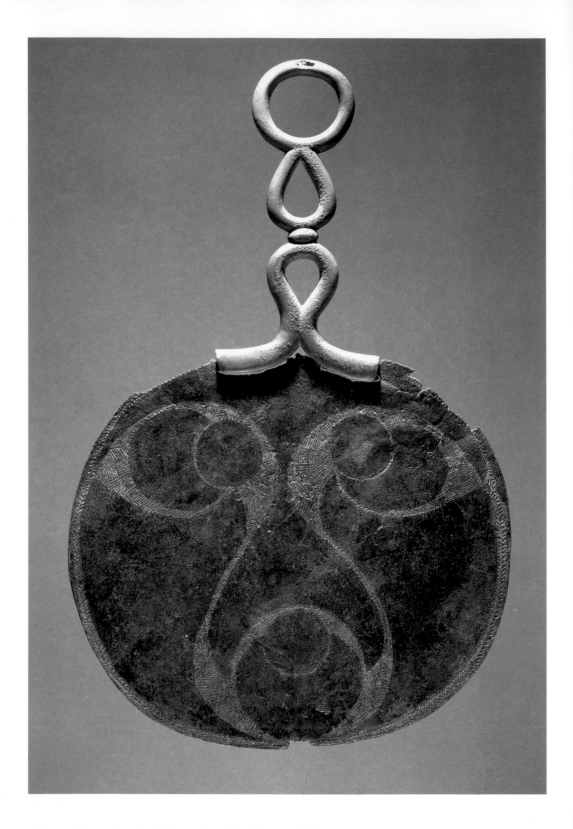

The absence of naturalistic representation which is noticeable in the images of humans can also be seen in portrayals of animals and plants. Beasts are frequently depicted as monsters of fantasy; realism is nearly always subjugated to schematism, exaggeration, distortion, and semi-abstraction. The same is true of plant motifs, which may ultimately derive from leaves, tendrils, and flowers, but which often become restless, abstract curvilinear patterns which meander across the surface of a mirror, scabbard, or stone in complex weaving designs, or turn into whirling triskeles and spirals. Time and again, whether human faces, animals, or plants are depicted, realism is displaced by abstraction, pattern, and form. Energy, tension, asymmetry, and opposition all play their part in enhancing the potency of the designs.

One of the most exciting aspects of the interplay between representation and abstraction is ambiguity, in terms of what the spectator sees. This may be described as an art of paradox, double meaning, and visual punning. An abstract curling pattern may, if looked at in a certain way, resolve itself into a leering human face (FIG. 82); a female face may, if turned upside-down, become a male head; a lobed triskele may turn itself into three birds' heads. Human faces peer out from a mass of foliage, seeming to appear and disappear, like Lewis Carroll's Cheshire Cat.

We need to ask what is being expressed by this art. In my opinion, it is highly symbolic, maybe deliberately enigmatic and arcane, readable – perhaps – by only a few. It may be a profoundly religious art and, if it is, we cannot hope to penetrate its meaning absolutely. The frequent presence of animals may – on comparison with other animistic systems (such as that of the Iban in modern Borneo) – reflect the perception of such creatures as mediators between the human and spirit-worlds. They may be "spirit-animals," communicators and links between earth and the Otherworld. The human faces may represent gods, spiritual leaders, amuletic masks, or symbols of power. The ambiguity of images could reflect liminality, that is, boundaries and links between worlds. The so-called abstract designs may be full of meaning and may represent a reality that is relevant to a different plane of consciousness or being.

The elaborate use of pattern, form, texture, and tension may lead one to speculate as to whether some artists were perhaps synaesthetes, people whose five senses were not entirely separate but, to an extent, merged. The apparently random curves, whirligigs, and patterns could represent not only physical shapes but also, perhaps, music, dance, or thought-patterns, and it could be conjectured that some Celtic artists may have used halluci-

82. Mirror showing pseudo-faces, from Aston, Hertfordshire, England, late 1st century BC. Bronze, diameter 7⅝" (19.4 cm). British Museum, London.

At first glance the design appears abstract, but it is possible to discern birds' heads and a human face. The images dissolve and re-form before the eyes.

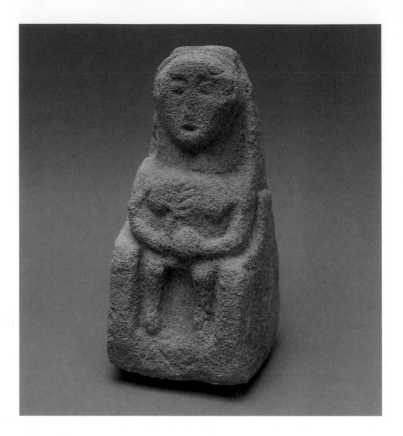

83. Mother-goddess, found deep in a well near a temple at Caerwent, South Wales, 2nd century AD. Stone, 10½ x 5 x 4¾" (27 x 13 x 12.5 cm). Newport Museum, Gwent.

natory drugs in order to enhance their imaginative perception: cannabis was found in the Hochdorf tomb, and other mind-altering substances have been discovered in some Iron Age bog-bodies. In any case, most of this enigmatic art is locked within its own context: we can only attempt to guess its meaning. Of course, we must not ignore the possibility that some abstract designs or animal images were chosen primarily as decorative motifs: it is as dangerous to see profound meaning in every pattern as it is to under-interpret it.

The material from which one can examine symbolism in Celtic art mostly dates from the pre-literate, literally "prehistoric" period. But it is necessary to remember that Celtic art did not die with the Roman occupation, even though Classical realistic imagery became a much more dominant tradition in Romano-Celtic Europe. Celtic ways of expression can still be found in the Roman period, in the form of exaggeratedly large heads (FIG. 83), schematic bodies, triadic images, and semi-zoomorphic monsters. And in the early Christian period, Celtic art forms fully re-established themselves in a renaissance of complex, glowing patterns and symbols.

From Tendril to Triskele

During the 5th and particularly the 4th centuries BC, there evolved a form of Celtic art which took as its inspiration vegetal motifs from the Mediterranean and Oriental worlds. These included the acanthus, the lotus leaf, bud, and blossom, the vine, and the palmette. Objects decorated with these designs were probably imported into the Celtic world, for example as vessels for the transport or consumption of wine. The palmette is particularly important: it is an Etruscan design, based ultimately upon the Oriental Tree of Life, and consists of a central stem with a number of joined lobes which form a stylised tree or fan-shape. Some artists used these vegetal images in such a way as to retain their essential plant form, but sometimes tendrils, leaves, and flowers are transformed into what appear to us as abstract designs, composed of swirling curvilinear patterns, trumpets, spirals, lyre motifs (formed of opposed double S-shapes), commas, and triskeles. There is evidence that, on the one hand, Celtic artists selected and retained Classical foliate forms because they fitted into the Celtic symbolic framework, and on the other, that they deliberately changed Graeco-Roman motifs into native Celtic images that perhaps had particular meaning to them.

The apogée of Celtic foliate art was in the 4th century BC. This style of ornament is variously known as the Vegetal or Waldalgesheim style – the latter named after the famous female grave which contained precious metal objects decorated with running tendrils, scrolls, and foliage. It is worth examining the palmette and the lotus in some detail as there is evidence that they were deliberately selected by native Celtic artists and imbued by them with some kind of magical symbolism. These two motifs first appear on metalwork in the Central European princely tombs of the 5th century BC.

The palmette is a ubiquitous symbol in Celtic art: it may appear alone, as part of a running frieze, associated with lyre or lotus motifs, or accompanying images of human faces. The cheek-piece of the Agris helmet (FIG. 84) is decorated with palmettes. The 4th-century bronze flagons from Waldalgesheim, Reinheim, and Basse-Yutz are engraved with palmettes and lotus buds, and the palmette motif is repeated on ceramic vessels of the

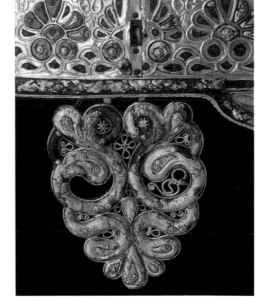

84. Detail of the cheek-piece of the Agris Helmet from Agris, France, 4th century BC (see FIG. 70, page 100). Iron with gilt-bronze overlay, decorated with gold, silver, and coral. Musée Municipal, Angoulême.

85. Pot with incised palmette design, from Saint Pol-de-Léon, Brittany, France, 4th century BC. Ceramic, height 10¼" (26 cm). Musée des Jacobins, Morlaix.

same date: an example is a pot from St.-Pol-de-Léon in Brittany (FIG. 85), which is ornamented with a double palmette associated with a swirling abstract pattern. That both palmette and lotus were symbolic is suggested by such images as the Pfalzfeld obelisk, where human heads have a trifoliate palmette beneath the chin and a lotus flower carved on the forehead (see FIG. 32). Palmettes associated with human faces had a wide spatial and temporal range in Celtic art. Such a link is seen all over the Celtic world, from Central Europe to Tal-y-Llyn in north Wales, where a bronze plaque generally dated to the 1st century AD was found, ornamented with conjoined human faces enclosed within palmettes.

That the palmette and lotus are such persistent motifs is highly significant, especially when associated with anthropomorphic images. The juxtaposition of images is so idiosyncratic as to suggest a symbolic meaning shared by artists over wide distances and over long periods. If we are right in interpreting

the palmette as being derived from a Tree of Life symbol, then its appearance in Celtic art may be associated with religious expression, perhaps linked to perceptions of fertility, rebirth, and eternity. It is worth remembering that trees were important symbols of regeneration and longevity in early Celtic art. The lotus, too, is often seen as a symbol of everlasting life and regeneration, because the bud takes the form of the blossom in perfect miniature.

Many designs are based upon meandering or running tendrils derived perhaps from vine-stems. Tendrils are very common and, indeed, gave rise to the convoluted curvilinear decoration of the abstract designs which belong to the later phases of Celtic art (see FIG. 20). Running tendrils, sometimes stamped on, decorate sword-scabbards.

Native Vegetal Symbolism

One of the most striking features of early Celtic art is the association between the human face and floreate designs. The gold armlet of the prince buried in the 5th century BC at Rodenbach in the Rhineland is decorated with a human face surmounted by what look like yew berries (FIG. 86). If they are yew berries, then religious symbolism may be present: the yew is an evergreen and may thus have represented eternity; in addition, the appearance of the bright pinkish-red fruit among the sober dark green of the foliage may have struck a chord in the heart of Celtic artists, who delighted in contrast, paradox, and opposites. That both

86. Detail of the armlet decorated with a human face crowned with yew-berries, from a chieftain's grave at Rodenbach, Germany, late 5th century BC (see FIG. 46, page 72). Gold, diameter 2²/₃″ (6.7 cm). Historisches Museum der Pfalz, Speyer.

wood and foliage are highly poisonous may also have added to the symbolism of death but, by contrast, the vibrancy of the red fruit may also have suggested blood, sacrifice, the promise of renewed life after the "death" of winter and the rebirth of the dead prince himself.

A recurrent symbol associated with the human face is the "comma-headdress" or leaf crown which repeatedly adorns male heads, both in stone and metalwork. We can see this on the bronze *phalera* at Hořovický, in Bohemia, decorated with seven heads wearing leaf crowns which droop down and enclose the faces (see FIG. 80); in the gilded bronze plaque from Weiskirchen; and the stone heads at Heidelberg and Pfalzfeld, all belonging to the 5th-4th centuries BC. The lid of a flagon from Reinheim bears a curious image of a horse with a human head wearing a leaf crown (FIG. 87). Such headdresses may be badges of rank, crowns displaying status or divinity, and in this context it is of considerable interest that some scholars interpret the leaves of these crowns as those of mistletoe, which indeed they closely resemble. Mistletoe had a particular symbolism for the Celts of Gaul, as chronicled by Pliny the Elder, whose *Natural History* contains a reference to a druidic ritual which involved cutting mistletoe from a sacred oak, accompanied by the sacrifice of two white bulls, on the sixth day of the new moon. Pliny describes this as a fertility ritual: when mixed into a potion, mistletoe was thought to be a powerful antidote to barrenness. It is easy to see why mistletoe should have acquired this kind of symbolism: it grows as a parasite on trees and flourishes in winter when its hosts are apparently lifeless; in addition, its white berries may have evoked milk. Finally, it may be significant that the sacrificial male victim, strangled and thrust into a bog at Lindow Moss in Cheshire, England, in the 1st century AD, was found to have mistletoe pollen in his stomach (FIG. 88).

The convoluted tendrils of early vegetal art became

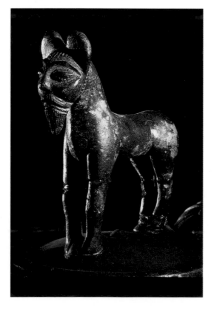

87. Flagon lid depicting human-headed horse, from Reinheim, Germany, mid-4th century BC. Gilded bronze, height of flagon 20¼" (51.4 cm); height of horse 2¼" (5.7 cm). Museum für Vor- und Frühgeschichte, Saarbrücken.

The body, preserved in the waterlogged marsh, was found by peat-cutters in August 1984, and was at first thought to be a modern murder victim. The body was that of a young, well-nourished man, whose trimmed moustache and manicured fingernails proclaim him to be of relatively high rank. Traces of body-paint were found on his skin. He had been subjected to what must have been a ritual killing: after a special meal of seeds and grains, he was given severe blows to the head (which fractured his skull), he was strangled, and his throat cut. His body, naked but for an armlet of fox-fur, was then taken into the bog and thrust face-down into a pool. Lindow man was a Celt; he may have been sacrificed at a time of great danger to the community, perhaps the threat of Roman invasion. Most Iron Age bog-bodies come from Danish peat bogs, but an example from Ireland is also known.

easily transformed into abstract curvilinear decoration, which can sometimes be resolved into recognisable symbols, whose significance may have been profound, but perhaps secret. A good example is the triskele, a three-armed whirligig which has a wide chronological and geographical range in late prehistoric Europe. Its tripartite form, like that of the trifoliate palmette, may tie it to the later Celtic tradition of triplism: in Romano-Celtic religious imagery and in early written Celtic myth, the number three had a sacred and magical symbolism (see chapter five).

Triskeles occur as early as the 5th century BC and remained an important motif right through to the early Christian period. The Agris helmet (see FIG. 70) bears a complex mixture of vegetal and abstract motifs, including palmettes, lyres, and triskeles. The motif was prominent in British art. From Moel Hiraddug in north Wales, for example, a 1st-century AD bronze mount displays a curious angled, broken-backed triskele (FIG. 89). The Irish Turoe stone, probably of the same date, is ornamented with

four panels of combined spirals, triskeles, and scroll designs (see FIG. 15). Triskeles also appear in Irish Christian art: the Lagore belt-buckle is decorated with whirling triskeles (see FIG. 51); and similar motifs in different sizes appear on the 8th-century AD Tara Brooch from the same area. Hanging bowls found in 7th-century AD Anglo-Saxon graves such as Sutton Hoo and Hitchin in eastern England have rich enamelled Celtic ornament, which includes triskeles. Illuminated manuscripts too, such as the Book of Durrow and the Book of Kells, are decorated with triskeles, spirals, tendrils, and petals (FIG. 90).

Some triskele motifs betray a blend of abstract and zoomorphic elements. A 3rd-century BC scabbard found at Obermenzing in Bavaria, Germany, has a design of a triskele whose arms terminate in long-necked birds' heads (FIG. 91). An essentially similar idea is expressed on the plaque from Llyn Cerrig Bach, which has a central roundel containing a bird-headed triskele (see FIG. 39).

89. Plaque with broken-backed triskele motif from Moel Hiraddug, Dyserth, Wales, 1st century AD. Bronze, length of each side 6½" (16.3 cm). National Museum of Wales, Cardiff.

The two distinctive elements of the triskele motif are the idea of rotary movement and triplism. A similar device also adopted by Celtic artists was the swastika or crooked cross, a four-limbed design which again evokes movement. The swastika is a very ancient Indo-European solar image which is still a symbol of good fortune in Hindu tradition. In Romano-Celtic Europe, it was also associated with the cult of the sun god. In Celtic art, swastikas appear in red-enamelled circles on the Battersea Shield from London (see FIG. 74), and an almost identical one is visible on a bronze yoke-terminal from Llyn Cerrig Bach (FIG. 92), both from the 1st century BC. The triskele and the swastika may have been powerful talismanic, perhaps apotropaic (endowing magical protection) devices which granted good fortune both to the objects which they adorned and their owners.

Other recurrent abstract motifs may have contained potent symbolism whose meaning is obscure to us. Spirals, scrolls, and S-shapes are very common: sometimes, as on the ring jewellery from Waldalgesheim, there is deliberate asymmetry. The scabbards from the River Bann in Northern Ireland are ornamented with tight spirals and tendrils; the late Iron Age bronze-covered wooden tankard from Trawsfynydd in North Wales is plain but for its handle, which takes the form of complex curls and S-motifs (see FIG. 37). Trumpet patterns, consisting of curved lines

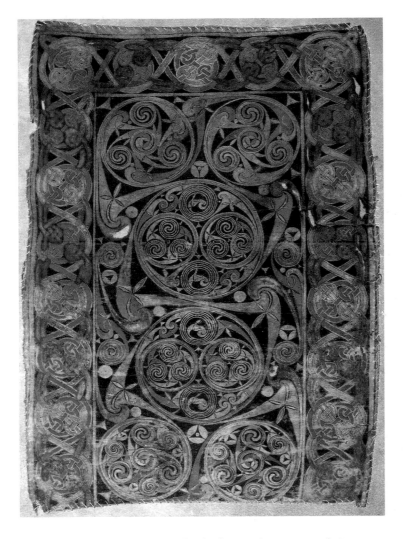

Left

90. The Carpet page from the Book of Durrow, 7th century AD. Painted vellum, 9⅝ x 5¾″ (24.5 x 14.5 cm). Trinity College Library, Dublin.

Below

91. Scabbard decorated with bird-head triskele, from a grave at Obermenzing, Germany, c. 200 BC. Iron, width 1⅝″ (4.8 cm). Prähistorisches Staatsammlung, Munich.

which swell out like the bell of a horn, decorate such items as the Stanwick horse-mask, the Llyn Cerrig plaque, and the Irish Broighter torc, all of 1st century BC/AD date. One design of a circle or half-circle bisected by an S resembles the Chinese yin-yang male/female, positive/negative symbol: the yin-yang motif can be seen as late as the 8th century AD, amid other Celtic designs, on the Chi-Rho page of the Book of Kells, from the late 8th or early 9th century AD.

One of the most fascinating features of Celtic art is its ambiguity and the hint of animal or human forms suggested by the swirls and spirals of meandering curvilinear designs. This ambiguity and double meaning between the abstract and the representational is quite deliberate. It is a simple matter to add a circle for eyes to a lobed shape, and thus create a bird's head, or to

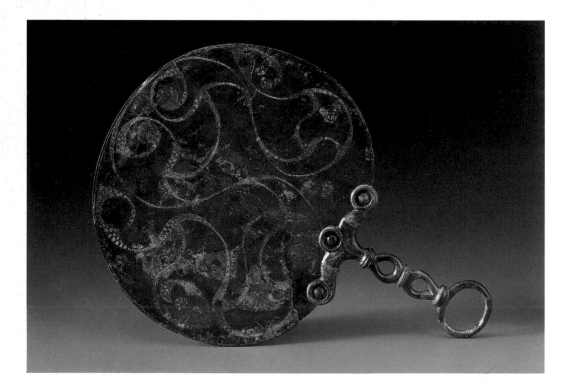

arrange a series of spirals to become the eyes and nose of a human face. Elusive faces peep out of the leaves, tendrils, scrolls, and lyres that decorate the bronze-covered iron Canosa helmet (see FIG. 63). The ring jewellery at Waldalgesheim bears scroll patterns that form human features, if studied long enough. The art on mirror-backs, which is exclusive to Britain during the 1st centuries BC and AD, consists of curvilinear patterns that can in some cases be seen as cartoon-faces, like the mad, grinning face on a mirror from Great Chesterford in Essex (FIG. 93). Birds' heads, too, often emerge from abstract patterns: foliate and bird images play against each other in a series of curves and counter-curves on a mid-3rd-century BC scabbard from a cremation grave at Cernon-sur-Coole in France. The same kind of ambiguity has already been noted at Llyn Cerrig Bach. Such abstract bird motifs are repeated on other British metalwork, such as the Torrs pony-cap and the Snettisham gold torcs. The recently discovered warrior-burial at Deal in Kent contained a scabbard decorated with swirls and birds' heads (FIG. 94). Pseudo-birds' heads occur in Irish art, such as the Petrie Crown; and they even appear on the hanging-bowls of the early Christian period.

Opposite above
92. Yoke-terminal decorated with a swastika from Llyn Cerrig Bach, Anglesey, Wales, 1st century BC. Bronze, diameter 1⁷/₈″ (5 cm). National Museum of Wales, Cardiff.

The form of the swastika motif closely resembles those on the Battersea Shield (see FIG. 74).

Opposite below
93. Mirror-back depicting a mad human face from Great Chesterford, Essex, England, early 1st century AD. Bronze, height 9¹/₄″ (23.5 cm). Cambridge University Museum of Archaeology and Anthropology.

In order to see the face, the mirror has to be positioned with the handle pointing downwards.

Right
94. Scabbard ornamented with birds' heads from a warrior's grave at Deal in Kent, England, late 2nd century BC. Bronze, width 2²/₃″ (6.8 cm). British Museum, London.

The birds' heads look so like those on the Llyn Cerrig Bach plaque (see FIG. 39) that they could be the work of the same artist.

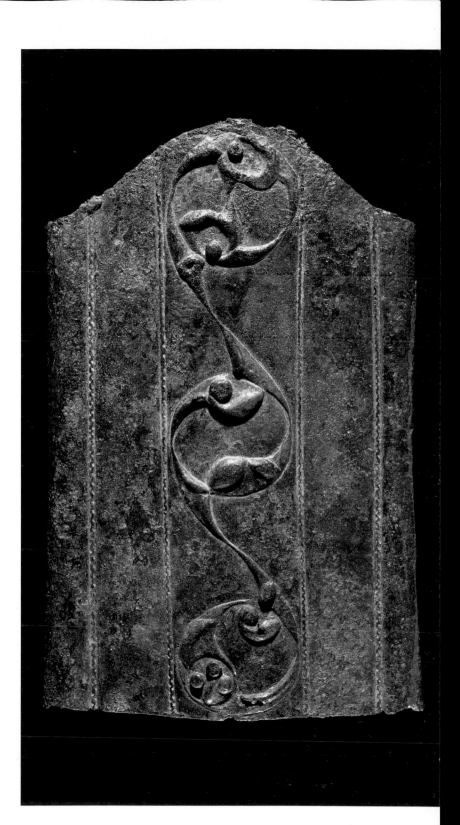

Animals and Monsters

Wild and domestic animals were constantly depicted in art, reflecting their importance to Celtic communities. Not only were the Celts a rural, farming society but they also possessed a horse owning, warrior-aristocracy, for whom horses and cattle were indicators of rank and of wealth. In addition, the evidence of Romano-Celtic iconography strongly suggests that animals were central to the Celtic religious system and, I think, justifies arguing backwards from the Roman period which has more concrete evidence (in the form of epigraphy and iconography) to the preceding Iron Age, where any hint at religious beliefs is much more tenuous. The link between animals and religion was retained into the early Christian period, which produced painted manuscripts, fine metalwork and stone carvings, all decorated with animal images.

A wide range of beasts is represented: horses, cattle, boars, stags, hares, wolves, dogs, and birds appear alongside exotic creatures such as leopards and sphinxes. Realism is sometimes present, but often the animals are distorted or schematised to reflect the artists' primary preoccupation with pattern: heads, dorsal bristles, and antlers may be exaggerated; tails may be triple-stranded; beasts

95. Bowl-handle in the form of a cat's face, from Snowdon, north Wales, 1st century AD. Bronze, width 1″ (2.5 cm). National Museum of Wales, Cardiff.

Domestic cats are first known in Britain from the late Iron Age.

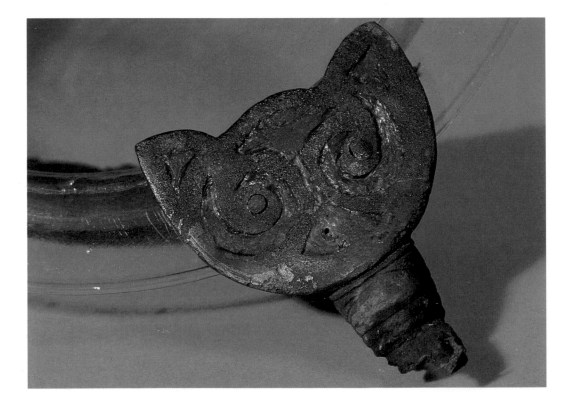

Nature in Art: Abstraction, Realism, and Fantasy

may appear as hybrid monsters, or have human faces – perhaps the products of dreams or nightmares. We have already seen that abstract art may form zoomorphic shapes, particularly those of birds: this kind of schematism and ambiguity is well represented in late Iron Age British art: the curvilinear pattern on the back of the mirror from Aston in Hertfordshire (see FIG. 82) looks like a human face or two birds' heads; and the schematic, smiling cat-faces adorning the handles of a mirror from Holcombe in Devon and of a bowl from North Wales (FIG. 95) remind one irresistibly of cartoon-cats. Sometimes bird imagery may be both enigmatic and intense: the shield-boss from Wandsworth in London bears a design in repoussé of long-tailed birds flying on outstretched wings, on which is engraved another bird, and more again appear on the central roundel.

The ubiquity of animals in Celtic art inevitably raises questions about their function on specific objects. The frequent images of birds on scabbards and shields may have been talismanic, for example. Boars and wolves are particularly appropriate as battle symbols (see chapter three). Interestingly, the early Irish mythic story in the Ulster Cycle, entitled the *Táin Bó Cuailnge* (*The Cattle Raid of Cooley*), refers to a warrior bearing an animal ornamented shield: "he carried a hero's shield graven with animals."

Realism and Distortion in Animal Art

The earliest Celtic art, from the Hallstatt phase of the early Iron Age, is relatively naturalistic in form. Schematism, exaggeration, and ornamental treatment of zoomorphic imagery became more common as Celtic art developed and pattern began to dominate form. But during the later Iron Age naturalism came back into fashion.

The swans and cygnets swimming down the shaft of the very early (perhaps 7th century BC) meat fork from Dunaverney in Co. Antrim, Northern Ireland (FIG. 96), are very realistic. But a coeval repoussé-decorated sheet-bronze bucket-lid from Kleinklein in

96. Meat fork decorated with swans, cygnets, and ravens, from Dunaverney Bog, Ballymoney, Co. Antrim, Northern Ireland, 7th century BC. Bronze, length 24" (60.7 cm). British Museum, London.

The skewer or fork was probably used for spearing lumps of meat cooking in a cauldron.

Austria, with its imagery of horses and water birds, shows elements of schematism. The tradition of representing water birds goes back into the Bronze Age, perhaps as early as the 13th century BC. They were often depicted with solar symbols (see FIG. 7) and may well have been associated with a complex belief-system about which we can say little. By the 5th century BC, animals display ornamental features which decrease their realism: the duck on the Basse-Yutz flagon (see FIG. 36) is a straightforward image, but the wolf or dog forming the handle has elaborate scroll-ears; and the horses on the Hallstatt scabbard decorated with cavalry and infantrymen (see FIG. 65), have haunch- and shoulder-spirals, which may betray Oriental influences.

Horses in the early Iron Age are sometimes quite naturalistically represented, as on a bronze figurine dating to the 5th or 4th century BC from Freisen in Germany (FIG. 97). But on coins of the late Iron Age, horses become disjointed and subjugated to pattern. Birds may be very schematised and non-specific, particularly in the late Iron Age, but some early bird images can be identified as belonging to particular species: the bird riding a horse on Breton gold coins (see FIG. 11) is almost certainly a bird of prey; the swans on the Dunaverney fork are equally explicit.

Quite simple images may have immense power and succeed in capturing the sense of a creature by means of a few lines: the horses on the 7th-century BC cult wagon from Strettweg, Austria

97. Horse figurine from Freisen, St. Wendel, Germany, 5th-4th century BC. Bronze, length 4³/₄″ (12 cm). Rheinisches Landesmuseum, Trier.

Nature in Art: Abstraction, Realism, and Fantasy

98. Stag figurine from Fellbach Schmiden, near Stuttgart, Germany, dated by dendrochronology to 123 BC (tree-felling date). Oak, height 30³/₈″ (77 cm). Württembergisches Landesmuseum, Stuttgart

99. Boar figurine from Neuvy-en-Sullias, Loiret, France, late 1st century BC-early 1st century AD. Bronze, height 26³/₄″ (68 cm). Musée Historique et Archéologique de l'Orléanais, Orléans.

The boar's raised bristles show aggression. The figure bears a marked resemblance to descriptions of boars in Welsh and Irish myth.

100. Triple-horned bull, 1st-2nd century AD. Height approx. 2″ (6 cm). Musée des Alpilles, St.-Remy-de-Provence.

(see FIG. 81, page 115), are presented with an economy of line which displays great skill and understanding of the creature represented. The same is true of the stag carved in wood, buried as a ritual deposit in a sacred pit at Fellbach Schmiden in the 2nd century BC (FIG. 98).

Exaggeration is a common feature in the treatment of animal images. Two little stags on the Strettweg wagon, the focus of what may represent a ritual hunt, have enormous tree-like antlers, as if to emphasise their symbolism as masters of the forest. Boar figures often have overemphasised dorsal bristles, perhaps to stress their ferocity (boars habitually raise their bristles when roused to anger). We can see this on many coins, and on late Iron Age figurines, such as that from Neuvy-en-Sullias in the Loiret, France (FIG. 99). Bulls or cows may have exaggerated horns as, for instance, on some of the iron firedogs of late British and Irish pre-Roman art. The most magnificent of these, from Capel Garmon in North Wales, has two bulls' heads with long horns and curious, ornate manes which are more appropriate to horses than cattle (see FIG. 38).

Triplism, already noted in the triskeles of abstract art, also appears in zoomorphic imagery: a 3rd-century BC sword-scabbard from La Tène in Switzerland bears a motif of three deer with foliage hanging from their mouths; many gold coins of the late Iron Age depict a galloping horse with a triple-stranded tail. In the Romano-Celtic period, bull figurines may have three horns (FIG. 100); and there is even a boar with three horns from Cahors in southern France.

Monsters of Fantasy and Myth

The distortion and exaggeration apparent in the treatment of many animal images displays an imagination which was responsible also for producing zoomorphic depictions whose models lay in the mind rather than in the landscape. They may, indeed, be creatures who belonged to complex mythological conceptions which are lost to us.

Images of monsters abound in Celtic metalwork. Sometimes these are exotic, derived from Oriental or Classical worlds. The sickle-winged sphinxes on the 5th-century belt plaque from Weiskirchen may be based on Near Eastern imagery; the griffons seen, for instance, on the Gundestrup Cauldron, may be modelled on mythic creatures from the Mediterranean world. The origins of other creatures are more difficult to trace: the sinuous "dragon pairs" decorating scabbards resemble sea-horses (see FIG. 66); that they sometimes appear guarding a Tree of Life image hints, perhaps, at an episode in a long-lost myth. Tiny dragon-headed serpents twist themselves down the cheek-piece of the Agris helmet. The Dürrnberg flagon (see FIG. 8) has some weird imagery, including two long-nosed, anteater-like beasts perching on the lid and a third strange quadruped which crawls up the handle to rest its head on a human face at the top. The *oppidum* (proto-town) at Manching in Bavaria produced the curious "push-me-pull-you" double bull's head, of the 2nd or 1st century BC, with protruding eyes and knobbed horns (see FIG. 77).

101. Cernunnos, the antlered god, detail from an inner plate of the Gundestrup Cauldron (see FIG. 29), from Jutland, Denmark, 1st century BC. Silver, length of plate 16" (40 cm).

Cernunnos – the name is recorded on an inscribed monument from Paris – wears one torc and carries another; he holds a ram-horned serpent, and is surrounded by animals. The Celtic avoidance of naturalism is demonstrated by the depiction of a god in human form but with antlers. Cernunnos illustrates the lack of perceived boundaries between human and animal which is distinctive of Celtic visions of the supernatural world.

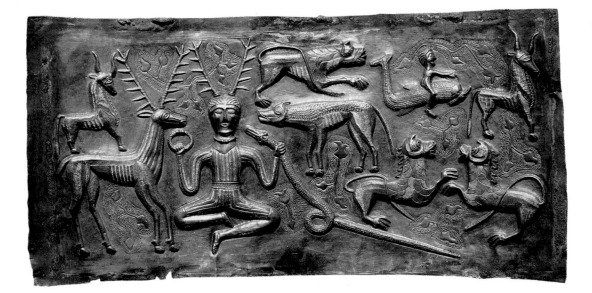

102. The Tarasque of Noves, a monster, half-lion, half-wolf, from Noves, Bouches-du-Rhône, France, 3rd century BC. Stone, height 3′ 8″ (1.12 m).

The animal is represented with a human limb in its jaws and its clawed front paws gripping two human heads. The term "Tarasque" comes from a Provençal legend concerning a monster which emerged from the River Rhône to attack the villagers of Tarascon, near Noves. The beast was defeated by St. Martha, who confronted it with the sign of the cross.

One monstrous image which appears in the Celtic art of both the Iron Age and Roman phases is the snake with a ram's head or ram's horns. The motif is present on a 3rd- to 2nd-century BC pot-handle from Novo Mesto, Slovenia; it appears in the 4th century BC on the rock art of Camonica, near Verona; and on the 1st-century BC Gundestrup Cauldron in company with an antler-wearing human figure (FIG. 101); and this partnership between antlered god and horned snake is repeated in several pieces of Romano-Celtic iconography, notably in eastern France. On the Gundestrup Cauldron the creature appears three times, once with the antlered god, once with a wheel-bearing figure, and a third time associated with a Celtic army attending a sacrifice. In Classical symbolism, the ram signified fecundity and the snake combined chthonic (underworld) and regenerative attributes (the latter because of its skin-sloughing habit). If these beasts had the same meaning in Celtic belief, then the hybrid ram-horned snake would have been a potent image of fertility and rebirth.

Mythic elements are suggested by particular combinations of symbols. The gold torc and armlet of the Reinheim princess bear the idiosyncratic imagery of a woman with a huge bird of prey perched on her head. The ring jewellery found at Erstfeld in Switzerland (see FIG. 48) is decorated with intertwined plant and animal motifs, including a bird with great talons devouring a bull or cow. The two ibexes flanking a human head on the Rodenbach armlet perhaps suggest a mythical hunt: the crown of yew berries worn by the man could suggest the shedding of blood. Death is the strong message conveyed by the Tarasque of Noves, a 3rd- or 2nd-century BC stone carving from the Lower Rhône Valley, France, which depicts a ravening beast, half-wolf, half-lion, devouring a human limb and resting its great paws, claws extended, on two human heads with their eyes closed in death (FIG. 102). Some coin iconography suggests the enactment of scenes from myth: on one Breton issue, a huge wolf appears to be snapping up (or spitting out) the sun and moon, and this has been tentatively interpreted as an

image of the death and rebirth of the world (just such a wolf creation-myth is present in early Norse tradition). The Brittany coin (see FIG. 11) bears symbolism which some scholars see as a reflection of an Irish myth: that of a horse ridden by a great bird, much larger than life. Its size may indicate supernatural status, and the imagery conveys a message which closely resembles descriptions of the Irish war furies of the Ulster Cycle, who could transform themselves from woman-shape to raven and harry soldiers and their horses on the battlefield.

Shape-shifting or Shamanism?

Some imagery depicts humans with animal characteristics or vice versa. It is possible that, in certain instances, we are witnessing shamanism, a religious ritual in which holy men or women assume animal costumes in order to help them cross the divide between the earthly and sacred worlds and act as mediators between humans and spirits. Such ritual behaviour is still widely practised in some societies: Siberian communities around the River Lena, for instance, have shamans who bellow like bulls and assume bull-horns. Such beliefs encompass the perception that animals are closer to the supernatural than people. Alternatively, what we may be seeing is shape-shifting: in many early Celtic myths – particularly those of Ireland and Wales (and, indeed, in Norse and other mythological traditions) – supernatural beings could metamorphose between human and animal form. So an image in Celtic art showing a semi-human, semi-animal figure may express the process of shape-shifting. In addition, liminality may be expressed in metamorphic imagery. Thresholds were important in Celtic myth and the need to represent two worlds (earthly and spiritual) may have contributed to such hybrid depictions.

The silver plates of the Gundestrup Cauldron display images of a number of animals, some of which – like the boar and dog – belong to temperate Europe, but others are exotic: hyaenas, leopards, and even elephants are present, reflecting links between the metalsmiths of south-east Europe (who probably made it) and communities living further east. An antlered anthropomorphic figure sits cross-legged, grasping his ram-horned snake, accompanied by a stag and surrounded by other animals, as though he is lord of the beasts. This antlered god, called Cernunnos in the Roman period, appears in other pre-Roman contexts: his image is present in the 4th century BC in Camunian rock art, and his head is depicted on a Celtic silver coin from the English Midlands.

Another vessel, the bronze-covered wooden bucket of the late

1st century BC from Aylesford in Kent, England (see FIG. 24), was found in a grave and contained cremated bones. Its iconography includes triskeles, wheel-like whirligigs, and two pairs of curious animals, which look like pantomime horses, with human knees, antler-like forms on their heads and thick, protruding lips. The two escutcheons (handle mounts) are in the form of human masks with leaf crowns, attesting to the sacred character of the vessel. The "horses" may reflect a kind of ritual, perhaps shamanistic, dance, in which humans dressed as animals invoked the spirit-world. It may even be that the antlered image at Gundestrup is not a god but a priest wearing an antler headdress to bring him close to the supernatural plane.

The Gundestrup image may be interpreted as a shaman, a shape-shifter or a god perceived as having a part-human, part-animal shape. The Bouray bronze figurine bears a torc and is human in form except for his stag-hooves (see FIG. 21). A late 5th- to early 4th-century BC bronze sword-hilt from Herzogenburg-Kalkofen in Austria is decorated with a human face but with long, hare-like ears. Human-headed horses appear on the lid of the flagon in the Reinheim grave and on a series of Breton coins, struck two or three hundred years later, where they are ridden or driven by female warriors or charioteers. Sometimes the form of the image depends upon which way it is viewed: for example, a 3rd-century BC flagon-mount at Maloměrice near Brno in Moravia takes the form of a half-human, half-bovine horned head, but when looked at from above a second (reversed) horned head can be seen.

The importance of zoomorphic images in Celtic art is very clear, whether such beasts are treated naturalistically, schematically, or as monstrous hybrid beings. Their symbolism may be straightforward or obscure: they belong both to the earthly world and that of dreams or myth. Perhaps most interesting of all is the apparent lack of boundaries between real and unreal and between animal and human form. Celtic symbolism was not confined to the conventions of the physical world but could transcend or defy them in order perhaps to express other, more fundamental spiritual truths.

The Sacred Head

Although human figures are rare in Celtic art, the head alone is not. Indeed, heads, masks, and faces are recurrent themes from the 5th to the 1st centuries BC and beyond, as we have seen. They vary in treatment from the realistic to the abstract and, in the latter form, they may be so elusive to the eye that it is often dif-

ficult to distinguish between a face and a pattern.

The presence of the leaf crown, perhaps made of mistletoe, is such a ubiquitous image on early Celtic precious metalwork and on monumental stone carvings that it must have contained some meaning and was probably a mark of divine or earthly status, perhaps as a symbol of a dead person, or as a sacred sign. This may be true of the faces on the *phalera* at Hořovický; the belt plaque from Weiskirchen; and the Rodenbach armlet. The face on the flagon-handle at Kleinaspergle has horns or pricked animal ears, and the leaves of the crown curl down to join the elaborately layered beard (see FIG. 34). The monumental stone pillar at Pfalzfeld, with its four leaf-crowned faces, must surely represent a deity.

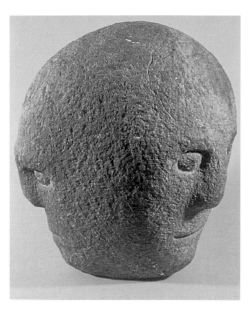

103. Triple head from Corleck, Co. Cavan, Ireland, 1st century BC-2nd century AD. Stone, height 12¾″ (32 cm). National Museum of Ireland, Dublin.

Many features of human heads recur on a number of pieces: some are horned, like that on the Kleinaspergle flagon and on the Rodenbach finger-ring; some have elaborately dressed, sometimes forked, beards, as on the mounts from Kleinaspergle and the Dürrnberg mount. The faces often display long, flowing moustaches: we see this on the 5th-century BC Weiskirchen belt and on the stone head from Mšecké Žehrovice in Bohemia. That such heads may have been perceived as possessing magical power or symbolism is suggested by their multiple imagery: the *phalera* from Hořovický is decorated with an inner circle of seven crowned heads and thirteen on the outer circle. The heads themselves may be janiform or triplistic: the Rodenbach finger-ring is ornamented with back-to-back heads. Triple heads occur in stone, for instance at Corleck in Co. Cavan, Ireland (FIG. 103). These are probably, but not certainly, Iron Age in date, but triple heads are more common in the Romano-Celtic phase, where they are unequivocal representations of divinities.

On many items of precious, decorated metalwork, particularly on armlets and torcs, heads are present as decorative motifs, even though sometimes very small or ambiguous in appearance. The 5th-century BC Rodenbach armlet is decorated with one very definite human face, but it is necessary to look hard to find the other two little faces which are integrated into the overall artistic design (see FIG. 46). Likewise, the 4th-century BC Waldalgesheim torc (FIG. 104) has an elusive human face, formed of curving lines. Such hidden heads were still present in the

Above

104. Detail of the decorated ring jewellery from the grave of a high-ranking woman at Waldalgesheim, near Bonn, Germany, 4th century (see FIG. 10, page 25) BC. Gold, diameter of torc 7¹/₃″ (18.7 cm). Rheinisches Landesmuseum, Bonn.

Opposite

105. Crucifixion plaque, from Rinnagan, St. John's, near Athlone, Ireland, 8th century AD. Gilt-bronze, height 8³/₈″ (21.1 cm). National Museum of Ireland, Dublin.

The plaque, which depicts Christ with two angels on his shoulder and Stephaton (who offered Christ the sponge soaked in vinegar) and Longinus the Roman centurian beneath, may have been a book cover. The over-large head of Christ appears to reflect the much earlier pagan tradition of exaggerating the head, considered the most important part of a sacred image. The style of the faces also resembles that of pagan images (see FIG. 112).

3rd century BC: an enamel-inlaid torc of this date (now lost) from a cremation burial at Dammelberg in Germany had a small face on the back. Elusive masks like this appear also in late Iron Age British contexts: the shields from Wandsworth and Battersea have enigmatic faces or pseudo-faces; the Battersea piece (see FIG. 74) bears a reversible human face: one way up it wears a crown, the other way a moustache.

Sometimes abstract patterns appear to resolve themselves into minimalist, cartoon-faces. The Walt Disney-like faces on British mirror-backs such as those from Great Chesterford and Aston have already been mentioned in connection with plant-derived abstract motifs. Even on more or less naturalistic faces, the artist's love of curvilinear pattern is still present: the 3rd-century BC stone head from Mšecké Žehrovice has spiral-decorated eyebrows and moustaches; the same idea can be seen on the face decorating the flagon-handle from Kleinaspergle.

The expression (or lack of it) on these mask-like faces deserves brief mention. On many, it is distant and impassive, as if to reflect the archetype of divinity. There is often schematism in the oval or circular eyes, wedge nose, and slit mouth: the carved stone heads from Noves in southern France illustrate this impersonal remoteness. The eyes may be large and staring, as on the faces at Pfalzfeld, whose expressions are fierce and threatening (their frowns caused by the lotus blossoms carved on their foreheads). But the expression on the Corleck face is shuttered, though equally forbidding, in great contrast to the insanely happy leer worn by the face on the Great Chesterford mirror-back (see FIG. 93).

What do the faces mean, and whom do they represent? It is clear, both from Romano-Celtic iconography and from comments by Classical writers on the late Iron Age Celts in Gaul, that the human head was a sacred symbol. It was regarded as the essence of the person or the god, and some tribes made a habit of decapitating and treasuring the heads of their enemies, offering them up in shrines or keeping them in their homes, as objects of great value. Pre-Roman sanctuaries of the Lower Rhône Valley exhibit intense head-symbolism in iconography and in the presence of real skulls embedded in the niches of the temple structures. The fact that in La Tène art, the face is often minute, almost impossible to make out and appears constantly on personal ornaments, like torcs and brooches, suggests that the human head held a talismanic function, perhaps giving protection and good luck

to the wearer. It is interesting that the motif of the face carried over into the early Christian art of illuminated manuscripts: the Chi-Rho page of the Book of Kells has tiny faces woven into the overall abstract pattern (see chapter five).

That the head was important in Celtic iconography is demonstrated not only by its frequency but also by the manner in which, if a complete human figure is depicted, the head may be exaggerated in size: this is illustrated by the Bouray statuette with the stag-hooves, whose head is nearly half the size of the entire image. Such deliberate disproportion is visible in much of the sacred iconography of Romano-Celtic Europe: the little stone mother-goddess statuette from Caerwent in South Wales is a good example (see FIG. 83). It is still present in the early Christian period: an 8th-century AD Irish crucifixion plaque from Rinnagan in Co. Roscommon (FIG. 105) has a schematic representation of Christ with a huge head; the pair of angels and the two humans that accompany him are similarly treated. The essentially Celtic character of the depiction is demonstrated also by the triskeles and spirals decorating the clothes, and the Tree of Life motif on Christ's breast.

Humans in Art: People or Deities?

Representations of the human figure (other than the head alone) are rare in Celtic art. In the Hallstatt Iron Age of the 7th-6th centuries BC, we can point to images such as the schematic figures engaged in everyday tasks incised on pots from Sopron in Hungary, or the goddess and her worshippers on the Strettweg wagon from Austria. The ithyphallic stone warrior from Ditzingen-Hirschlanden in Germany may represent a god, perhaps the apotheosis of the dead soldier in the barrow (see FIG. 47). The bronze statuette from St. Maur-en-Chausée, France, depicts a warrior; and other soldiers are represented, for example on the scabbard from Hallstatt. The later Iron Age anthropoid sword or dagger hilts, such as that from Tesson in the Charente-Maritime, France (see FIG. 67), may represent the warrior himself, an apotropaic symbol, or a divinity. At the end of the pre-Roman Iron Age, complete human figures were more commonly represented and are more often associated with sanctuaries: the wooden figurine of a lady wearing a torc from Chamalières may be a goddess; the lithe bronze female dancer from Neuvy-en-Sullias, Loiret, may represent an acolyte or a priestess (FIG. 106).

Under Roman influence, there was a great upsurge in anthropomorphic representation, mainly in the form of divine imagery.

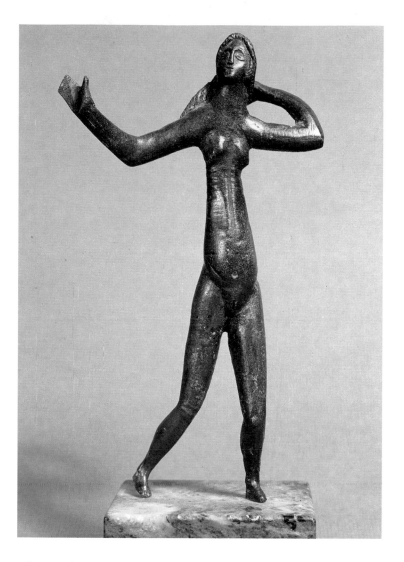

106. Naked female dancer from a hoard of religious bronzes found at Neuvy-en-Sullias, France, late 1st century BC–early 1st century AD. Bronze, height 5¹/₂″ (14 cm). Musée Historique et Archéologique de l'Orléanais, Orléans.

The identity of this figure is unclear, but since the hoard probably comes from a local shrine, she could represent a cult initiate or priestess.

The emphasis on the human head (which was sometimes horned, janiform, or triplistic), on schematism, minimalism, and semi-zoomorphism were still present. As we saw earlier, the exaggerated head and schematised treatment were retained by Christian Celtic artists, who decorated metalwork, carved stone crosses, and painted sacred manuscripts. What is so striking about Celtic art in the Roman and early Christian periods is its constancy. It retained the identity which first manifested itself in the middle of the first millennium BC, despite the powerful influences caused firstly by the Roman conquest of Celtic lands and secondly by the introduction of a new, monotheistic faith.

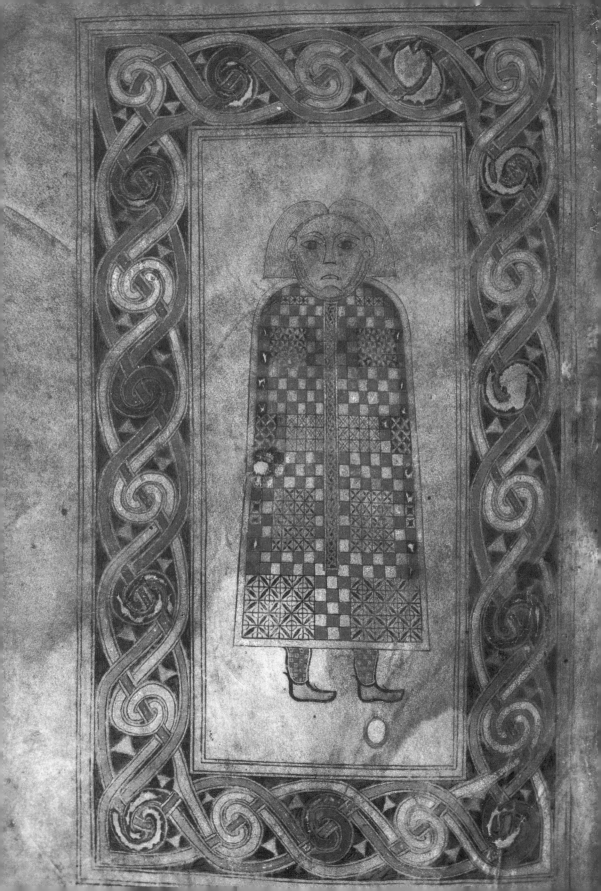

FIVE

Symbolism and Spirituality: From Paganism to Christianity

The whole Gallic people is exceedingly given to religious superstition.

Julius Caesar (100–44 BC)

Before the period of Roman influence in Celtic Europe (which commenced around the 1st century BC), narrative art is almost unknown and human images are both scarce and unrealistic in form. Despite this emphasis on schematism and abstraction, Celtic art was nonetheless a highly symbolic and indeed religious art. In theory it is possible to make a distinction between symbolism and religious imagery: we may cite modern examples of non-religious symbols such as the logos used for purposes of immediate identity by companies, banks, and colleges, flags or badges of rank in the armed forces. But it is arguable that for the ancient Celts, for whom religion was central to life, such a distinction may have been meaningless.

This final chapter examines some of the specifically religious elements in Celtic art. In the pre-Roman period it is possible, for the most part, only to make indirect inferences concerning the motifs used by Celtic artists. This is because we have no written evidence to suggest their function. But there is one important indicator for the ritual associations of some Iron Age art, and that is its context. By the Roman period, religious imagery was becoming an increasingly specific medium for art and, because of its association both with Roman iconography and epigraphy (inscrip-

107. One of the Four Evangelists, from the Book of Durrow, 7th century AD. Painted vellum, 9⅝ x 5¾" (24.5 x 14.5 cm). Trinity College Library, Dublin.

tions), its significance becomes clearer. Apart from the material evidence for religious art in the Romano-Celtic period, it is also interesting to explore the possibility of establishing links between art and themes which occur in the earliest written Celtic myths. Finally, the chapter will examine the very important subject of Celtic art in the early Christian period, when artists directed their skill towards the expression of a new and powerful faith.

Art and Pagan Symbolism: Context

The importance of context in assessing the function of Celtic art cannot be emphasised too much. Earlier chapters have made it clear that many pieces of pre-Roman European art came from contexts that were associated with ritual behaviour. Precious, high-status decorated objects were apparently deliberately cast into rivers, lakes, or marshes. The Battersea Shield, the Waterloo Helmet, the Loughnashade trumpets, the Llyn Cerrig Bach plaque, and countless other items may be cited as examples. Weapons, jewellery, and feasting equipment accompanied the dead in the tomb, as in the graves of the Rodenbach chieftain and the princesses of Waldalgesheim and Reinheim. Objects were also placed in symbolic locations within the landscape: for example, the Gundestrup Cauldron was dismantled and placed on a dry part of the surface of a peat bog. A find from a similar context, although a less overtly religious piece, is the Capel Garmon fire dog, which was deposited in a marsh.

Apart from sepulchral or aquatic contexts, precious art objects were carefully hidden in the ground, arguably as cult offerings. These deposits may consist of huge quantities of material, as occurred at Snettisham in England (see FIGS 29 and 30). At Niederzier in the Rhineland, Germany, two torcs, an armlet, and some coins were placed in a bowl next to a timber cult post, on a settlement site. The ritual deposition of valuable objects is specifically mentioned as a Celtic custom by such Classical commentators as Diodorus and Strabo, who described the (to them) curious practice of offering enormous quantities of rich metalwork in the sanctuaries of their gods.

Whether or not some of this material was made especially for a religious purpose, it must surely be the case that the presence of the art itself enhanced the value of the gift. In addition, there are (as we have seen) identifiable symbols contained within pre-Roman Celtic designs – human faces, animals, the Tree of Life, lotus flowers, triskeles, and many others.

Pre-Roman Celtic imagery, too, may be associated with sacred

places. The Strettweg cult wagon was placed in the grave of a chieftain interred in the 7th century BC. The stone figure from Ditzingen-Hirschlanden surmounted a funeral mound while the 3rd-century BC stone head of a man from Mšecké Žehrovice in Bohemia was associated with a shrine, as were the carvings of heads and warriors depicted at Entremont near Marseille. The Gundestrup Cauldron, ceremonially placed in a marsh, depicts a number of deities, some of whom closely resemble those venerated in Romano-Celtic Gaul. These include the antlered god Cernunnos (FIG. 108) and the solar wheel-god.

We assume that these images, together with others from pre-Roman Celtic contexts, represent gods and goddesses, but it is usually difficult to identify them with any certainty, except by means of their intrinsic symbolism. This is because – until the Roman period – we have no names for Celtic divinities. Romano-Celtic Europe presents us with a much fuller tapestry of sacred beings.

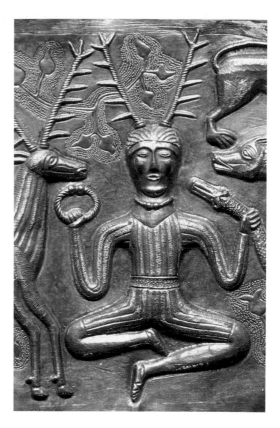

108. Cernunnos, the antlered god, detail from an inner plate of the Gundestrup Cauldron (see FIG. 101, page 135), from Jutland, Denmark, 1st century BC. Silver, length of plate 16″ (40 cm).

Divine Imagery in the Romano-Celtic World

When the Romans conquered Celtic Europe over the 1st centuries BC and AD, they introduced methods of representing their gods which were, for the most part, alien to the Celts. From this time, the practice of depicting divine beings as more or less realistic images in human form became common among the Celts in their increasingly integrated Romano-Celtic culture.

It would be inappropriate to enter into a detailed discussion of Romano-Celtic art here, since it is so heavily influenced by Roman traditions. But it is true to say that the adoption by the Celts of Roman ways of expressing the divine meant that Celtic perceptions of the supernatural were defined with much greater clarity than before. Celtic cult images of Cernunnos from the pre-Roman Iron Age, for example, are rare – one such is that on the 1st-century BC Gundestrup Cauldron. In the Roman period, by contrast, more than fifty representations of this god are recorded, mainly clustered in north-east Gaul (FIG. 109).

A great deal of Celtic religious imagery appears for the first time in the Roman era, influenced by Roman forms of expression.

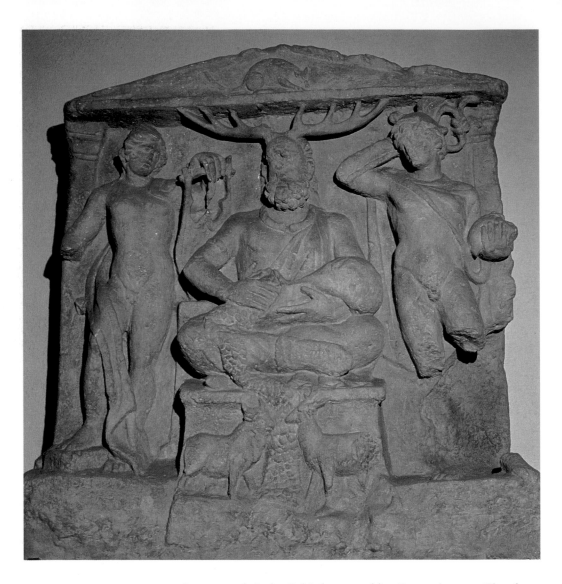

109. Relief of Cernunnos from Rheims, France, 1st–2nd century AD. Stone, height 51″ (1.3 m). Musée Saint-Rémi, Rheims.

Cernunnos sits cross-legged on a dais, a torc around his neck, pouring money or corn from a bag to feed a small bull and a stag at his feet. Flanking him are the Classical gods Apollo and Mercury.

One example is the Celtic horse-goddess Epona (see FIG. 50), whose iconography is unknown before the Roman period but who was so popular in Romano-Celtic Europe that images and inscribed dedications to her appear all over, and beyond, the Celtic world, from Britain to Bulgaria. In addition, she is the only Celtic deity to have been granted her own festival day in the Roman religious calendar – 18 December. A comparable example is the image of the Celtic sun god, who borrows many attributes (such as the thunderbolt) from the Roman sky god Jupiter and closely resembles him. But his essentially Celtic character is displayed by his solar symbol of a spoked wheel (FIG. 110), which is a non-Classical motif and, indeed, appears on its own as an amulet in Celtic

Europe long before the Roman period.

Epona and the solar god illustrate what happened to Celtic religious art during the Roman occupation of Celtic Europe, particularly in Gaul and Britain. Many gods and goddesses, with their Celtic names recorded on inscriptions, appear as Romanised images, wearing Roman clothes and hairstyles, but with Celtic emblems such as hammers or cauldrons. One of the most diagnostic indications of Celtic influence on divine images is the presence of the torc. The endowment of cult statues with torcs probably arose from their significance as prestige jewellery in secular contexts. A huge variety of deities is represented adorned with neck-rings, both in the pre-Roman and Romano-Celtic periods. They range from statues of totally indigenous divinities, such as Epona and Cernunnos, to gods who appear wholly Roman, except for the torc: one such is a little bronze Mercury figurine from Verulamium (St. Albans) in Hertfordshire, England.

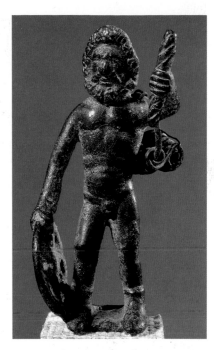

110. Figurine of the sun god from Le Châtelet, Haute-Marne, France, 1st-2nd century AD. Bronze, height 5½" (14 cm). Musée des Antiquités Nationales, Saint-Germain-en-Laye, Paris.

With his long curly hair and beard and his thunderbolt, the god resembles the Roman sky god Jupiter, but the solar wheel is a Celtic motif.

Art and Myth

The vernacular myths (those written in Irish or Welsh rather than in Latin) of Ireland and Wales were compiled in written form within a Christian milieu, in the early medieval period from about AD 700 to 1300, although the tales on which these texts were based are arguably part of a much earlier oral tradition. Despite the late date of this literature, it nonetheless contains a considerable body of pagan tradition, especially in the Irish texts. It is sometimes possible to link themes in these myths with some aspects of pagan art, particularly that of the Romano-Celtic period. Such a link is exemplified by the presentation of beings in triple form. Triadism (or triplism) runs as a constant thread through much of the mythic literature: the Irish war goddesses of the Ulster Cycle – the Morrigán, Macha, and Badbh – each possessed a triple identity; the Welsh heroine Branwen, of the *Mabinogion*, is described as "one of three matriarchs"; and there are many other instances of mythic threeness. Triplism is also prominent in pagan Celtic art: the triskele (triple-armed whirligig) has been discussed in previous chapters. In Romano-Celtic religious art, many deities appear in triplicate: the three mother-goddesses (FIG. 111) and the triadic *Genii cucullati* (hooded gods) illustrate this form, as do depictions of a bull with three horns (see FIG. 100). Three seems to have possessed considerable sanctity for the Celts. We can only guess

Symbolism and Spirituality: From Paganism to Christianity

at the reason: three may reflect aspects of time (past, present, and future); or of space (the infernal, earthly, and heavenly worlds); or of age (youth, maturity, and old age). We can never be certain of the true significance of this undoubtedly sacred number. It is interesting, for example, to note the centrality of the Holy Trinity within Christian tradition.

The importance of the human head presents another link between art and myth: we have seen that in pre-Roman Celtic art, heads form a prominent motif among the highly abstract patterns adorning metal and stone objects. The cult images of Celtic Europe also display this tradition: some deities are represented simply as heads (FIG. 112); and there are frequent instances of deities represented with heads of exaggerated size. The hooved god from Bouray (see FIG. 21), and the little stone mother-goddess from Caerwent (see FIG. 83) show this emphasis very clearly. In both Welsh and Irish myths, the human head is in some cases endowed with supernatural properties: in the *Mabinogion* (a collection of mythic stories which were first written down in the thirteenth or fourteenth century), the hero Brân is fatally injured by a poisoned spear-wound; he instructs his companions to behead him and his severed head remains uncorrupted, bringing Brân's men good luck and encouragement during their subsequent wanderings over many years. The head of the Irish mythic hero Conall Cernach is of enormous size; after its severance from his body, it acts like a cauldron of plenty and renewal (an important theme in Celtic myth): whoever drinks milk from it has their strength regenerated.

A third significant link between art and myth is that of animal symbolism. Beasts, sometimes of fantastic form, are common motifs in pre-Roman Celtic art. Animals are also prominent in Romano-Celtic religious imagery: indeed, they are sufficiently important to give rise to depictions of gods, like Cernunnos, who are semi-zoomorphic in form. If we scrutinise the Celtic myths, we see similar prominence given to animals, particularly in the concept of shape-shifting, whereby supernatural beings can change between human and animal form. In the Welsh tale of *Culhwch ac Olwen*, a giant boar, Twrch Trwyth, alludes to his transformation to animal shape by God because of his wickedness (see FIG. 99). In the *Mabinogion* we

112. Head of a Celtic god, from Corbridge, Northumberland, England, 2nd century AD. Stone, height 7″ (17.7 cm). Corstopitum Museum, Corbridge.

hear of errant princes being turned – for a term of three years – into pairs of beasts. The Irish myths are similarly redolent with shape-shifting: this is well illustrated by the "War Furies" who shift from female human form to that of cruel and predatory ravens, feasting upon the carnage of the battlefield.

The Context and Symbolism of Early Christian Art

> All these things must have been the result of the work...of angels.
>
> <div align="right">Giraldus Cambrensis (1146-1223)</div>

Both Celtic society and Celtic art were transformed by Christianity. The new faith brought with it a strong ethical code which changed all aspects of Celtic life. After the collapse of Roman rule in Europe, the survival of Celtic culture and its art was concentrated in the far west. New groups of people colonised what had been Celtic Europe: the Franks invaded Gaul; Germanic Anglo-Saxons took over most of Britain. But Celtic Ireland remained untouched by external invaders until the Vikings arrived at the end of the 8th century AD.

Christianity came to Britain during the Roman period, probably by the 3rd century AD. At first, Christian communities were concentrated in the urban regions of Roman Britain, in the southeast. However, after the Roman withdrawal from Britain in AD 410, the Britons called in Anglo-Saxon mercenaries to help protect their borders from "barbarian" invasion. It is generally thought that this invitation opened the door to the full-scale occupation of south-east Britain by pagan Anglo-Saxons in the 5th and 6th centuries and that Christianity was wiped out in lowland Britain, only to be revived by the mission of St. Augustine from Rome in AD 597. This traditional view of Anglo-Saxon England is now being challenged by certain scholars, who argue that the Anglo-Saxon invasion was much less total and that therefore some Christianity survived in Britain until the arrival of Augustine.

It was in the far north and west of Britain that Christianity survived unbroken by pagan Anglo-Saxon intrusion. By the 5th century, there were groups of Christians in Scotland, Wales, Cornwall, north-west England, and also in Ireland. In these areas, independent Celtic kingdoms established themselves and, indeed, royal patronage was to play a large role in the florescence of both the early Church and its art.

Ireland was in the forefront of Celtic Christianity: the Irish were in contact with Christians by the early 5th century at the

latest, the tradition being that St. Patrick brought the faith to the island in AD 432. Patrick was allegedly born of a Romano-British family near Carlisle in Cumbria, and was captured in his youth by slave-traders from Ulster. He escaped to the Continent and later returned to Ireland as its first consecrated bishop, founding a basically Roman form of Christianity there. But it is widely accepted that by the mid-6th century the episcopal church in Ireland was replaced by monasticism, although there is controversy as to whether or not and how far the two systems may have co-existed: monasteries began to spring up, often linked to noble dynastic family communities. One of the most important 6th-century monastic founders was St. Columba (c. AD 521-97), who established the monastery of Durrow in Co. Offaly and the great foundation on the island of Iona off the north-west coast of Scotland in AD 563. Iona exemplifies the close kinship network which sometimes operated in religious establishments: all but one of the first nine abbots of Iona belonged to the same family group. Once these early Irish monasteries were founded, missionary activity spread the Christian message from there to other communities. In AD 635 St. Aidan from Iona founded the monastery of Lindisfarne, off the Northumberland coast, near the residence of the Northumbrian king at Bamborough. In AD 590, St. Columbanus (c. AD 543-615) and his twelve companions (in conscious imitation of Christ and his Apostles) travelled from the monastery of Bangor in Co. Down, Northern Ireland, as missionaries to the Frank-

113. The monastery of Skellig Michael, off the coast of Co. Kerry, Ireland, founded in the 8th century AD.

The bleak island monastery is an example of the austerity in which some early Celtic monks chose to live.

ish kings and to the pagans in Germany. By the 7th century, the Irish church was dominated by monastic foundations, often ruled by aristocratic abbots who held considerable power.

During the 6th century, Celtic monasteries were mostly fairly small, but, by the end of the 7th, the Irish Christian monk Aenghus was able to speak of Kildare and Clonmacnois in Co. Offaly as though they were great cities. These monasteries were important centres of learning: education was seen as an essential aspect of the new Church, and great monastic schools were established. The active religious ministry which promoted scholarship also promoted the arts.

In Ireland, paganism had largely died away by the end of the 7th century, but some elements of pagan superstition inevitably remained for centuries longer. Many monks from the great foundations were fully integrated into Celtic society, but others took to an ascetic, eremitic monasticism based upon the withdrawal of the individual from public life to seek God in the solitude of wild and lonely places (FIG. 113). Although there is literary evidence for conflict between the two faiths (for example in the lives of St. Patrick), to some extent there was an easy transition from paganism to Christianity. Christian saints filled the vacuum left by the myriad pagan spirits, and acted as mediators between God and humankind. Water, perceived as sacred by the pagan Celts, retained its sanctity as a symbol of purification, and pagan holy wells readily became focuses of Christian spirituality (FIG. 114). The perception of water as a healing force was equally prominent in pagan and Christian religion.

Archaeological evidence for the monasteries themselves, which were the major centres of art production, suggests that many early buildings were of wood. Clonmacnois, bounded by a low bank and ditch to demarcate its sacred space, was built of wood in its early phases; and there were timber structures on Iona. But there was some comparatively early building in stone: the "bee-

114. The holy well of Saint Winifride at Holywell, north Wales.

Winifride was an early Welsh saint who is thought to have lived in the late 6th century AD. The story goes that when she rejected the sexual advances of the young prince Caradoc, he cut off her head with his sword. Where the head touched the ground, a spring miraculously gushed out. Winifride's uncle Saint Beuno restored his niece to life and cursed the family of Caradoc. The well is still a holy healing centre today. The tradition of early Christian holy wells may have had its genesis in the many pagan Celtic sacred springs and wells that had become the focus of curative sanctuaries in the Roman period.

hive" cells of the monks on Skellig Michael, off the Irish coast of Co. Kerry, may be as early as the 8th century, and there are documentary references to a stone church at the monastery (founded by St. Patrick) at Armagh in AD 789.

The missionary activity of the early Christian church was crucial for the development of Christian Celtic art. In the first place, religious art – such as church plate or illuminated manuscripts (see FIG. 107, page 145) – was expensive, making some royal patronage necessary. Indeed, there was sometimes a close link between the secular aristocracy and the large and wealthy monasteries. St. Columba of Iona was himself of royal lineage. Secondly, monks travelling from Ireland to Anglo-Saxon England and to Continental Europe, absorbed foreign artistic traditions which were

115. Carved cross at Moone, Co. Kildare, Ireland, 8th century AD. Granite, height 17'4½" (5.3 m).

The simple yet powerful human figures are highly reminiscent of pagan Celtic sculpture (see FIGS 83 and 111).

then blended into Celtic designs and motifs. Thus the sculptured crosses (FIGS. 115 and 116), the manuscripts, and the metalwork of the Christian Celts reflect an amalgam of Celtic, Germanic, and Mediterranean ideas.

This then was the context of Christian art between the 5th and 10th centuries AD. The most mature development of La Tène art was now used to decorate not just secular objects, such as jewellery, but these wholly new sacred pieces. Celtic art was now employed, above all, in the glorification of God and in the teaching of scripture. Art and Christianity went hand in hand: it is alleged that Patrick himself was accompanied by craftspeople on his mission to Ireland in the early 5th century. If this is cor-

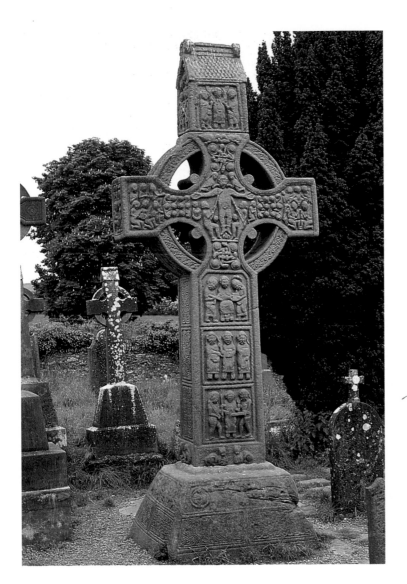

116. Carved cross at Monasterboice, Co. Louth, Ireland, late 9th-early 10th century AD. Stone, height 18' (5.5 m).

The cross bears an inscription stating its dedication by Muirdach, Abbot of Monasterboice. It is decorated with biblical scenes.

rect, it marks the beginning of a great period of cross-fertilisation of art ideas between Ireland, Britain, and Europe. Nonetheless, the strongly Celtic element – traceable in origin back to pre-Roman centuries – was retained, both in terms of the motifs used and in the artists' approach. The old "oscillation between life and geometry," between realism and fantasy, representation and abstraction, can still be discerned. Tension, asymmetry, meandering spirals, and whirling triskeles are still present in Christian art. A delight in illusion and ambiguity remained, together with the use of beasts and human faces as motifs within design. The scholar and author Françoise Henry even speaks of "half-disguised figurations of Celtic gods" lurking amid the Christian symbolism.

Christian Metalwork

The decorated metal artefacts of the early Christian Celtic period can be divided into secular and sacred objects. Metalworking took place at settlements such as Garranes in Co. Cork, which was a ring-shaped fort (rath) containing the remains of wooden houses in which smiths had left crucibles, unfinished ornaments, and enamelling debris. Craftpeople could be attached to chiefs' courts or were sometimes itinerants. Metal objects were made at the lake settlement at Lagore in Co. Meath, which is recorded in the Irish Annals as a seat of a minor dynasty in the mid-8th-9th centuries. Archaeologically speaking, Lagore is a modest site, but it produced the superb buckle named after it (see FIG. 51). But there is also evidence that artists worked in the monasteries, and some were undoubtedly monks. In about AD 800, Aenghus wrote that there were craft workshops in the monasteries.

Some of the most important secular pieces were the penannular (in the shape of a broken ring) brooches, some of which were quite large. The sculpture at White Island in Co. Fermanagh depicts a warrior with an oversized head (typical of the Celtic style of imagery), bearing a sword and shield, with a great penannular brooch fastening his cloak at the shoulder (see FIG. 53). Such brooches were also worn by priests. A spectacular example of this type of jewellery is the Tara Brooch from Bettystown in Co. Meath, with its intricate decoration of gold wire, bands of amber, and red and blue enamel (FIG. 117).

It is the Church plate that formed the medium for the most ambitious Christian decorated metalwork. Its manufacture placed new demands of skill on Celtic craftworkers. Decorated vessels were used as part of the liturgical paraphernalia of the Church. Some of the earliest are the so-called "hanging bowls." The plain metal is relieved by decorative handle-mounts (escutcheons) which were embellished with champlevé enamel and adorned with Celtic designs such as running spirals and bird-headed triskeles. They may have been used to hold holy water or for priests to wash their hands, and their function as sacred vessels is supported by the presence of the Christian symbol of the fish on a bowl from Sutton Hoo in East Anglia. Some

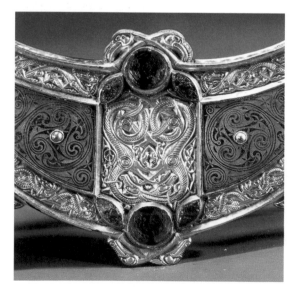

117. Detail of the the Tara Brooch, found at Bettystown, Co. Meath, Ireland, 8th century AD (see FIG. 54, page 82). Silver-gilt, diameter c. 2" (4.6 cm)). National Museum of Ireland, Dublin.

118. The Ardagh Chalice,
c. AD 700. Silver, height 7"
(17.8 cm). National
Museum of Ireland, Dublin.

The chalice was made from
two bowls, one (inverted)
forming the base. The vessel
is decorated with gilt-
bronze filigree and chip-
carving, and the circular
medallions are inlaid with
red and blue glass. The
chalice was found in 1868
by a boy digging for
potatoes.

hanging bowls are securely dated from their context, in that many were buried in Anglo-Saxon graves, such as those at Sutton Hoo: most of them belong to the period AD 550–650. But an interesting feature of their use is that some were placed in graves during the 7th century when they were already old; in addition, the ornamental mounts were sometimes re-used, and thus clearly valued in their own right. One antique bowl was found among the hoard of silver-ware known as St. Ninian's Treasure. The deposit, buried in about AD 800, was discovered in 1958 under the chancel arch of a tiny church on a tidal island off the coast of the main island of Shetland. The decorative style on this plate owes a great deal to Pictish influence, discussed later in this chapter.

Chalices, specifically for sacramental use, were also made by Christian metalsmiths. The most splendid is the Ardagh Chalice (FIG. 118), found concealed with another vessel and four brooches in a rath at Ardagh in Co. Limerick. The great silver vessel is decorated with gilded bronze, gold, and enamel, with glass and mica insets like jewels: a rock crystal was set into the underside of

119. The Monymusk Reliquary, late 8th century AD. Wood, with silver overlay, decorated with bronze and enamel, height 3⁷/₈" (9.8 cm). National Museums of Scotland, Edinburgh.

The reliquary once contained a relic of Saint Columba. The veneration of the mortal remains of holy men and women was popular in the early Christian period. Much later, in 1314, this reliquary was carried as a standard by the Scots at the Battle of Bannockburn.

the cup. It has been suggested that the ultimate model for the chalice is Byzantine, but the decoration owes much both to Celtic and Anglo-Saxon art. A Celtic feature is the deliberate contrast between the plain silver surface and the riot of ornament which was confined to bands and medallions. The motifs include a combination of curvilinear La Tène designs and Anglo-Saxon animal interlace. The sacred function of the vessel is proved beyond doubt by the names of the Apostles inscribed upon its surface. The chalice is at the same time simple and sophisticated, and has been described as a "hymn of praise."

Bright metal enhanced the interiors of churches. Chalices, censers, plates, bells, croziers, reliquaries, and book covers adorned altars and tables. The boxes for holding holy relics are interesting: they sometimes resemble little churches, and are decorated with a combination of Celtic and Germanic (Saxon) ornament. The 8th-century reliquary from Monymusk in Scotland (FIG. 119) has bosses, like the Ardagh Chalice, but its surface is covered with fine patterns.

The gilt-bronze crucifixion plaque from St. John's Rinnagan

may have been the decoration for a book cover (see FIG. 105). Its iconography of Christ with two angels and two men is unique in early Christian metalwork. The great heads and small bodies of Christ and his companions betray the Celtic artist's desire to exaggerate the human head, a tradition traceable to the last few centuries BC, although the plaque itself belongs to the 8th century AD. Indeed, with their almond-shaped eyes and schematic features, the figures could just as easily represent pagan gods as Christians.

The great range and quantity of Christian sacred metalwork which must have been present in the Celtic West by the 8th century is hinted at in the comments of Tírechán, a biographer of Patrick writing in the 7th century AD. He refers to the Irish saint as bringing with him to heathen Ireland "50 bells, 50 patens, 50 chalices, altar stones, books of the law, books of the Gospels" and leaving them in "new places."

Christian Sculpture

Carving in stone produced the most visually prominent and enduring expressions of Christian reverence. The symbol of the cross was chosen as the predominant sculptural motif to represent the message of God (see FIG. 115). Stone slabs bearing cross symbols were associated with the early monasteries of the 6th-7th centuries AD. The stones themselves were often roughly hewn, but, in contrast, the crosses were carefully and precisely sculpted. Here it is possible to see the influence of Celtic artistic tradition: an example of this is the cross on a stone at Kilshannig in Co. Kerry, where La Tène plant tendrils sprout from the ends of the cruciform design. The old La Tène swastika symbol of pagan art reappears on a stone at Cloon Lough (also in Co. Kerry), where the cross has become a swastika.

By the 7th century, stonemasons began to make the stones themselves cross-shaped, instead of merely carving a cross on a flat surface. By the 8th century, the so-called "High Crosses" were the main ornament of monasteries – both large and small – in Ireland (see FIG. 116). The typical cross has a great wheel or circle framing the upper part of the stone. The ring is symbolically important and may reflect solar imagery, the motif of a wreath of victory, or some other expression of the dominance of Christ. What seems clear is that whatever ornamental features the stones may have, the cross itself is the most important religious symbol.

Many Celtic crosses of the 7th-9th centuries were vehicles for complex artistic designs, which were frequently a blend of Ger-

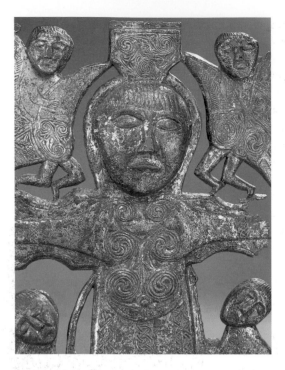

120. The head of Christ from the crucifixion plaque from Rinnagan, St. John's, near Athlone, Ireland, 8th century AD (see FIG. 105, page 140). Gilt-bronze, height 8³/₈" (21.1 cm). National Museum of Ireland, Dublin.

manic and Celtic forms. Interlaced animals are common, with Celtic spirals and triskeles. Alongside such patterns there appear human images and narrative scenes, but it is interesting that these often betray the old Celtic traditions of schematism and exaggeration that belong to the pagan past. The Carndonagh Cross has elaborate Germanic plaiting or interlace decoration on the top and shaft, but in its midst are Celtic bird-headed triskeles. The focus of ornament is a schematised or simplified crucifixion scene: the head of Christ is over-large, just as it is on the Rinnagan plaque (FIG. 120). The 8th-century cross of Moone in Kildare is likewise carved with simple, flat-relief drawings, but here there is intense iconography: the crucifixion scene is accompanied by a series of biblical events, such as the Flight into Egypt; and the base bears images of the twelve Apostles. The treatment of all the human figures is very Celtic: they have huge heads, round eyes, sketchy bodies, and small limbs. Indeed, they are "reduced to something resembling comic-strip personalities." The cross itself remains the dominant symbol, although the narrative scenes contain spiritual messages for the spectator, and enhance the power of the monument.

The Viking invasions of Ireland, which began in the 9th century, seem to have stimulated artists to concentrate on narrative religious iconography, perhaps on account of the perceived necessity to reaffirm the Christian faith in the face of the Vikings. The cross of Patrick and Columba at Kells bears themes which appear to have been specially selected to carry metaphysical messages, such as the use of sacrifice to free people from sin. Subjects portrayed on this cross include Adam and Eve, and Abraham preparing to sacrifice his son Isaac. The cross at the monastery of Monasterboice in Co. Louth is important because it is precisely dated: it bears an inscription stating that the stone was the gift of Muiredach, abbot of Monasterboice, who died in AD 923. The cross is decorated on both sides with narrative scenes from the Old and New Testaments: the message conveyed is that of Redemption.

We should not forget the sculptural traditions which pertained in other Celtic regions, such as Wales and Scotland. Celtic ring

crosses were erected in Wales, but figural iconography developed later here than in Ireland. Some Welsh crosses bear triskeles, and it has been suggested that, in a Christian context, they may represent the Holy Trinity. Cross slabs, as opposed to freestanding crosses, continued in Wales much longer than in Ireland: a 10th-century stone at Meifod in Powys is decorated in relief with a crucifix surmounted by a ring cross bearing the image of the crucified Christ. The stone is ornamented with a combination of Celtic and Germanic designs. Another 10th-century stone, at Margam in West Glamorgan, bears a hunting scene (this theme is also present in Ireland, for instance on a cross at Ahenny, Tipperary). Such a scene probably reflects Christian symbolism, with Christ as the victim represented by the deer, pursued by devils represented by the hounds and riders.

In Scotland, the tradition of stone-working in the early Christian period is complicated by the presence of an art of a different culture, that of the Picts. Pictish art is highly idiosyncratic and distinct from mainstream Celtic art, although there are many points of convergence. Most decorated Pictish stones were apparently set up as funerary monuments. Early Pictish stone art dates mainly to the 6th and 7th centuries AD: it includes incised outlines of animals, some of which are fantastic in form. The beasts often bear decorative shoulder-spirals, and in this respect resemble pagan Celtic animal images, such as the boar on the monument at Euffigneix in eastern France. Pictish iconography also includes curious, enigmatic symbols, such as the "V-rod and crescent" or the "mirror and comb" (FIG. 121). Some people hold the view that these are pagan, magical devices stimulated by the threat of advancing Christianity.

The later Pictish stones include slabs with relief-carved crosses. Many of the animals which decorate the stones are as monstrous as any appearing in pre-Christian Celtic art: a monument at Gask bears the image of a creature with a head at each end; at Meigle in Perthshire, beasts share a head; groups of animal-headed men appear on stones at Kettin and Murthly. Such creatures may be allegorical rather than pagan, but their significance remains obscure.

Pictish art is important not simply in its own right but because it also influenced specifically Christian art, for example on some crosses and manuscripts.

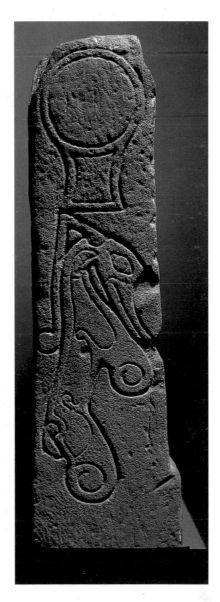

121. Pictish stone from Meigle, Scotland, 8th or 9th century AD. National Museums of Scotland, Edinburgh.

The stone depicts the so-called "Pictish Beast" and a mirror symbol.

The Illuminated Manuscripts

The painted Gospel books of the 7th-10th centuries AD represent the height of artistic excellence in Celtic Christian Europe. The tradition of producing such works developed out of the monastic foundations, with their stress on education and scholarship. Monks were faced with the new challenge of presenting the Word of God to an essentially non-literate world, and that may at least in part account for the importance of visual symbolism in these books. The vellum on which the manuscripts were written in ink and painted was itself a new medium, as was the concept of presenting Celtic art on flat surfaces (see FIG. 90). Artists working on vellum were at the same time released from the constraints of stone and metal but also confined to two dimensions. Indeed, it is possible to see that the painters were sometimes influenced by metalworking decorative conventions, just as were the sculptors of the great crosses, who carved rivet-like bosses on their stones.

The rich kaleidoscope of ornament on manuscripts came from a variety of influences in the Celtic, Germanic, and Mediterranean worlds. Because of the seamless blending of Celtic and Anglo-Saxon artistic features, manuscript art has been labelled "Hiberno-Saxon." This Irish and Anglo-Saxon connection may have come about because of the long-established Irish missionary presence in Northumbria, which itself came to produce such fine manuscripts as the Lindisfarne Gospel. But whatever the mix of traditions, there is no doubt that the origin of illuminated manuscripts lay in Ireland. The presence of Celtic ideas can be discerned in such motifs as spirals, curves, and triskeles. The deliberate avoidance of copying from life continued, as did the depiction of elusive human heads and sinuous animal symbols. Zoomorphic and plant forms continued to display a need to break out from the mould of purely geometric design. The striking feature of the styles and motifs employed by the illuminators is that, although the books themselves were specifically Christian objects, much of the artists' inspiration was drawn from the dream-images of myth and the pre-Christian supernatural world. The painters were working in a Christian context and were themselves Christian, but they illuminated the holy scriptures with pagan as well as Christian motifs.

The Book of Durrow is one of the oldest surviving manuscripts, dating to the second half of the 7th century AD. It is named after the monastery of Durrow in Co. Offaly, founded by Columba in the mid-6th century. It consists of the Latin text of the four

Gospels (Matthew, Mark, Luke, and John). Of its 496 pages, 11 are fully illuminated: 6 consist of panels of tapestry-like "carpet" pages, where the entire surface is covered with decoration; one page bears a group-portrait of the four Evangelists at the beginning of the book (see FIG. 107); the remaining 4 pages are illustrated with the symbols of the four saints, at the start of each Gospel. The opening words of each text are also illuminated. The painter of the Durrow manuscript used red, yellow, brown, and green against the rich creamy texture of the vellum. Saxon influences are indicated, for instance by the frieze of interlaced and biting animals. Other beasts look very Pictish in their design. But the Celtic artistry is also prominent, in the same contrast and balance between intricate and detailed ornament and empty space that we saw on the Ardagh Chalice. Celtic symbols are present on the Carpet page ornament, which contains triple spirals, scrolls, and triskeles. The treatment of the human images displays Celtic schematism: the Evangelists are stiff and unrealistic, like so many depictions of the human form both from the pagan era and from the other contemporary Christian art of sculpture and metalwork.

The full development of Christian manuscript art is illustrated at its superb best by the Book of Kells, which was completed in the late 8th or early 9th century (FIG. 122). In AD 807 the abbot of Iona and his monks fled to Kells in Ireland after the Vikings sacked their great monastery. The refugees took with them, perhaps incomplete, what the Annals of Ulster in 1007 described as "the great Gospel of Columkille." The Annals also record how, in that year, the "chief relic of the western world" was "wickedly stolen in the night." The great book was rediscovered a few months later, stripped of its gold ornament and buried under a sod of earth. The Book of Kells has more than two thousand illuminated capital letters, all different, which mark the sections of the text. More than forty full-page illustrations display the work of several artists, some obviously brilliant, others not so competent, perhaps apprentices. Some pages were never finished. Ornament was clearly of great importance, for it permeates the entire document. The Book of Kells was a luxury, made to be placed, open, upon an altar for all worshippers to see and admire.

The artistic influences of the Kells Gospel-book are many: the decorated pages present a fusion of Coptic (Christian Egyptian), Merovingian (Frankish), Mediterranean, and Celtic traditions. But it is essentially Irish, and clearly represents a development from earlier manuscripts, such as Durrow. The miniaturist detail of animals, palmettes, triskeles, and scrolls, so beloved of pagan artists, on the so-called Monogram or Chi-Rho page make it a

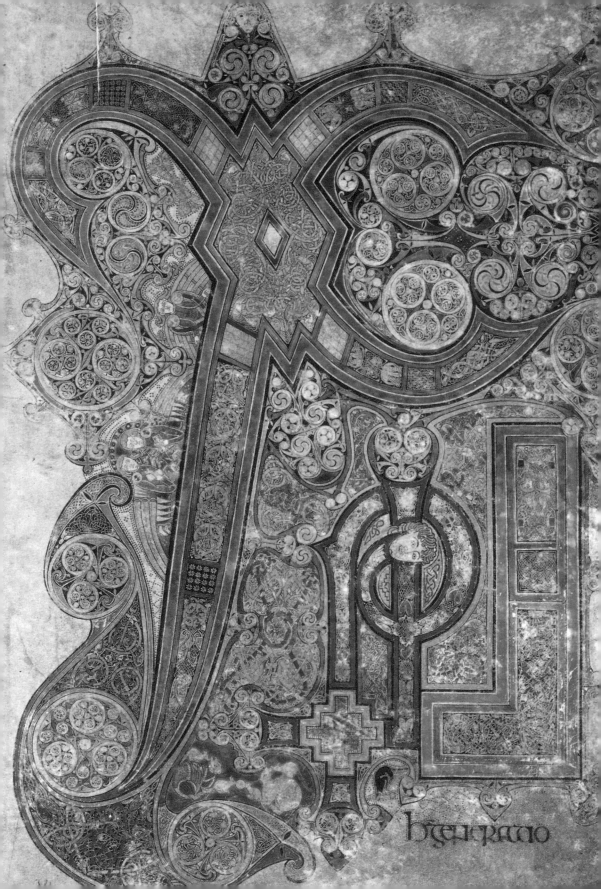

hgenerario

magnificent piece of Celtic art. There is even a tiny human face terminating the curve of one of the letters. This page has been rightly described as an illustration of "the marriage of pagan superstition and Christian belief."

There is no doubt that, in all its manifestations, early Christian Celtic art – like its pagan counterpart – expressed deeply held religious beliefs; beliefs that were charged with emotion for which the outlet was art. In the same way that pagan Celtic artists made beautifully ornamented jewellery and weapons as offerings to their gods, so Christian monks presented the gifts of carved crosses or brilliantly decorated manuscripts to the new God. Such art transcended the need for words; the Christian doctrine was conveyed, above all, by visual symbolic expression. Christian Celtic art has been likened to the great sacred choral works of Bach and others, where the words sung are less important than the glory of the music itself. The skill of the early Christian artists, together with their beliefs and innermost feelings, were poured into a visual expression of awe, love, and reverence which was as eloquent as any human or animal sacrifice offered to the gods in the pagan Celtic period. But the brilliance of the Celtic artists manifests itself equally within both pagan and Christian contexts. Indeed, Celtic art can be counted as one of the great artistic traditions of the world and one which, furthermore, retained its integrity for more than fifteen hundred years.

The charisma of Celtic art is still very much alive today. In Britain, continental Europe, and the United States of America, Celtic patterns and designs – based on La Tène art – are popular motifs on clothes, jewellery, and even greetings cards. The present-day attraction of two-thousand-year-old motifs stands as strong testimony to its ageless appeal as an art of the imagination and of the spirit.

122. The Chi-Rho page from the Book of Kells, Kells, Ireland, late 8th-early 9th century AD. Painted vellum, 13 x 9¾" (33 x 25 cm). Trinity College Library, Dublin.

The Chi-Rho page is so-called because the first two Greek letters of "Christ" (chi and rho) form the main motif.

	Historical Events	Phases of material culture
800 BC		Hallstatt Iron Age
700 BC		
600 BC	Foundation of Greek colony at Massalia (Marseille)	
500 BC		La Tène Iron Age
400 BC	Celtic Gauls sack Rome (387)	
300 BC	Celts sack Delphi (329)	La Tène tradition in Britain and Ireland
200 BC	Romans defeat Celts at battle of Telamon (225)	
100 BC	Romans conquer south of Gaul (Narbonensis) (124)	
0	Caesar conquers all Gaul (58-50) and invades Britain (55/54) Claudius invades Britain (AD 43) Britain conquered as far as Scotland (84)	Romano-Celtic culture
100 AD	Hadrian's Wall built (120s)	
200 AD	Gallic Empire (260-274)	
300 AD	Constantinople becomes Roman capital (330)	
400 AD	Romans withdraw from Britain Visigoths sack Rome (410) Saxons invade Britain	Early Christian (Britain and Ireland)
500 AD	Frankish kingdom founded by Clovis (486) St. Patrick brings Christianity to Ireland St. Columba establishes Iona (563)	Anglo-Saxon (East Britain)
600 AD		
700 AD	Establishment of Byzantine (East Roman) Empire (610)	
800 AD	First Viking attack on Eastern Britain (789) Vikings invade Ireland 795 Charlemagne crowned in Rome (800) Scots take Pictland (843)	Viking
900 AD		
1000 AD	Irish defeat Vikings at battle of Clontarf (1014)	

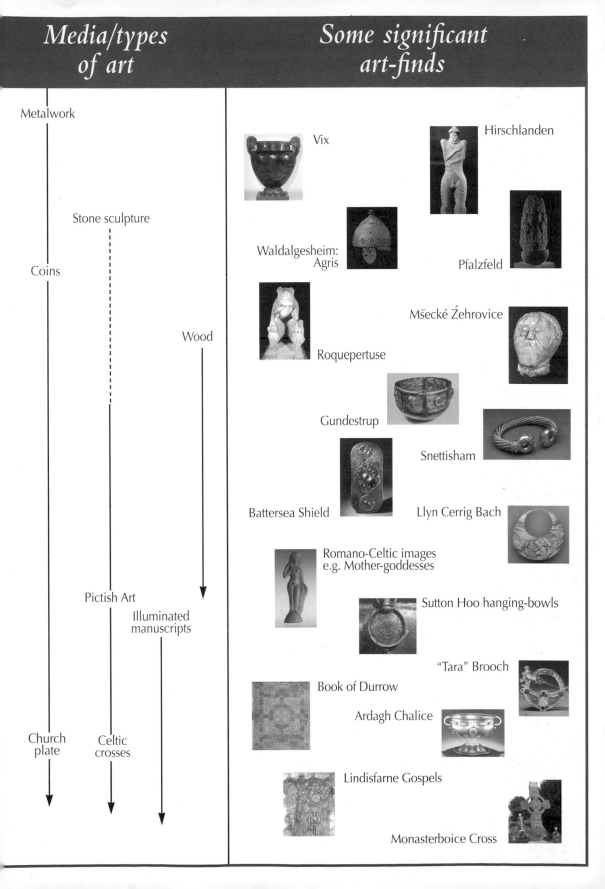

Media/types of art	Some significant art-finds

Media/types of art

Metalwork

Stone sculpture

Coins

Wood

Pictish Art

Illuminated manuscripts

Church plate

Celtic crosses

Some significant art-finds

Vix

Hirschlanden

Waldalgesheim: Agris

Pfalzfeld

Mšecké Źehrovice

Roquepertuse

Gundestrup

Snettisham

Battersea Shield

Llyn Cerrig Bach

Romano-Celtic images e.g. Mother-goddesses

Sutton Hoo hanging-bowls

"Tara" Brooch

Book of Durrow

Ardagh Chalice

Lindisfarne Gospels

Monasterboice Cross

Bibliography

GENERAL READING ON THE CELTS

COLLIS, JOHN, *The European Iron Age* (London: Batsford, 1984)

DUVAL, PAUL-MARI, *Les Celtes* (Paris: Gallimard, 1977)

GREEN, MIRANDA, J. (ed.), *The Celtic World* (London: Routledge, 1995). Very comprehensive; deals with every aspect of Celtic society and material culture.

KRUTA, VENCESLAS, and others (eds), *The Celts* (catalogue of an exhibition held in Venice in 1990; London: Thames and Hudson, 1991). Comprehensive and superbly illustrated.

JAMES, SIMON, *Exploring the World of the Celts* (London: Thames and Hudson, 1993). Very readable, a good introduction.

GENERAL READING ON CELTIC ART

DUVAL, PAUL-MARI, *L'Art Celtique de la Gaule au Musée des Antiquités Nationales* (Paris: Musée des Antiquités Nationales, 1989)

JACOBSTHAL, PAUL, *Early Celtic Art* (2 vols; Oxford: Oxford University Press, 1944). The seminal work on pagan Celtic art.

LAING, LLOYD, AND LAING, JENNIFER, *Art of the Celts* (London: Thames and Hudson, 1992)

— *Celtic Britain and Ireland: Art and Society* (London: Herbert Press, 1995)

MEGAW, VINCENT, *Art of the European Iron Age* (New York: Harper and Row, 1970)

MEGAW, RUTH, AND MEGAW, VINCENT, *Celtic Art from its Beginnings to the Book of Kells* (London: Thames and Hudson, 1989)

OLMSTED, GARRETT, *The Gundestrup Cauldron* (Brussels: Latomus, 1979)

RAFTERY, BARRY, AND OTHERS, *Celtic Art* (Paris: Unesco/Flammarion, 1990)

STEAD, IAN, *Celtic Art in Britain before the Roman Conquest* (London: British Museum Publications, 1985)

CHAPTER ONE

ALLEN, DEREK, *The Coins of the Ancient Celts* (Edinburgh: Edinburgh University Press, 1980)

ELUÈRE, CHRISTIANE, *The Secrets of Ancient Gold* (Düdingen: Trio Verlag, 1989)

— *The Celts: First Masters of Europe* (London: Thames and Hudson, 1993)

JOPE, MARTYN, "The social implications of Celtic Art," in GREEN, MIRANDA, J. (ed.), *The Celtic World* (London: Routledge, 1995), pp. 376–410

MANNING, WILLIAM, H., "Ironworking in the Celtic world," in GREEN, MIRANDA, J. (ed.), *The Celtic World* (London: Routledge, 1995), pp. 310–20

MAYS, MELINDA (ed.), *Celtic Coinage: Britain and Beyond* (Oxford: British Archaeological Reports, no. 222, 1992)

NORTHOVER, PETER, "The technology of metalwork: bronze and gold," in GREEN, MIRANDA, J. (ed.), *The Celtic World* (London: Routledge, 1995), pp. 285–309

WELLS, PETER, S., *Culture Contact and Culture Change: Early Iron Age Central Europe and the Mediterranean World* (Cambridge: Cambridge University Press, 1980)

CHAPTER TWO

CHAMPION, S., "Jewellery and Adornment," in GREEN, MIRANDA, J. (ed.), *The Celtic World* (London: Routledge, 1995), pp. 411–19

CHAMPION, TIMOTHY, "Power, Politics and Status," in GREEN, MIRANDA, J. (ed.), *The Celtic World* (London: Routledge, 1995), pp. 85–94

FREY, OTTO-HERMANN, "Celtic Princes," in KRUTA, VENCESLAS, AND OTHERS (eds), *The Celts* (London: Thames and Hudson, 1991), pp. 75–92

JOFFROY, RENÉ, *Le Trésor de Vix (Côte d'Or)* (Paris: Musée des Antiquités Nationales, Saint-Germain-en-Laye, 1954)

MEGAW, VINCENT, AND MEGAW, RUTH, *The Basse-Yutz (1927) Find: Masterpieces of Celtic Art* (London: Society of Antiquaries of London, 1990)

STEAD, IAN, "The Snettisham Treasure: excavations in 1990," *Antiquity*, vol. 65, 1991, pp. 447–65

CHAPTER THREE

CUNLIFFE, BARRY, *Iron Age Communities in Britain* (3rd ed; London: Routledge, 1991)

DE NAVARRO, J.M., *The finds from the site of La Tène. I: scabbards and the swords found in them* (London: British Academy, 1972)

DENT, JOHN, "Weapons, wounds and war in the Iron Age," *Archaeological Journal*, vol. 140, 1983, pp. 120–28

RITCHIE, GRAHAM, AND RITCHIE, WILLIAM, *Celtic Warriors* (Princes Risborough: Shire Publications, 1985)

STEAD, IAN, *The Battersea Shield* (London: British Museum Publications, 1985)

— "Kirkburn: a Yorkshire chariot-burial with a coat of mail," *Current Archaeology*, no. 111, 1988, pp. 115–17

— *Iron Age Cemeteries in East Yorkshire* (London: English Heritage, 1991)

CHAPTER FOUR

DUVAL, PAUL-MARI, "Celtic Art," in KRUTA, VENCESLAS, and others, *The Celts* (London: Thames and Hudson, 1991), pp. 25–28

FOX, CYRIL, *Pattern and Purpose: A Survey of Early Celtic Art in Britain* (Cardiff: National Museum of Wales, 1958)

GREEN, MIRANDA, J., *Animals in Celtic Life and Myth* (London: Routledge, 1992)

NYBERG, HARRY, "Celtic ideas of plants," in
HUTTUNEN, H.-P., AND LATVIO, R. (eds), *Entering
the Arena (Presenting Celtic Studies in Finland),
Etäinen*, vol. 2, 1993, pp. 85-114 (Department of
Cultural Studies, University of Turku, Finland)
STEAD, IAN, AND OTHERS, *Lindow Man: the Body in the
Bog* (London: British Museum Publications, 1986)

CHAPTER FIVE
On Celtic religion and myth:
GREEN, MIRANDA, J., *The Gods of the Celts* (rev. ed.;
Gloucester: Alan Sutton, 1993)
— *Dictionary of Celtic Myth and Legend* (London:
Thames and Hudson, 1992)
— *Celtic Myths* (London: British Museum Press, 1993)
MAC CANA, PROINSIAS, *Celtic Mythology* (London:
Newnes, 1983)

On Romano-Celtic sacred art:
GREEN, MIRANDA, J., *Symbol and Image in Celtic
Religious Art* (rev. ed.; London: Routledge, 1992)

On Christianity in Roman Britain to AD 500:
THOMAS, CHARLES, *Christianity in Roman Britain*
(London: Batsford, 1981)

On early Christian Celtic Art:
BACKHOUSE, JANET, *The Illuminated Manuscript*
(Oxford: Phaidon, 1979)
FINLAY, IAN, *Celtic Art: an introduction* (London: Faber,
1973)
HENRY, FRANÇOISE, *Early Christian Irish Art* (Dublin:
Colm O Lochlainn, 1954)
— *Irish Art in the Early Christian Period* (London:
Methuen, 1965)
— *The Book of Kells* (London: Thames and Hudson,
1974)
REDKNAP, MARK, *The Christian Celts: Treasures of
Late Celtic Wales* (Cardiff: National Museum of
Wales, 1991)
YOUNGS, SUSAN, *The Work of Angels: Masterpieces of
Celtic Metalwork, 6th-9th centuries AD* (London:
British Museum Publications, 1989)

Picture Credits

Museums of Scotland 1996
65 AKG, London, photo Eric Lessing
66 right © British Museum, London
67 RMN, Paris
68 © British Museum, London
70 Musée des Beaux-Arts
 d'Angoulême, Dépôt de l'Etat,
 © Musée d'Angoulême, photo
 G. Martron
72-74 © British Museum, London
76 © British Museum, London
78 © National Museum of Ireland,
 Dublin
79 Národní Muzeum: Historické
 muzeum-prehistoric, Prague
80 © The Trustees of the National
 Museums of Scotland 1996
page 115 detail of figure 96
82 © British Museum, London
83 Newport Museum & Art Gallery,
 photo by Rex Moreton
84 Musée des Beaux-Arts

d'Angoulême, Dépôt de l'Etat,
© Musée d'Angoulême, photo
G. Martron
85 © Musée des Jacobins, Morlaix,
 photo Alain Le Nouail
87 AKG, London, photo Eric Lessing
88 © British Museum, London
90 The Board of Trinity College
 Dublin
94 © British Museum, London
96 © British Museum, London
99 Collection du Musée Historique et
 Archéologique de l'Orleanais,
 Orleans, # A 6301
100 Courtesy Musée des Alpilles, St
 Rémy de Provence, photo L'Oeil
 et la Mémoire
103 National Museum of Ireland,
 Dublin
105 © National Museum of Ireland,
 Dublin
106 Collection du Musée Historique et

Archéologique de l'Orleanais,
Orleans # 6296
107 The Board of Trinity College
 Dublin
page 145 detail of figure 118
109 C.M. Dixon, Canterbury
110 RMN, Paris
111 The Roman Baths Museum, Bath
112 English Heritage, Newcastle upon
 Tyne
113 Michael Jenner, London
114 Mick Sharp, Caernarfon
115-16 C.M. Dixon, Canterbury
117-18 © National Museum of Ireland,
 Dublin
119 © The Trustees of the National
 Museums of Scotland 1996
120 © National Museum of Ireland,
 Dublin
121 Historic Scotland, Edinburgh
122 The Board of Trinity College
 Dublin

Index

abstract motifs 11, 18, 117, 118, 123, 124, 125
Aenghus (Irish monk) 154, 158
Agris Helmet *100*, 101, 119, *119*, 123, 135
Ahenny, Tipperary, Ireland: stone cross 28, *28*, 163
Aidan, St. 153
Alise-Ste.-Reine, Burgundy: Epona (stone statue) 78-79, *79*
amber 18, 45, 57, 73, 82, 90, *91*, 93
Amfreville, France: helmet 102
Anglesey, Wales *see* Llyn Cerrig Bach
Anglo-Saxons 36, 152, 160, 165; hanging bowls 40, 66, 124, 159
animal motifs 18, 118; on belts 80; on brooches 81, 82; on coins 70; distortion and exaggeration of 129, 130, 134; fantastic *21*, 104, 105, 117, 118, 128-29, 135-37, 151; on helmets 101; and religion 117, 128; on shields *92*, 104, 105, 129; on swords and scabbards 97-98, 129; symbolism of 109, 113, 117, 129, 151-52; *see also specific animals*
anthropomorphism 11, 60, 97, 98, *98*, 120

Antigonos Gonatas, King of Macedon 12
apotropaic motifs 96, 124
Ardagh Chalice 66, *159*, 159-60, 165
Ariovistus, ruler of the Insubres 77
armlets 55, 58, 79; Erstfeld 74; Reinheim 69, *69*, 73, 136; Rodenbach 72, *72*, 79, 83, *121*, 121-22, 136, 139
armour and armourers 16, 18, 32, 38, 89, 90, 100, 113; *see also* helmets; scabbards; shields; swords
artists: patronage of 21, 32-33, 34, 38, 40; status of 33
Aston, Hertfordshire: mirror back 117, *117*, 129, 140
Attalus of Pergamon 12
Attymon, Galway, Ireland: horse-bits 109-10, *110*
Augustine, St. 28, 152
Augustus, Emperor 77
Aylesford, Kent: bucket 40, *40*, 42, 63, 137-38

Bad Dürkheim, Germany: plaque 83, *83*

Ballyshannon Bay, Ireland: hilt 97
Bann, River, Antrim, N. Ireland: scabbards *38*, 39, 43, 124
Barton graves 63
Basse-Yutz, France: wine-flagons *frontis.*, 32, 61, *62*, 119, 130
Bath, Avon: plaque 149, *151*
Battersea Shield, The *9*, 18, 32, 104-05, *105*, 124, 140, 146
belts 55; buckle 80, *80*, 125, 158; plaque 32, *33*, 35-36, 80, 122, 135, 139
Besseringen graves, Germany 40
Bettystown, Meath, Ireland: Tara Brooch 82, *82*, 124, 158, *158*
Birdlip, Gloucestershire: mirror 42, *43*, 69
birds 98, 109, 128, 129; birds' heads 35, *36*, 103-04, 111, 113, 125, 126, *127*; bird-head triskeles 66, 67, 110, 124, *125*, 158; birds of prey *26*, 70, 73, 136; owl 109; ravens 70, *101*, 102, 137, 152; water birds 19, *19*, 129, *129*, 130
bits *see under* horse-gear
blacksmiths 49-50

boars 70, *92*, 94, 102, 104, 115, 128, 129, *133*, 134, 137, 151, 163; boar's head trumpet 94, *94*, 99-100

bog finds 18, 57, 63, 109, 111, 113, 122, *123*, 129, *129*, 146

bone objects 29; tools 42-43; "trial-piece" 42, *42*

Book of Durrow *see* Durrow, Book of

Book of Kells *see* Kells, Book of

Boudica, Queen *50*, 77, 83-84

Bouray, France: bronze hooved god 36, *36*, 84, 138, 142, 151

Bouy, Marne, France: scabbard 97

bowls: sheet-bronze 42; *see also* hanging bowls

bracelets, gold *25*, 45, 48, 49, *49*

Brigantes, the (tribe) 109, *109*

Britain: Celtic art 16, 26-27, 39-40; Roman occupation of 12-13, 16, 17, 27, 33-34, *63*, 88, 106

Brittany 17; coins *26*, 70, *70*, 130, 136-37, 138

Broighter torc 125

bronze and bronzesmiths 39, 40, 42-43, 49-50, 57

Bronze Age 14, 19

brooches 31, 32, 55, 58, 71, 80; *fibulae* 80-81; penannular *81*, 82, 158; Tara 82, *82*, 124, 158, *158*

bucket-lid, bronze 129-30

buckets (tubs), wooden 29, *29*, 58; Aylesford 40, *40*, 42, 63, 137-38

buckle, belt (from Lagore) 80, *80*, 124, 158

buildings 22, 68, *68*

Bulbury, Dorset: chariot-mounts 109

bulls and cows 65, 66,98, 109, *109*, 128, 134, 135; triple-horned 134, *134*, 149

burial practices 26, 89

Býčiskála, Moravia: cart 66

Caerwent, Wales: stone goddess 118, *118*, 142, 151

Caesar, Julius 12, 26, 70, 88, 106, 145

Camunian rock art 137

Canosa Helmet 93, *93*, 126

Capel Garmon, Wales: firedog 63, *65*, 66, 134, 146

Caratacus *63*

carburisation *91*, 95

Carndonagh Cross, Ireland 162

cat faces *128*, 129

"Cathach of Saint Columba" 51, 113

cauldrons 15, *15*, 42, 43, 58, 59, 60; *see also* Gunderstrup Cauldron

ceramics *see* pottery

Cernon-sur-Coole, France: scabbard 126

Cernunnos (god) 78, *135*, 137, 147, *147*, *148*, 149, 151

chain-mail 89, 100

chalices 159, 160; Ardagh *159*, 159-60, 165

Chamalières, France: wooden figure 84, *84*, 142

champlevé enamelling 44, 158

chariots 16, 26, 66, 68, 89, 90, *90*, 106-07; fittings and plaques *66*, 66-67, 107, 109, *109*, 110

chasing 42, 95

children's graves 71, *71*

chip-carving 30, 36, 42, 66, *159*

Christianity, early 17, 27-28, 81, *see also* missionaries, monasticism; art and artefacts 66, 113, 118, 157, 158-61, 167, *see also* crosses, manuscripts

cire perdue casting method 42-43

Çiumeşti, Romania: armour 100, *101*, 101-02

clay statuettes 34, *35*

Clevedon, Avon: torch 78

Clonmacnois monastery, Ireland 154

Cloon Lough, Kerry, Ireland: cross 161

coins 13, 26, 33, 45, 49, 70, 83, 102, 134; Breton *26*, 70, *70*, 130, 136-37, 138

Columba, St. 29, 53, 153, 155, *160*, 164; "Cathach" 51, 113

Columbanus, St. 153

Como, Italy: battle 77

coral 18, *33*, 44, 44-45, 57, 61, *62*, 73, 80, 90, *92*, 93, *93*, 96

Corbridge, Northumberland: head of god 151, *151*

Cork, Ireland: crown 67

Corleck, Cavan, Ireland: triple head 139, *139*, 140

Cornwall 17, 27, 152

couch, Hallstatt funerary 59, *61*, 83

cremation 26, 89

crosses, stone 28, *28*, 30, 31, 36, 53, 156, *156*, *157*, 161-63

cross slabs 161, 163

crowns: bronze 67, *67*; leaf *40*, 83, 110, 122, 139

crucifixion plaque, Irish *140*, 142, 160-61, 162, *162*

Cú Chulainn 98

Culhwch ac Olwen 151

cult wagon *115,* 130, 134, 142, 147

curvilinear designs 39, 63, 81, 117, 123, 126, 140

daggers 89, 97, *98*

Dammelberg, Germany: torc 140

Danes Graves, Yorkshire: pin 80, *81*

Deal, Kent: headdress 67, *68*; scabbard 126, *127*

deer *see* stags and deer

Desborough, Northamptonshire: mirror 69

Deskford, Scotland: boar's head war-trumpet 94, *94*, 99-100

Dio Cassius 12, 77

Diodorus Siculus: *Library of History* 9, 58, 88, 89, 98, 101, 115, 146

Ditzingen-Hirschlanden, Germany: Hallstatt warrior 57, 74, *75*, 84, *142*, 147

dogs 128, 137

"dragon-pair" motifs 97, *97*, 135

drinking equipment 58, 59, 61, 63, *see* cauldrons; flagons

drugs, hallucinatory 117-18

Dunaverney Bog, Ballymoney, Antrim, N. Ireland: fork 129, *129*

Durotriges, the (tribe) 88

Dürrnberg, Austria: child's grave 71, *71*, flagon *21*, 35, 61, 83, 135, 139

Durrow, Book of 53, 124, *125*, *145*, 164-65

Durrow monastery, Offaly, Ireland 153, 164

Dying Gaul, The 77, *78*

Eberdingen-Hochdorf, Germany: Hallstatt prince's tomb 15, *15*, 59, *61*, 83, 96, 118

electrum jewellery 45, 48, 74

elephants 115, 137

enamelling *9*, 18, 21, 39, *39*, 40, 44, 61, *62*, 79, *81*, 82, 90, *91*, 105, *105*

engraving 40, 42, *42*, 95-96, *96*, 99

Entremont, France 84, 147

Epona (goddess) 78-79, *79*, 148, 149

Erstfeld, Switzerland: torcs 74, 77, 136

Etruscans 15, 16, 35, 119; *stamnos* 60-61

Euffigneix, France: monument 163

exaggeration 129, 134, 135, 142, 143, 151, 161, 162

faces, human (motifs) 18, 113, 117, 126, *127*; in Christian art 157, 167; with foliage *93*, 97, 117, 119, 120, 121-22, 126; on headdresses and helmets 67, *93*, 126; pseudo 117, *117*, 140; reversible *9*, 83, *83*, 105, 140

Fellbach Schmiden, Germany: stag *131*, 134

fibulae 80-81

finger-rings 55, 73, 79, 83, 139
firedogs 63, *65*, 66, 134, 146
flagons 40, 60; Basse-Yutz *frontis.*, 32, 61, *62*, 119, 130; Dürrnberg *21*, 35, 61, 83, 135, 139; Kleinaspergle 58, *59*, 61, 139, 140; Reinheim 42, 60, 119, 122, *122*, 138; Waldalgesheim 42, 60, 61, 119
Florus 77
foliage *see* vegetal motifs
fork, meat 129, *129*
Freisen, Germany: horse 130, *130*

gaesatae (Celtic spearmen) 77
Garranes, Cork, Ireland 158
Gask, Scotland: monument 163
Gaul and Gauls 9, 11, 12, 13, 16, 26, 70, 77, 88, 106, 147, 149, 152
Giraldus Cambrensis 152
Glastonbury Lake Village, Somerset: utensils 29, *29*
Glendalough monastery, Wicklow, Ireland *27*, 28
gods and goddesses: and Christian symbolism 157; human figures as 117, 142-43; statues *11*, 34, *35*, 36, *36*, 84, *84*, 138, 142, 149, 151, *151*; *see also* Cernunnos; Epona; sun god
gold and goldsmiths 35, 40, 45, 49, 55, 56-57, 72
Goldberg, nr Aalen, Germany 22
graves 57, 58, 71, 113, 146, 147, 159
Great Chesterford, Essex: mirror back 126, *127*, 140
Greece 12, 15, 19, 35, 36, 61
griffons 115, 135
guilds 32, 38
Gundestrup Cauldron, The 45, *45*, 78, 84, 99, *99*, 102, 135, *135*, 136, 137, 138, 146, 147, *147*
Gussage, Dorset 33, 34-35, 42, 43, 49-50

Hallstatt culture *13*, 14-15, 21-22; drinking equipment 59-60, 63; hearses 66; swords and scabbards *91*, 93, 95-96, *96*, 130; tombs 22, *23*, 55, 60, 73; *see also* Ditzingen-Hirschlanden; Eberdingen Hochdorf
hanging bowls *39*, 40, 66, 124, 126, 158-59
harness decoration 67, 107, 109; *phalerae* 109, 110, *111*, 122, 139
headdresses *see* crowns
heads, human (*see also* faces, human)

97, 115, 138-40, 143, 164; janiform 73, 79, 115, 139; symbolism of 98, 113, 140; triple 115, 139; *see also* crowns; faces; gods
helmets 89, 90, 101; Agris *100*, 101, 119, *119*, 123, 135; Canosa 93, *93*, 126; from Çiumeşti *101*, 101-02; horned 102, *102*, 146
Henley Wood, Avon: bronze figure 84
Herodotus 11
Herzogenburg-Kalkofen, Austria: sword-hilt 138
Heuneberg, Germany 22, 73
Hiberno-Saxon manuscript art 164
Hirschlanden *see* Ditzingen-Hirschlanden
Hitchin, Hertfordshire 124
Hochdorf *see* Eberdingen-Hochdorf
Hockwold-cum-Wilton, Norfolk: headdresses 67
Hohmichele, Germany: graves 22, 73
Holcombe, Devon: mirror 69, 129
Holywell, Wales: well *155*
horns 42; drinking 58, 59, 61
Hořovičký, Bohemia: *phalera* 110, *111*, 122, 139
horse-gear 33, 34, 39, 42, 43; bits 35, 109-10, *110*; mask 109, *109*, 125; rein-rings 109, *109*, 110; *see also* harness decoration
horses 26, 89, 128; images of *26*, *40*, *56*, *70*, *70*, 128, 130, *130*, 138
human form, representations of 31, 81, 97, 115, 137-38, 142-43; *see also* faces, human; heads, human
Hungary 16, 23, 35, 38, 97, *97*, 99, 142

illumination *see* manuscripts
inscriptions 13, 145-46, 149
Iona monastery 29, 153, 154, 165
Ipswich, Suffolk: jewellery 48-49, 77
Ireland 17, 33, 35, 152-53; bone "trial-piece" 42, *42*; chariots 106-07; crosses 28, *28*, *156*, *157*, 161, 162, 163; fork 129, *129*; horse-bits 109-10, *110*; monasteries *27*, 28, 153, *153*, 154, 155, 164; querns 57; scabbards and swords 38, 39, 43, 91, 97, 124; stone statues *81*, 82, 139, *139*, 140, 158; trumpets 31, *31*, 68, 69, 146; *see also* Lagore; Navan Fort; Rinnagan; Tara; Turoe
iron 14, 49-50, 51, 57; firedogs 63, *65*, 66; *see also* Agris helmet
Iron Age *13*, 14, 15, 19, 21
Isleham, Cambridgeshire: sword and

scabbard 90
ivory 18, 45, 57, *91*, 93

jewellery *see* armlets; bracelets; brooches; finger-rings; torcs

Kells, Ireland: cross 162
Kells, Book of 53, 124, 125, 142, 165, 167, *167*
Kettin, Scotland: stones 163
Kilshannig, Kerry, Ireland: cross 161
King's Barrow, Yorkshire 107
Kirkburn, Yorkshire: sword *91*, 95
Kleinaspergle tomb, Germany 60-61; flagons 58, *59*, 61, 139, 140
Kleinklein, Austria: bucket-lid 129-30
Kosd, Hungary: scabbard 97, *97*
krater (from Vix) *14*, 15, 60

Lagore, Meath, Ireland: belt buckle 80, *80*, 124, 158
La Gorge-Meillet, Marne, France: chariot-burial 90, *90*
languages, Celtic 13, 14, 17
La Tène (Lake Neuchâtel), Switzerland 15, *16*, 38, 134; culture, art and artefacts 15-16, 17, 35, 40, 60, 63, 68, 73, 134, 140, 156, 161
leaf-crowns 40, 83, 110, 122, 139
leaves *see* vegetal motifs
Le Châtelet, France: sun god 148-49, *149*
leopards (motifs) 115, 128, 137
Lindisfarne, monastery of 153
Lindisfarne Gospel 51, 53, *53*, 164
Lindow man 122, *123*
Lisnacrogher, Antrim, N. Ireland 38-39; scabbards *38*, 39
Livy (Titus Livius) 11, 77
Llyn Cerrig Bach, Anglesey 38, *107*, 110-11; plaque *66*, 67, 110, 124, 125, 126, 146; yoke-terminal 124, *127*
London: bronzesmiths 39; scabbard 97, *97*; *see also* Thames, River
lost wax casting method 42-43
lotus flowers and leaves *55*, 96, 113, 115, 119, 120, 121
Loughcrew, Meath, Ireland: "trial-piece" 42, *42*
Loughnashade Lake, Antrim, N. Ireland: trumpets 31, *31*, 68, 69, 146
lynch-pins 109
lyre motifs 69, 119, 123, 126

Mabinogion 149, 151
Maiden Castle, Dorset 43, *88*

Maloměřice, Moravia: flagon-mount
138
Manching, Germany: rein ring 109, *109*,
135
manuscripts, illuminated 30, 31, 32, 36,
51, 53, *53*, 128, 155, 156, 164; *see
also* Durrow and Kells, Books of
Margam, Wales: stone cross 163
Mariesminde, Denmark: sacred vessel
19, *19*, 130
Marne region, France 16, 23, 38, 90, *90*,
93, 106
Marseille, France 36, 84, 147
masks: human 138; Stanwick 109, *109*
Meifod, Powys, Wales: stone cross 163
Meigle, Scotland: Pictish stone 163, *163*
metalwork: Celtic 9, 23, 29, 32, 38;
Christian 158-61; *see specific items*
millefiori glass *39*, 40, 44
minimalism 11, 109
mirrors, mirror backs 9, 40, 42, *43*,
69-70, 117, *117*, 126, *127*, 129, 140
missionaries, Irish 29, 36, 153-54, 155,
156-57, 164
mistletoe *55*, 110, 122, 139
Moel Hiraddug, Wales: plaque 123, *124*
Monasterboice, Louth, Ireland: cross
157, 162
monasteries, monasticism 27, 28-29, *153*,
153-55, 161, 162, 164
Mons Graupius, battle of 100
monsters 117, 128-29, 135-37
Mont Lassois, Burgundy *14*, 22
Monymusk Reliquary 160, *160*
Moone, Kildare, Ireland: cross *156*, 162
Mšecké Žehrovice, Bohemia: stone
head 9, *11*, 84, 139, 140, 147
Münsingen cemetery, Switzerland 79
Murthly, Scotland: stones 163
myths 17; Irish 68, 70, 98, 102, 107,
129, 137, 149, 151, 152; Welsh 149,
151-52

naturalism 11, 18, 31, 96, 117, 129-30
Navan Fort, Armagh, N. Ireland 31, *31*,
68, 68-69
neckrings 71, 72, *see also* torcs
Neuvy-en-Sullias, France: boar *133*, 134;
dancer 142, *143*
Niederzier, Germany: torcs and coins
70, 146
niello decoration 40
Noves, France: Tarasque 136, *136*, 140

Obermenzing, Germany 94; scabbard
124, *125*

palmette design 96, 119-20, *120*, 121, 123
Patrick, St. 28, 153, 154, 155, 156, 161
Petrie Crown 32, 67, *67*, 126
Pfalzfeld, St. Goar, Germany: pillar 30,
55, 82-83, 120, 122, 139, 140
phalerae 109, 110; from Hořovičký 110,
111, 122, 139
Philostratus: *Lives of the Sophists* 21, 44
Pictish art 163, *163*, 165
pillars *see* Pfalzfeld; Turoe
pins 80; wheel-headed 80, *81*
plant motifs *see* vegetal motifs
plaques 13, *66*, 67, 83, *83*, 110, 124, *124*,
125, 126, 146; *see also* crucifixion
plaque
Pliny the Elder 77, 110, 122
Polden Hills, Somerset 109
Polybius 11; *Histories* 77, 78, 88-89
pony-cap, Torrs 111, 113, *113*, 126
pottery 29, 34, 35, 38, 58, 60, 119-20,
120

quernstones 57, 58
Quintilian 77

ram-horned snakes 136, 137
ravens 70, 102, 137, 152
realism 117, *see* naturalism
Reinheim graves, Germany 40, 146;
armlet 69, *69*, 73, 136; flagons 42,
60, 119, 122, *122*, 138; ring jewellery
73, 78, 83, 136
rein rings 109, *109*, 135
reliquaries 113, 160; Monymusk 160, *160*
repoussé decoration 32, 33, 35, *36*, 39,
40, *40*, 42, 45, 67, 90, 104-05
Rheims, France: Cernunnos 147, *148*
Rhineland, the 16, 23; *see* Rodenbach;
Weiskirchen
ring jewellery *see* armlets; finger-rings;
torcs
Rinnagon, Roscommon, Ireland:
plaque *140*, 142, 160-61, 162, *162*
ritual depositions 146-47; in water *16*,
18, 51, 58, 59, 89-90, 91, 94, 110-11,
113, 146; *see also* Thames
Rodenbach graves, Germany 40, 146;
armlet 72, 72-73, 79, 83, *121*,
121-22, 136, 139; finger-ring 73, 79,
83, 139
Romania 16, 97, 100, *101*, 101-02
Romans 11, 12, 16-17, 26, 70, 77, 87,
88-89, 142-43, 145-46, 147-49;
in Britain 12-13, 16, 17, 27, 33-34,
39, *63*, 77, *88*, 100, 106, 118, 149, 152
Roquepertuse, France: skulls 84

St. Albans, Hertfordshire: Mercury
figurine 149
St.-Maur-en-Chaussée, France: bronze
warrior *87*, 142
St. Ninian's Treasure 159
St.-Pol-de-Léon, France: pot 120, *120*
Santa Paolina di Filottrano, Italy:
scabbard-plate 97
Santon Downham, East Anglia 109
scabbards 32, 38, *38*, 39, 42, 43, 95, 95-
97, 121, 124, 125, *125*, 126, *127*, 130,
134
schematism 117, 128, 129, 130, 162, 165
schools, craft 32, 38-40
Scotland 17, 27, 106, 152; finds 79, 94,
94, 99-100, 111, 113, *113*, 126; Pictish
stones 163, *163*
scrolls 99, 119, 124, 126
sculpture *see* stone sculpture
Severus, Emperor 106
shamanism 137, 138
shape-shifting 137, 138, 151-52
shields and shield-covers 35, *36*, 42, 89,
90, 95, 102-104, 129, 140; *see also*
Battersea Shield; Witham (River)
signatures 33
silver, use of 45, 55
Skellig Michael monastery, Ireland *153*,
155
slabs, cross 161, 163
snakes, ram-horned 136, 137
Snettisham, Norfolk: goldsmiths 40;
hoard 45, 48, 49, *49*, 74, 77, 78, 126,
146; Torc 49, *50*
Snowdon, Wales: bowl-handle *128*, 129
solar god *see* sun god
Sopron, Hungary: pots 142
spears 89, 98-99, *99*
sphinxes 35, 115, 128, 135
spirals 119, 124, 125, 126, 142, 158, 163,
164
stags and deer 70, 98, 115, *115*, 128, 129,
131, 134
Stanwick Mask 109, *109*, 125
Staple Howe, Yorkshire 22-23
statues (*see also* stone sculpture): bronze
36, *36*, 77, 78, 84, *87*, 130, *130*, *133*,
134, 138, 142, *143*, 148, 149, *149*, 151;
clay 34, *35*; wooden 84, *84*, *131*,
134, 142
stone sculpture 57; gods/goddesses *11*,
78-79, 79, 118, *118*, 142, 151, *151*;
Hallstatt warrior 57, 74, *75*, 84, 142,
147; Pictish 163, *163*; pillars *see*
Pfalzfeld, Turoe; relief of
Cernunnos 147, 148; Tarasque of

Noves 136, *136*; triple head 139, *139*; White Island *81*, 82, 158; *see also* crosses
Strabo: *Geographia* 45, 55, 87, 90-91, 146
Strettweg, Austria: cult wagon *115*, 130, 134, 142, 147
sun god 124, 148-49, *149*; *see also* Cernunnos
Sutton Hoo ship-burial *39*; hanging bowls 39, 40, 66, 124, 158, 159
swastika motifs *9*, 66, 78, 105, *105*, 113, 124, **127**, 161
swords 9, 26, 33, *34*, 38, 89, 90, *91*, 95, 97, *98*, 142; *see also* scabbards
symbolism 18, 81, 117, 118, 138; and animals 109, 113, 117, 129, 151-52; on armour and weaponry 93-98, 100, 102, 113; Christian 157, 158, 161-62; and the human head 139-40, 142; religious 78, 100, 128, 145-47; and vegetal motifs 96-97, 119-23

Tacitus 12, *63*, 84
Táin Bó Cuailnge (*The Cattle Raid of Cooley*) 129
Tal-y-Llyn, Wales: plaque 120
tankards, wooden 42, 63, *63*, 124
Tara Brooch 82, *82*, 124, 158, *158*
Tarasque of Noves 136, *136*, 140
Tayac, France: torcs and coins 70
Telamon, Italy: battle 12, 77, 89
tendril patterns *36*, 83, 96, 104, 119, 121, 122-23, 124
terrets 109, *109*
Tesson, France: hilt 97, *98*, 142
Thames, River: finds *9*, 18, 32, 35, *36*, 91, 99, *99*, 102, *102*, 104-05, *105*, 124, 129, 140, 146
three 78, *see* triplism; triskeles
tin 40
Tírechán 161
tools 42-43, 50-51

torcs 9, 32, 45, 55-56, 70, 74, 77-78, 83, 84; Dammelberg 140; Erstfeld 74, 77, 136; Ipswich 48-49; iron 73; Reinheim 73, 78, 83, 136; Snettisham 48, 49, *49*, 50, 74, 77, 126; on statues *11*, 74, 78-79, 84, *84*, 149; of Vix princess 56, *56*; Waldalgesheim *25*, 26, 48, 139, *140*
Torrs Farm, Kelton, Scotland: pony-cap 111, 113, *113*, 126
trade 15, 16, 21-22, 73
Trawsfynydd, Wales: yew-wood tankard 63, *63*, 124
trees 115, 121; "Tree of Life" *34*, 97, 135, 142
triplism (triadism) 123, 124, 134, 149, 151, *see also* triskeles
triskeles *30*, 63, 78, 80, *80*, 100, 102, 103, 113, 119, 123-24, *124*, 142, 149, 157, 164; bird-headed *66*, 67, 110, 124, *125*, 158
trumpet patterns 119, 124-25
trumpets 31, *31*, 35, 42, 67, 68, 69, 89, *94*, *99*, 99-100, 146
Tübingen-Kilchberg, Germany: funerary mound 22, *22*
tubs *see* buckets
Turoe, Galway, Ireland: pillar 30, *30*, 32, 57, 123-24

Ulster Cycle 68, 129, 137, 149

vegetal motifs (leaves, plants) 18, 36, 80, 83, *93*, 104, 115, 164; and human faces *93*, 97, 117, 119, 120, 121-22, 126; symbolism of 96-97, 119-23; *see also* leaf-crowns
vellum, use of 51, 164
Vercingetorix 70
Verulamium: Mercury figurine 149
Vikings 152, 162, 165
vine motifs 115, 119, 121

Vix princess, tomb of 22, 73; *krater 14*, 15, 60; torc 56, *56*
Volcae Tectosages (tribe) 45

wagon, cult *115* 130, 134, 142, 147
Waldalgesheim grave, Germany 146; chariot 107, 109; flagons 42, 60, 61, 119; jewellery and torc 23, *25*, 26, 48, 72, 83, 119, 124, 126, 139, *140*
Wales 17, 27, 152; crosses 162-63; finds 63, *63*, *65*, 66, 118, *118*, 120, 123, *124*, *128*, 129, 134, 142, 146, 151, *see also* Llyn Cerrig Bach; myths 149, 151-52; well *155*
Waltham Abbey, Essex: tools 50-51
Weiskirchen, Germany: belt plaque 32, *33*, 35-36, 80, 122, 135, 139
wells, holy 154, *155*
Wetwang Slack, Yorkshire: grave 68, 107
White Island, Fermanagh, Ireland: stone statues *81*, 82, 158
Winifride, St. *155*
Witham, River, Lincolnshire: shield-cover *44*, 44-45, 91, *92*, 104
wolves 70, 94, 99, 115, 128, 129, 136-37
women: graves of 73, 74, 83, *see also* Reinheim; Vix; Waldalgesheim; Wetwang; status of 59-60, 83-84
wooden objects 9; figurines 84, *84*, *131*, 134, 142; reliquary 160, *160*; tankard 63, *63*, 124; *see also* buckets
workshops, craft 32, 38-40

yew *121*, 121-22, 136
yin-yang motifs 103, 125
yoke-terminal, bronze 124, *127*

zoomorphism 11, 60, 124, 129, 134, 138, 164; animal motifs